AMERICAN IMPRESSIONIST IMAGES OF SUBURBAN LEISURE AND COUNTRY COMFORT

VISIONS OF HOME

LISA N. PETERS

WITH CONTRIBUTIONS BY

Jack Becker

May Brawley Hill

Carol Lowrey

David Schuyler

EDITED BY

Lisa N. Peters and
Peter M. Lukehart

The Trout Gallery, Dickinson College
Distributed by University Press of New England
Hanover and London

CATALOGUING INFORMATION

The exhibition was made possible by the Henry D. Clarke, Jr. Foundation for the Arts.
The presentation of *Visions of Home* at the Florence Griswold Museum is supported by a grant from the Connecticut Humanities Council.

Exhibition Dates
The Trout Gallery, Dickinson College, Carlisle, Pennsylvania 4 April – 14 June 1997
The Florence Griswold Museum, Old Lyme, Connecticut 28 June – 28 September 1997

Copyright © The Trout Gallery, Dickinson College, Carlisle, Pennsylvania. All rights reserved.
The book was produced by the staff of The Trout Gallery
Director and Editor, Peter M. Lukehart
Copy Editor, Timothy Wardell
Designer, Michael Gunselman Incorporated
Printer, Schneidereith and Sons Printing
The catalogue is distributed by University Press of New England

Library of Congress Cataloging-in-publication Data
Peters, Lisa N.
Visions of Home: American Impressionist Images of Suburban Leisure and Country Comfort/
Lisa N. Peters, with contributions by Jack Becker, May Brawley Hill, Carol Lowrey and David Schuyler.
"Exhibition dates, The Trout Gallery, Dickinson College 4 April – 14 June 1997,
the Florence Griswold Museum, Old Lyme, Connecticut 28 June – 28 September 1997" T.p. verso
Includes index.
ISBN 0-87451-970-5
CIP 96-061734

Cover: John Henry Twachtman, *My House*, Yale University Art Gallery,
New Haven, Connecticut, Gift of the Artist (cat. 9)

AMERICAN IMPRESSIONIST
IMAGES OF SUBURBAN LEISURE
AND COUNTRY COMFORT

VISIONS

OF HOME

CONTENTS

LENDERS TO THE EXHIBITION

CALIFORNIA
Natural History Museum of Los Angeles County, Los Angeles
San Diego Museum of Art, San Diego
A. Jess Shenson, MD, San Francisco
Michael W. Voorhees, Aliso Viejo

CONNECTICUT
Florence Griswold Museum, Old Lyme
New Britain Museum of American Art, New Britain
Wadsworth Atheneum, Hartford
Yale University Art Gallery, New Haven

DISTRICT OF COLUMBIA
National Museum of American Art, Smithsonian Institution

ILLINOIS
The Art Institute of Chicago, Chicago
Terra Museum of American Art, Chicago

MARYLAND
Ursula & Leftwich D. Kimbrough, Chevy Chase

MASSACHUSETTS
Art Complex Museum, Duxbury
Franklin P. Foltz, Edgartown
Private Collection
Springfield Museum of Fine Art, Springfield
Mr. and Mrs. Abbot W. Vose, Vose Galleries of Boston, Inc., Boston

NEW YORK
Brooklyn Museum, Brooklyn, NY
Guild Hall Museum, East Hampton
The Museums at Stony Brook, Stony Brook
National Academy of Design, New York
The National Arts Club, New York
Spanierman Gallery, New York
Strong Museum, Rochester

PENNSYLVANIA
Museum of American Art of the
Pennsylvania Academy of the Fine Arts, Philadelphia

VIRGINIA
Caroline Sullivan Trust, Alexandria
Virginia Museum of Fine Arts, Richmond

ONTARIO, CANADA
Art Gallery of Ontario, Toronto

FOREWORD

Visions of Home: American Impressionist Images of Suburban Leisure and Country Comfort is, admittedly, a descriptive title. It encapsulates what late nineteenth- and early twentieth-century writers felt were the essential elements of the ideal setting for domestic life in America: a tranquil and preferably pastoral site, well-tended gardens and grounds, a refuge from the frantic pace and clamorous congestion of the city. This exhibition is the first to be devoted exclusively to American Impressionist views of their homes and grounds in the country. As such, it affords us the opportunity to establish the American character of one of the most important subjects of our native Impressionist school. For while the divided brushwork and plein air (placement of the easel directly in the outdoors) technique are informed by the work of their French contemporaries, the American Impressionists sought to depict a place that was redolent with meaning for them — the artist's home, a place that often had an organic relationship to its natural surroundings.

The idea to organize an American Impressionist exhibition grew out of a discussion, in 1993, with two of the Gallery's most devoted patrons, Henry and Donna Clarke. Not coincidentally, that conversation took place in Greenwich, Connecticut, the very landscape that inspired so many of the artists of the period. We are all grateful to Henry and Donna for their enthusiastic and generous support of *Visions of Home* which was underwritten by the Henry D. Clarke, Jr. Foundation for the Arts. The scope and ambition of this show could not have been achieved without their considerable financial and personal commitment to the arts at Dickinson College.

It was the Clarkes, as well, who suggested that we invite Lisa N. Peters to curate the exhibition. Lisa's specialized knowledge of John Twachtman's paintings of his Connecticut home coupled with her command of the culture of American Impressionism made her the perfect choice as guest curator. In fact, the theme of the exhibit brings together material from Lisa's recently completed dissertation. Lisa has been instrumental to every phase of this enterprise from ideation to loan agreements and from writing the lead essay to taking on the lion's share of the catalogue entries. All this while balancing a family and a job. It has been an honor and a privilege to collaborate with her on this project.

As the exhibition began to take shape, the planning committee decided that we should share it with another venue. We were thus pleased when Jeffrey Andersen agreed to display *Visions of Home* at one of the preeminent pilgrimage sites for the American Impressionists, the Florence Griswold home (now the Florence Griswold Museum) in Old Lyme, Connecticut. We offer our thanks as well to the Griswold's administrative staff, including Laurie Bradt and Jack Becker. They have contributed much of their time and resources to making this show a success. We hope that this collaboration will lead to future ventures. The presentation of *Visions of Home* at the Florence Griswold Museum is supported by grants from the Connecticut Humanities Council and the Connecticut Commission on the Arts.

In addition to their role as a venue for the exhibition, the Florence Griswold Museum is also lending four important paintings. These and the other twenty-nine pictures from public and private lenders comprise *Visions of Home*. The communities of Dickinson College, Carlisle, PA and Old Lyme, Connecticut are most grateful to all the lenders (listed on the facing page) for their generous and expeditious assistance in organizing the show. We also thank the staffs of the lending institutions for the many kindnesses that they performed and information that they provided. The paperwork and coordination of loans was supervised by Lisa and Sherron Biddle, guest registrar at The Trout Gallery. We could not have accomplished this Herculean effort without their expertise and dedication. Special thanks are due to Sherron for her creative work on publicity.

At Dickinson we were aided in the organization of the exhibition by many of my colleagues who served as advisors on various matters. Let me start by thanking President A. Lee Fritschler and Dean Lisa Rossbacher for their advice and support; and by acknowledging the important contributions of Professors Sharon L. Hirsh and Melinda Schlitt. For their help with financial and insurance arrangements, we thank Michael Britton, treasurer, Nick Stamos, deputy treasurer, Annette Parker, associate treasurer, and Joanne Gingrich, assistant treasurer. Issues regarding facilities and security were vetted through the capable offices of the Physical Plant and Safety and Security. We are therefore beholden, on one hand, to Ken Shultes, Frank Laquitara, Whitey Ellerman, and Jake Bear, and, on the other, to Sam McKelvey and his staff. For their assistance in organizing the symposium on American Art and Culture, we thank Neil Weissman and the staff of the Clarke Center. At the same time, my own staff was occupied with the details of installation, educational programming, and catalogue production. The handsome layout of the exhibit at Dickinson owes much to the aesthetic sensibilities and strong back of our exhibition preparator, Dwayne Franklin. He was assisted by students Aaron Cratty, Patrick Holden, Sam Ong, and Kate Stewart, as well as by volunteer extraordinaire Peter Martin. The educational programs were ably designed and implemented by outreach coordinators Martha Metz and Wendy Pires. They were assisted by student docents Erin Dempster, and Tami Anderson. The information and security desk is overseen by our knowledgeable and vigilant attendants Ann Martin and Skip Marcello.

The production of the exhibition catalogue consumed nearly as much time and effort as did the loans. Beyond the significant contributions of Lisa Peters, we offer our deepest gratitude to authors May Brawley Hill (independent scholar) and David Schuyler (professor of American Studies at Franklin and Marshall College). The originality of their essays is matched only by the scrupulousness of their scholarship. For their enlightening entries we also thank Carol Lowrey, curator at the National Academy of Design, and Jack Becker, curator at the Florence Griswold Museum. Timothy Wardell carefully and diplomatically copyedited this manuscript in the most timely fashion. It is a pleasure to collaborate with him once again. To Michael Gunselman we owe profound thanks for the elegant design of the catalogue; to his associate Ralph Billings, we offer our gratitude and appreciation for his expert handling of the editorial changes. Thanks, too, go to Kelly Alsedek, director of publications at Dickinson, for her advice and encouragement in this endeavor.

In the course of organizing the exhibition and creating the catalogue we incurred many debts of kindness to a wide range of colleagues and institutions, including The Art Institute of Chicago, Faith Andrews Bedford, Berry-Hill Galleries, Bowdoin College Museum of Art, The East Hampton Free Library, Jo Ann and Julian Ganz, Gulf States Paper Corporation, The Henry Art Gallery, Isabella Stewart Gardner Museum, Boston, The Irvine Museum, The Josyln Art Museum, Robert Koch, Judith Lefebvre of Hartford Steam Boiler Inspection and Insurance Company, John Loftin, trustee of The Kate Freeman Clark Art Gallery, Lee Mooney of The Toledo Museum of Art, The Musée D'Orsay, The Museum of Fine Arts Boston, The National Museum of American Art, The Parrish Art Museum, The Shadek-Fackenthal Library, Franklin and Marshall College, Dr. A. Jess Shenson, Spanierman Gallery, New York, Star Island Corporation, The Terra Museum of American Art, The Valley House Gallery, Abbot William Vose of Vose Galleries of Boston, Weir Farm Heritage Trust, and The Zigler Museum. For their advice on curatorial and registrarial matters, we would like to express our gratitude to our colleagues Judy Cline, Susan E. Hanna, John Poliszuk, and N. Lee Stevens.

Finally, I am deeply indebted to all members of my own staff who have contributed to the success of *Visions of Home*, and no one more than our exemplary office coordinator, Stephanie Keifer. Stephanie has, by turns, held the show together and steered it through the most difficult problems. She and I were aided in the final stages of the project by student assistant Jason Lippy and our most efficient gallery intern, Erin Dempster.

Peter M. Lukehart
Director
The Trout Gallery

ACKNOWLEDGMENTS

It has been a privilege and a pleasure to work on this exhibition and catalogue for The Trout Gallery, as well as to take part in the Dickinson College community. The idea for the show emerged while I was working on my dissertation on John Henry Twachtman. Upon discovering the ways in which Twachtman's home in Greenwich, Connecticut, and his paintings of it, reflected the aesthetics and attitudes expressed in contemporary home magazines, I wondered whether other American Impressionists artists were similarly emulating in their art prevalent viewpoints regarding the home. The chance to organize this exhibition provided the opportunity to explore this question. As part of my research, I traveled to many of the places where the artists worked, several of which are remarkably intact. My visits to artists' homes and sites were extremely illuminating. A number of the places where they lived and that they painted still remain, providing a chance to step back in time, seeing the landscape through their eyes. Indeed, the peaceful, and rejuvenating, qualities of many of their sites can still be sensed today. By including many photographs — both archival and recent — that show the places where artists worked, we have attempted to capture some of what the artists experienced and saw and to demonstrate that they were inspired specifically by their familiar sites rather than primarily by a desire to imitate the images of the French Impressionists.

For making this endeavor possible, I want to extend my thanks first to Mr. and Mrs. Henry D. Clarke, Jr., who had the idea of bringing an important American Impressionist exhibition to the college and who underwrote the project. Secondly, I would like to give recognition to the generosity of the lenders, who responded to loan requests with interest and parted with well-loved paintings. Gratitude is also due to Dickinson's administration, in particular President A. Lee Fritschler, who assured the support and encouragement of the college.

At Dickinson College, the show was made possible by Peter Lukehart, Director of The Trout Gallery, with whom I have enjoyed collaborating. From the beginning, Peter was excited by a theme that linked the disciplines of art history, social history, and architectural history, and his careful and thoughtful attention to all intellectual and administrative matters allowed the exhibition and catalogue to become a reality. I also wish to extend my appreciation to The Trout Gallery's staff. I am especially grateful to Sherron Biddle, who has been an efficient and organized registrar and Stephanie Keifer, office assistant, who managed many different facets of the show and catalogue. For all aspects of traveling the exhibition to The Florence Griswold Museum in Old Lyme, Connecticut, I would like to thank Jeff Andersen, Director of the museum. Jeff also freely made the resources of the Griswold Museum available, allowing a number of valuable photographs and important historical references to be used, several for the first time.

For their contributions to the catalogue and their help with research issues, I am indebted to my coauthors May Brawley Hill and David Schuyler, who supplied essays, and Jack Becker and Carol Lowrey, who provided entries.

Many people from the scholarly and museum world freely gave their expertise and assistance as well, generously answering research questions, furnishing consultation, or helping to facilitate loans. In particular, I would like to acknowledge the contributions of Dorothy Aronson, Patricia Barratt, Faith Andrews Bedford, Elizabeth Broun, Phyllis Braff, Laurene Buckley, Kathleen Burnside, Terry Carbone, David Park Curry, Diana Dayton, David Dearinger, Sheila Dugan, Amy Eller, Judith Estes, Carolyn Fell, Deborah Fillos, Linda Ferber, Janet Fireman, Tom Folk, Debra Force, Kathy Foster, Barbara Gallati, William H. Gerdts, Madeleine Grynsztejn, Tim Hardacre, Karen Hensel, Fred Hill, Erica Hirshler, Martha Hoppin, Lance Humphries, Laura Kaufman, Leftwich Kimbrough, Dorothy King, Robert Koch, Laura Makaluso, Glen Peck, Ron Pisano, Lynne Porier-Wilson, Stuart Popowcer, A. Jess Shenson, Ira Spanierman, Diana Strazdes, George Sullivan, Gay Vietzke, Susan Vogel, Bill Vose, Bruce Weber, Charles Weyerhaeuser, Renée Williams.

A number of libraries and institutions were consulted for research, and they, too, deserve appreciation for sharing their resources and providing consultation, including the Archives of American Art, Smithsonian Institution; Dickinson College Library, Carlisle, Pennsylvania; the East Hampton Free Library; the library of Dr. William H. Gerdts; the New York Public Library; Shadek-Fackenthal Library, Franklin & Marshall College, Lancaster, Pennsylvania; and the Spanierman Gallery Library, New York.

Finally I am grateful to my husband Jerry for his patience and inspiration and my son Joshua who arrived while this catalogue was in process.

Lisa N. Peters
Curator

Cultivated Wildness
and Remote Accessibility:

AMERICAN IMPRESSIONIST VIEWS OF THE HOME AND ITS GROUNDS

STUDIES OF AMERICAN IMPRESSIONIST art have until recently generally focused on issues of style, investigating the ways that native artists derived inspiration from their French Impressionist counterparts. It has only been in the last decade and a half that scholars have begun to suggest that American Impressionist art may also be looked at in a social context, examined for its content and for how artists interpreted certain subjects.[1] This approach is especially appropriate when considering the landscapes American Impressionists created at home in the United States. An examination of their subjects and stylistic interpretations reveals their responsiveness to the values and attitudes prevalent during the period from around 1890 until 1925.

Within the genre of American Impressionist landscape painting, views of the home and its surroundings are especially conducive to a study of the relationship between art and culture. Since artists painted places where they lived, summered, and visited, they were especially attuned to the unique and characteristic features of these sites. However, they did not merely create records of their subjects. Accentuating the aspects of places that they knew intimately, they mirrored, albeit unwittingly, the tastes and preferences of their era. The degree to which they did so may be seen especially in the remarkably close parallels between their images and those recommendations made in American publications of the day that dealt with the home, garden, and grounds. Popular journals identified not only the particular aesthetic ingredients that were to comprise the home and its surroundings but also the qualities they should reveal.

Articles on the home in contemporary American periodicals echoed certain developments that took place during the era. As the modern city's social problems became increasingly apparent, there was a rising tide of anti-urban sentiment. In response, writers proposed that domestic dwellings in the country and suburbs should be as different as possible from those in the city, conveying such properties as a feeling of spontaneity, a sense of individuality, and an appearance of being safeguarded from the outside world. Beginning in the 1890s, the Western frontier was perceived to be closed. Suggesting that there was nonetheless still something unique about the American landscape that recalled the nation's wilderness tradition, writers called for homeowners to design country places that preserved the natural lay of the land, evoking the freedom, spaciousness, and harmony between man and nature that were considered characteristically American.

Reflecting the ideals expressed in journals and books, rather than merely emulating French mentors in their Impressionist works, American Impressionists reveal an "American" orientation in their views of the home and its grounds. Indeed, American Impressionist paintings reflect nationalistic ideals that were simultaneously being expressed in the country's books and periodicals.

The City Unbeautiful
At the end of the nineteenth century, several factors affected how Americans chose to live. Of the greatest significance was a growing antipathy to city life.[2] With industrial manufactures generally located within cities rather than outside of them as they were in Europe, the nation's urban centers became increasingly polluted. Population growth, due largely to widespread immigration, made cities crowded, tense, and noisy. Certain urban neighborhoods became notorious places of danger and unrest. As a result of this deterioration, an increasingly larger sector of the middle class moved out of town. Instead of settling in the city's borderlands, where factories dominated, they established homes in rural countrysides that were linked to the city by train.[3] Beginning in the 1890s, such areas, even when they were thinly populated, were referred to as "suburbs."[4] Contrary to our image of the suburbs today, which often brings to mind the monotony of all-too-similar houses, side-by-side lawns, and nearby shopping malls, suburban areas at the turn of the century were generally not close-knit neighborhoods, but in ideal instances consisted of detached homes on

lush green tracts of land that offered zones of peace, privacy, and contentment. Indeed, what the new residents of these places sought was a retreat from the jangling of the city to bastions of seclusion where one's home grounds could be personally designed to soothe frayed nerves. An individual home on a spacious plot provided the benefit of direct contact with nature which was considered both conducive to good health and to the development of a family's strength of character.

Clearly, the idea that the country engenders a more fulfilling, contented, and morally correct life than does the city is an old theme. In America, this idea was expressed even when the country was sparsely settled. During an epidemic of yellow fever in the late eighteenth century, Thomas Jefferson pronounced that large cities were "pestilential to the morals, the health, and the liberties of man" and that the "useful arts" could "thrive elsewhere…with more health, virtue, and freedom."[5] However, it was not until the late nineteenth century that an awareness of the city's ills became overwhelmingly apparent. The sheer density, foreignness, and verticality of the urban environment shocked many people. Expressing the viewpoint of the era in his book *Right and Wrong Contrasted* (1884), Thomas Hill presented the differences between city and country in two images. His city view, captioned *Poverty, Squalor, Intemperance, and Crime*, was described as "a representation and true type of hundreds of localities which exist all over the face of this fair land. The scene tells its own story—a tale of brutal passion, poverty, base desires, wretchedness and crime." Of his image of country life captioned *Pleasant, Beautiful, Happy Homes*, Hill stated: "How great the difference! Intelligence, refined taste and prosperity are indicated in these beautiful dwellings. There may be error committed even here, but whatever morality, good sense and culture can do to make people better and happier is to be sought in such homes."[6]

In the decades that followed, popular magazines took up this theme, calling attention to the detrimental effects of the city and advocating the country and suburbs as places to escape not only the difficulties and ugliness of urban life, but also its malaise and soullessness. In 1901 J. P. Mowbray stated in *World's Work:*

IT HAS BEEN NOTICED OF LATE YEARS THAT THE PACE OF EXISTENCE WHERE THE ARTIFICIAL EXCITEMENTS ARE GREATEST, RESULTS IN AN ENNUI AND SENSE OF WASTE, AS THE STRUGGLE FOR INDEPENDENCE BECOMES MORE SERIOUS AND THE DESIRE FOR EQUILIBRIUM MORE PRONOUNCED. ALL THE TRIUMPHS OF SCIENCE IN SUCH A CITY AS NEW YORK ARE AT THE EXPENSE OF SECURITY AND REPOSE. THE CITY GROWS FROM HOMES TO HOTELS TO BARRACKS. ITS STREETS PASS INSENSIBLY FROM SUNLIT THOROUGHFARES TO VAST DITCHES, THE BUILDINGS RISE HIGHER ON EITHER SIDE. ALL THE CONVENIENCES ARE FOR THE AGGREGATES, NOT FOR THE INDIVIDUAL, AND ALL ITS ACHIEVEMENTS IN LOCOMOTION ARE AT THE COST OF SECURITY. WHEREVER HUMAN BEINGS ARE MASSED MOST DENSELY, THE DANGER OF FIRE IS ENHANCED. WHEREVER THE MODERN CONVENIENCES ARE MULTIPLIED, THE NATURAL ADVANTAGES DECREASE. THIS ARTIFICIAL TENDENCY OF THE CITY HAS GIVEN RISE IN OUR TIME TO AN ENTIRELY NEW FACTOR CALLED SUBURBAN LIFE, THAT IS, AN EXISTENCE WHICH IS SPENT BETWEEN CITY AND COUNTRY.[7]

In the same year, in the first issue of *Country Life in America,* Liberty Hyde Bailey also connected the new disillusionment with the city to the flight to the country:

THERE IS A GROWING INTEREST IN COUNTRY LIFE: THIS JOURNAL WOULD BE ITS REPRESENTATIVE. THE INTEREST IN COUNTRY LIFE IS VARIOUS. MANY PERSONS ARE DRAWN TO IT BECAUSE IT IS RELEASE FROM THE CITY. SOONER OR LATER EVERY BUSY MAN LONGS FOR A QUIET NOOK IN THE COUNTRY WHERE HE MAY BE AT PEACE. HE WANTS A COUNTRY RESIDENCE. EVERY YEAR THE OUTFLUX TO THE COUNTRY IS GREATER AND FARTHER REACHING. THE CITY MAY NOT SATISFY THE SOUL.…IT WAS NOT MANY YEARS AGO THAT PEOPLE LIVED IN THE SUBURBS AS A MATTER OF ECONOMY. NOW THEY LIVE IN THESE PARTS BECAUSE HIGHER IDEALS MAY OFTEN BE ATTAINED THERE.[8]

As suggested by Bailey, choosing to move to the country was a new phenomenon at the turn of the century; previously economic necessity and not personal desire had dictated such a change. Several factors made it possible to leave the city behind. The first was, of course, the development of new and improved means of transit. Train routes, as well as horsecar, trolley, and streetcar lines, provided options for daily commuting and facilitated access to places in the country that had previously been remote.[9] As Mowbray acknowledged in 1901:

THE EXPANSION AND PERFECTION OF RAILROAD TRANSIT, WHICH HELPED TO RUIN THE EASTERN FARMER IN MAKING KANSAS AND MONTANA HIS RIVALS, HAS NOW BROUGHT THE COUNTRY TO THE RELIEF OF THE CITY WORKER AND ENABLED HIM TO ESCAPE IN SOME MEASURE FROM THE CHARIVARI OF ENTERPRISE AND MOCKERY OF THE FLAT TO A DETACHED AND EXCLUSIVE HOUSE OF HIS OWN.[10]

Suburban Life stated in its 1905 introductory issue: "The overcrowded condition of our large cities, combined with the multiplicity of suburban trolley lines has rendered feasible a life of country living for the city business man, which a decade ago would have been practically an impossibility."[11] The new varied choices for life beyond the city were recognized in *Country Life in America* in 1901:

THE GENERAL REGION IN WHICH YOU ARE TO LOCATE IS TO BE DETERMINED CHIEFLY BY ITS ACCESSIBILITY TO YOUR PLACE OF BUSINESS, AND BY THE KIND OF NATURAL SCENERY THAT YOU MOST ENJOY. IF IT IS YOUR DESIRE TO LEAVE THE CITY ENTIRELY FOR THE SUMMER, YOUR COUNTRY PLACE MAY WELL BE FAR AWAY IN THE MOUNTAINS OR ON THE SEA-SHORE; BUT MOST PERSONS CANNOT DIVORCE THEMSELVES WHOLLY FROM BUSINESS FOR A PROTRACTED PERIOD, AND THE COUNTRY PLACE THEREFORE SHOULD BE WITHIN A SHORT DISTANCE OF TOWN. EVEN IF ONE IS NOT TO LIVE IN THE COUNTRY CONTINUOUSLY FOR ANY LENGTH OF TIME EACH YEAR, THE COUNTRY PLACE MAY AFFORD OPPORTUNITIES FOR FREQUENT RESPITES THROUGHOUT THE BUSY SEASONS.[12]

Other factors that contributed to the suburban exodus included new express delivery systems and cheap, available land.[13] *Country Life in America* reported:

IT IS SURPRISING HOW MUCH UNIMPROVED OR EVEN WASTE LAND THERE IS WITHIN ONE TO TWO HOURS' RIDE OF OUR LARGE CITIES. MANY OF THESE UNCARED-FOR AREAS MAKE MOST ATTRACTIVE HOME SITES IN THE HANDS OF PERSONS OF GOOD TASTE. FOR $100, AN ACRE OF LAND CAN BE BOUGHT HERE AND THERE WITHIN EASY ACCESS OF OUR GREAT CITIES. YOU CAN BUILD A COMFORTABLE SUMMER LODGE FOR THE REMAINING $400 IF YOU HAVE THE KNACK; AND YOU CAN MAKE IT ATTRACTIVE OUTSIDE AND INSIDE IF YOU HAVE THE ART. IF YOU HAVE $2,000 AND UPWARDS TO SPEND, YOU CAN MAKE A PERMANENT COUNTRY HOME AND CAN HAVE LAND ENOUGH TO CONSUME YOUR ENERGY FOR DIGGING AND EXPERIMENTING.[14]

Although recommending "digging and experimenting," this author did not imply that the homeowner was to live off the land. Indeed, in the extensive material on the home that emerged at the turn of the century, there was little mention of farming. It was assumed that the home was a place for pleasure and recreation, not for tilling the soil. Even the construction of vegetable gardens and the raising of chickens were considered hobbies rather than necessities, and those who resided in rural places were advised to live simply rather than to saddle themselves with tiring and onerous chores. E. S. Martin explained in *Harper's New Monthly Magazine* in 1902 that for those families who acquired permanent places "in the real country in some region that is not suburban, nor citified enough to impair either its charm or its cheapness," the ideal would be to "have a house so simple as not to be burdensome, a horse possibly, a hired man or part of a hired man, a garden with nasturtiums and hollyhocks in it, a barn, perhaps a cow, and very likely chickens, and to have time to read, time to sew, time to rest, and do nothing."[15] At the turn of the century, it was understood that the urbanite who sought a country place would have a completely different set of concerns from the farmer. In an 1894 article in *Century Magazine*, entitled "Hunting an Abandoned Farm in Connecticut," William Bishop wrote of his search for a home in the country. Of a stop in Wilton, Connecticut, near the home of the artist J. Alden Weir, he wrote:

MY GUIDE HERE WAS ONE OF THE VERY FEW OF HIS KIND WHO KNOW JUST WHAT A CITY PERSON WANTS IN THE COUNTRY. HE KNEW THAT IT WAS PRETTY NEARLY THE OPPOSITE OF THE DEMANDS OF THE ACTUAL DENIZEN OF THE COUNTRY. HE WAS NOT SURPRISED THAT I WAS WILLING TO SACRIFICE FERTILITY OF SOIL TO A VIEW, THAT I WISHED TO HAVE SOME GRAY BOULDERS ON MY LAND, THAT I WISHED AN OLD-FASHIONED HOUSE INSTEAD OF A NEW-FASHIONED ONE, AND THAT I WOULD NOT HAVE IT TOO CLOSE UPON THE ROAD, WHERE ONE "COULD SEE EVERYTHING GOING BY."[16]

Implied in the advice to new suburban dwellers was the notion that one did not have to forgo the conveniences of the city even when leaving its stresses behind. Indeed, as many American authors suggested, an ideal home life merged the best aspects of urban and rural existence. *Country Life in America* clarified in 1901: "It is more and more apparent that the ideal life is that which combines something of the social and intellectual advantages and physical comforts of the city with the inspiration and the peaceful joys of the country."[17] In an 1897 article in *Century Magazine* describing the home and property of a resident of the Boston suburb of Brookline, Mariana van Rensselaer explained that the word "suburb" used to have an "unattractive, hybrid meaning," but that it could now be viewed positively. She defined the terms: "[A] real suburban place is rural in aspect, but urban in convenience—private, green, and peaceful in itself, yet close in touch with the true self of the town."[18] The idea that city and country were necessary to each other was related to the notion of an obligatory compromise between the two, since only a familiarity with the city's repulsiveness made it possible for one to appreciate the country.[19] J. Alden Weir expressed this sentiment, stating to his parents in 1877 that: "The city life where one is imprisoned amongst walls, make's one's faculties more appreciative."[20] In 1902 John Twachtman similarly referred to the city as "a den of iniquity," which made him wish to be back in the peaceful town of Cos Cob, Connecticut.[21]

A New American Landscape Image for the Post-Frontier Age
The new appreciation of suburban places can be related to a broad shift in attitudes about the American landscape. As the end of the century approached, there was a growing awareness that instead of a nation characterized by vast wilderness areas and seemingly boundless frontiers, the country had become largely settled and its boundaries had become fixed. In 1890 the United States Bureau of Census helped to cement this idea by pronouncing that there was no longer a line of settlement and that the Western frontier had officially closed.[22] Newspapers and the popular press reinforced the awareness that the West had been populated by reporting on the immigrant waves that crossed the country, establishing communities in previously remote outposts. Tales of the exploitation of Western resources by "Robber Barons" and industrialists further suggested that the country's vast wilderness was rapidly being used up and that it no longer promised the endless possibilities for conquest.

As a result of these changes, the nation went through an identity crisis. In the antebellum period, America's distinctiveness was associated with the novelty and promise of the frontier. In the post-frontier era, a new view of the nation was needed, and it was in art and literature that the country's new landscape image emerged. In novels and paintings, writers and artists respectively focused on the specific qualities of the typical regions where Americans lived, suggesting that the country could now be seen as the sum of its parts—that it was its varied districts and communities with their particular features and nuances that represented the nation's richness and future.[23] Among the writers were early twentieth-century authors

Hamlin Garland, Lewis Mumford, Willa Cather, Lincoln Steffens, and D. H. Lawrence, who described the settled regions where they lived, chronicling the lives of ordinary Americans and describing the typical features of their communities. These writers employed the environment as a psychological device rather than merely as a setting for their dramas. They sought to express the spirit of the place by describing the associations and experiences that made familiar locales special. Magazine authors also expressed this viewpoint, urging readers to notice not just the obvious differences between regions, but also their subtle distinctions. Landscape architect Beatrix Jones wrote in *Scribner's* in 1907:

ALTHOUGH EACH YEAR AN INCREASING NUMBER OF PEOPLE INTEREST THEMSELVES IN OUT-OF-DOOR LIFE AND THE HABITS OF BIRDS, TREES, AND WILD FLOWERS, THEY MAY REALIZE ONLY THE STRIKING CONTRAST BETWEEN A LANDSCAPE WHERE DECIDUOUS TREES PREDOMINATE AND ANOTHER WHERE EVERGREENS GIVE THE CHARACTERISTIC NOTE. EVERYONE CAN SEE THE DIFFERENCE BETWEEN THE AUSTERITY OF THE ROCK-BOUND COAST OF MAINE, THE QUIET BEAUTY OF A MASSACHUSETTS INTERVALE, AND THE SLEEPY LUXURIANCE OF THE PENNSYLVANIA PASTORAL COUNTRY, BUT SLIGHT VARIATIONS BETWEEN THESE MAY OFTEN PASS UNNOTICED; IT IS ONLY IN TRYING TO COPY THE EXPRESSION OF A LANDSCAPE, OR RATHER TO FIT IN WITH ITS CHARACTER, THAT IT IS POSSIBLE TO REALIZE HOW INFINITE AND YET HOW MINUTE THESE VARIATIONS ARE.[24]

The nature writer and art critic John C. Van Dyke took a similar stance, writing in his *Nature for Its Own Sake* (1898) that "the humble things of the earth are the real treasures such as the very commonplace ten-acre pasture. The quaint lines, the warmth and glow of color, and above all, the broad area of sunlight, affect one emotionally. Take any man from the bustle of the city and place him there and he will instinctively breathe deeper, and though he may say little, yet be sure he is making confession in his secret soul—confessing to a feeling he cannot describe."[25] It was exactly this viewpoint that American Impressionists adopted. Instead of portraying the remote and dramatic wilderness areas that had been the focus of the Hudson River School, they chose to depict the commonplace locales where they lived or spent summers, and they sought to capture the features and moods of their sites, creating personally meaningful images that expressed the spirit of the place.

The American Impressionists Migrate
A number of American Impressionists established homes in the new areas classified as suburban, and many summered in small towns and coastal resorts that had become accessible to the city by train. Several times a week during the 1890s, John Twachtman took the forty-minute express train to New York from his home in Greenwich, Connecticut, in order to teach at the Art Students League. From 1883 through the first decade of the twentieth century, J. Alden Weir lived during much of the year in Branchville, Connecticut, fifteen miles north of Greenwich. From his home, his commute to New York, where he was involved in many clubs and organizations and also taught at the League, was an efficient hour and a half. His route home took him on the New Haven line to Norwalk, Connecticut, and then on the Danbury line to Branchville.[26] Other artists who lived for periods of time within commuting range of Manhattan included William Merritt Chase, who resided during the late 1880s in what is now the Bedford-Stuyvesant neighborhood of Brooklyn, Ernest Lawson, who in 1898 settled in the Washington Heights neighborhood of Inwood at the northern tip of Manhattan, and Louis Comfort Tiffany and Thomas P. Rossiter, who resided in the Long Island town of Oyster Bay, reached easily on the Long Island railroad. In the early twentieth century, a colony of artists established homes in the Westchester suburb of Bronxville, including George Henry Smillie, William Henry Howe, Mile Ramsey, Will Lowe, Bruce Crane, Robert Reid, Hobart Nichols, Orrin Sheldon Parsons, and Charles Louis Hinton.[27]

Outlying areas of Boston were also home to a number of artists. Philip Leslie Hale may have chosen to live in Dedham, Massachusetts, because of its position on the suburban railroad route to Boston. His teaching duties required his frequent presence in Boston where he taught at the Museum School. Dennis Miller Bunker spent the summers of 1889 and 1890 in the town of Medfield, eighteen miles south of Boston.

Figure 1.
Childe Hassam, *Old House and Garden, East Hampton, Long Island*, 1898, oil on canvas, 24 1/16 x 20 in. (61.1 x 50.8 cm), Henry Art Gallery, University of Washington, Seattle, Horace C. Henry Collection. acc. #26.70.

Figure 2. (Following Page)
Sanford Gifford, *A Home in the Wilderness*, 1865-1867, oil on canvas, 9 1/8 x 14 3/4 in. (23.2 x 37.7 cm), Jo Ann and Julian Ganz, Jr. Collection.

Although Bunker prized his isolation, Medfield was also directly linked to Boston on the Mansfield to Framingham train, which stopped at three railroad stations in Medfield. John Enneking lived in New Hyde Park, another Boston suburb, while Frank Benson was a prominent figure in the Boston art scene, although his life was centered around his home in Salem, Massachusetts, twenty miles up the coast from Boston, where he resided with his family. Even the Massachusetts coastal town of Gloucester, which drew artists from all over the East Coast, was only an hour's commute from Boston by train in the 1890s.

The environs of Philadelphia were home to a number of artists. Hugh Henry Breckenridge lived in the "old time village" of Fort Washington, on the outskirts of Philadelphia, where he maintained a teaching job at the Pennsylvania Academy of the Fine Arts. The painters who worked in Bucks County were not far away, with their homes in the towns of Lumberville, New Hope, Sellersville, and Center Bridge. Indeed, many artists took part in summer artist colonies that were connected to urban centers by train. In addition to Gloucester and New Hope, the most popular were Cos Cob and Old Lyme, Connecticut, East Hampton, New York, and Cornish, New Hampshire. However, artists did not have to live in the suburbs or to visit popular artists' colonies in order to capture the desired characteristics of the American country and suburban home; such an awareness was intuitive, received from many sources in their everyday experience.

American Impressionist works reveal not only a change of subject matter from that of the Hudson River School; they also demonstrate a shift in point of view. In images of vast wilderness sites, Hudson River School artists showed nature as a source of spiritual awe where God's creative force was to be discerned and revered. By contrast, American Impressionists portrayed a kind of accessible nature to be enjoyed by the individual for its beauty as well as its recreational opportunities. The difference in attitude between Hudson River School artists and American Impressionists is illuminated by their images of homes. In most of their views of homes, Hudson River School artists featured log cabins in the wilderness, whose tiny forms are seen from distant aerial perspectives. By contrast, American Impressionists portrayed homes from close-up vantage points and depicted the world they found by looking out of their front and back doors and by standing in their gardens and in those of their neighbors. Such a perspective can be seen by a comparison of Childe Hassam's *Old House and Garden, East Hampton* of 1898 (fig. 1) with Sanford Gifford's *A Home in the Wilderness* of 1865-1867 (fig. 2). American Impressionists' intimate vantage points reveal their joy in discovering familiar places, and their lively canvas surfaces reveal their use of the Impressionist method's inherent spontaneity to explore new facets of often-observed sites. J. Alden Weir made note of this tendency to use process as a means of pleasurable discovery, remarking that in the art of his friend, John Twachtman, one can "feel the spirit of the place and the delight with which his work was done."[28]

By choosing to depict familiar aspects of home life and to explore effects of light and atmosphere in the landscape locales where they lived, American artists clearly emulated the French Impressionists, who had begun to portray their residences, families, and gardens in the 1870s. However, the parallels between American Impressionist paintings and recommendations in popular American home magazines regarding the home grounds reveal that native artists were responding as well to the social climate of their time in their own country.

The Ideal American Home Grounds
Although American journal writers promoted the view that suburbanites were to have urban sophistication and take advantage of urban amenities, their most common and vehement advice was that a suburban home was to be in all respects different from a city dwelling. Whereas an urban rowhouse or apartment was boxlike, confined, anonymous, and oriented toward the street and the public sphere, a suburban place was to be rambling, hidden in nature, and to evoke a sense of freedom, release, spontaneity, informality, privacy, and individuality.

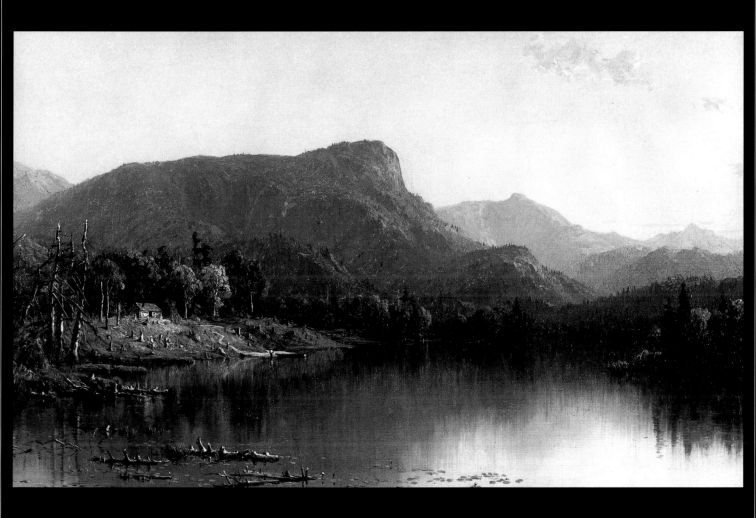

Many authors focused on the fact that a country home was a creative endeavor whereas a city home was not. *Architectural Record* magazine reported in 1901: "[I]n the midst of a city the ordinary resident has little or no personal participation or responsibility in the making of the house in which he lives. His dwelling is forced upon him, and he has to take it as the good builder made it, whether he likes it or not. The suburban resident, on the other hand, as often as not, mixes personally in the high art of architecture. His house frequently does, and always can, embody his own ideas and tastes."[29] John Buckham similarly explained in *Country Life* in 1902: "The great opportunity of the country home, as contrasted with the city home, is the opportunity of individuality. To put yourself into your home, to make it in some real fashion an expression of your ideas, preferences, tastes—this is the secret charm and joy of building or reconstructing."[30]

However, the idea that a country home was to be imbued with personality did not mean that it should be quirky or gaudy. Indeed, beginning in the 1890s, writers on the home reserved their greatest condemnation for domestic structures in the Queen Anne style as well as in other excessively eclectic and highly decorative architectural modes.[31] In her first three articles on American country dwellings published in *Century Magazine* in 1886, van Rensselaer decried the "tendency toward ignorant, reckless, 'originality.'"[32] Specifically referring to the Queen Anne style, *Architectural Record* commented in 1901:

[S]URELY NO "STYLE" WAS EVER INVENTED WHICH LENT ITSELF MORE TO THE FREAKISH AND MEANINGLESS ECCENTRICITIES WHICH ARE AS UTTERLY OUT OF PLACE IN RURAL AS THEY ARE IN EVERY OTHER KIND OF ARCHITECTURE. A "QUEEN ANNE" COTTAGE WAS AT BEST A PRETTIFIED BIJOU FRAME BUILDING, WHICH IN ITS DESIGN WAS A COLLECTION OF INCONGRUITIES AND IN ITS EFFECT GAVE THE IMPRESSION OF SOMETHING PERCHED UPON THE LAND, INSTEAD OF SOMETHING GROWING LOGICALLY OUT OF IT. AND THE DETAIL WAS AS INCONGRUOUS AND MEANINGLESS AS THE MASSES AND OUTLINES.[33]

The following year, Clarence Martin noted in *Country Life*:

THE FANTASTIC LINES AND BRILLIANT DECORATIONS ENTIRELY APPROPRIATE IN A TEMPORARY STRUCTURE FOR THE CELEBRATION OF A FESTIVE EVENT WOULD OBVIOUSLY BE DISTINCTLY OUT OF CHARACTER FOR THE WORK-A-DAY FARMHOUSE THAT SHOULD BE SO DESIGNED AND CONSTRUCTED THAT IT MIGHT HOLD ITS PLACE AS THE HOMESTEAD FOR A FULL CENTURY....NATURALLY THE LINES AND MASSES OF THE HOUSE RATHER THAN THE DETAILS ARE THE FIRST IMPORTANT CONSIDERATIONS. A LONG, STRAIGHT OR GENTLY CURVED LINE IS A THING OF BEAUTY, AND SUCH LINES COMBINED WITH PLAIN WALL-SURFACES AND SIMPLE OUTLINES GO FAR TOWARD GIVING A HOUSE THE TRUE HOME CHARACTER.[34]

In the place of the Queen Anne style, writers on the home proposed that country houses, regardless of the styles in which they were built, were to have "balance and harmony without symmetry," with their "dominant and subordinate features...so arranged as to give a feeling of unity, strength and repose."[35] As *Architectural Record* commented in 1901, such qualities could be seen in houses constructed since 1895, which had increasingly shown tendencies toward

A MORE REPOSEFUL AND INTELLIGENT TREATMENT....AS A RULE THEY ARE NO LONGER COCKED UP CAPRICIOUSLY IN THE AIR, BUT TAKE THEIR PLACE MORE NATURALLY AND SMOOTHLY ON THE GROUND....THE ROOFS ARE FOR THE MOST PART PITCHED LOWER, AND THE OUTLINE IS NOT BROKEN BY A NUMBER OF MEANINGLESS AND FUSSY GABLES. THE WHOLE DESIGN IS PRONE TO BE DECIDEDLY SIMPLER AND MORE LOGICAL, AND WHATEVER ORNAMENTAL DETAIL THERE IS, IS BETTER MANAGED.[36]

The type of home that was considered the ideal antidote to the showy Queen Anne dwelling was the old farmhouse. As suggested in this publication by May Hill and David Schuyler, such structures answered a longing for a simpler past and represented the preservation of American traditional values that seemed to be slipping away in a rapidly changing modern world. With its simple lines and horizontal orientation, the old farmhouse was perceived as having a classical quality of permanence and stability that was desirable. Van Rensselaer praised "those old farm-houses built by Dutch or English settlers, which still survive in many a quiet spot" as distinctly American, stating that "nothing could be more simple, more utilitarian, more without thought of architectural effectiveness. And yet such a farm-house is often extremely good in its own humble way—good in its general proportions, and especially in the agreeable and sometimes picturesque, yet simple and sensible, outlines of its roof."[37]

The farmhouse, however, was criticized for a number of its features. The most common attack centered on its lack of privacy. Given that the purpose of moving to the country was to escape the barrage of the city's stimuli, it did not make sense to relocate to a structure that faced the road and was vulnerable to passing traffic, dust, noise, and the invasive stares of travelers. Addressing this concern, many writers suggested that the farmhouse should be either closed off from public view with plantings or that its entryway was to be moved so as to conceal the house from the road. Its porches and verandas were similarly to be hidden from plain sight, their vantage points open only to the homeowner's property. In *House and Garden* in 1910, Alfred Morton Githens described the old and new approaches:

MOST [OLD FARMHOUSES] STAND BEHIND OLD ELM TREES, CLOSE TO THE ROADSIDE, WITH A STRAIGHT PATH TO THE ROAD IN FRONT; THE REAR IS GIVEN OVER TO TANGLED BRIARS AND ASH-HEAPS. IT IS STRANGE HOW THE PAST GENERATION SEEMS TO HAVE FOUND ITS AMUSEMENT IN WATCHING PASSING NEIGHBORS FROM THE "PIAZZA" IT GENERALLY STRUNG ALONG THE HOUSE-FRONT, CARELESS OF THE OLD, GABLED ENTRANCE PORCH OR "PORTICO," DESTROYED TO MAKE ROOM FOR IT. WHAT THE LAST OWNERS DID WE MUST UNDO; THE PART THEY NEGLECTED WE MUST DEVELOP INTO THE LIVING PORTION OF THE HOUSE. HAPPILY THE DAYS OF "FRONT" AND "BACK" ARE OVER, AND NOW THERE IS A RETURN TO THE WISER ENGLISH TRADITION OF ENTRANCE FRONT AND GARDEN FRONT; THE GARDEN IS NO LONGER BETWEEN THE HOUSE AND THE ROAD, BUT BEHIND OR AT THE END, SCREENED IN SOME WAY FROM THE AUTOMOBILE DUST AND CURIOUS GAZE OF PASSERS-BY.[38]

Both Weir and Twachtman changed the orientation of their homes so that entering from the back side was encouraged. A proper screening of the home was desired by Robert and Elizabeth Shackleton, who wrote in their *Adventures in Home-Making* (1910) of their quest for a suburban residence that attained the seemingly contradictory experience of being both remote from and connected to the city. They sought "that delightful desideratum, a home of accessible seclusion; a home where we should have privacy and isolation and where we should…be in easy touch with our friends, and whence we could readily go to the near-by city, whether by day or night."[39]

Another attack on the old farmhouse was that it was too stark, and writers called for it to be adapted so as to be harmonized with its site. Instead of standing upright on a cleared plot, it was to be integrated into the landscape. This harmonizing process was, indeed, carried out by Twachtman, whose home was the topic of an article by Alfred Goodwin in *Country Life in America* in 1905. In the 1890s, Twachtman gradually modified the small boxy structure built in approximately 1840 that stood on the land he had purchased. Extending the roof eaves downward, building a new wing of the house into the side of a hill, and relieving the expanse of the roof with dormer windows, Twachtman created a unified arrangement of architecture and nature (fig. 3). Goodwin reported: "As it now is, the house flows up the hill, it fits into the curves and continues on up to the crest."[40]

Just such an aesthetic approach was frequently advocated in contemporary publications. Van Rensselaer wrote in *Art Out-of-Doors* (1893):

THERE MUST BE HARMONY BETWEEN THE GROUNDS AND THE HOUSE ITSELF. AND ALL THE MORE DISTANT DEVICES OF THE GARDENER WILL NOT EFFECT THIS UNLESS ITS WALLS SEEM INTEGRALLY UNITED TO MOTHER EARTH.…THE ARCHITECT MUST SEIZE UPON EVERY PECULIARITY OF THE SITE WHICH CAN BE USED TO GIVE HIS BUILDING THE LOOK OF BELONGING JUST WHERE IT STANDS—TO MAKE IT APPEAR AS THOUGH IT COULD NOT BE MOVED ANYWHERE ELSE WITHOUT DETRIMENT TO ITS OWN EFFECT.[41]

Architectural Record reported in 1901: "The one characteristic which should distinguish rural architecture is that of possessing some organic and necessary relation to the land on which it is situated and the landscape by which it is surrounded." The author of this article went on to propose ways that houses could have the "appearance of composing unobtrusively and effectively with their site and surroundings."[42] In *Country Life* in 1902, Claude Bragdon wrote that a "house should rhyme with its surroundings" and be "chameleon-like." He advised: "The exterior aspect of a country house should be determined as far as possible by its site and surroundings, that it may appear a thing not alien to its environment, but a product, as it were, of the soil itself."[43] In *Remodeled Farmhouses* (1915), Mary Northend summed up a number of points, suggesting that in joining a house with its site, homeowners could express their personalities with a freedom not possible in the design of a city dwelling:

NATURE LENDS ITSELF TO THE REMODELING AND SUGGESTS MANY IDEAS THAT HELP TO IDENTIFY THE HOUSE WITH THE PERSONALITY OF ITS OWNER. EVERYTHING ATTEMPTED IN THE WAY OF IMPROVEMENTS CAN BE BROAD AND EXPANSIVE AND NOT CONGESTED, AS WOULD BE NECESSARY IN THE CITY. YOU SHOULD IN EVERY PARTICULAR MAKE THE HOUSE GROW TO FIT THE SURROUNDINGS AND DO IT IN SUCH A WAY THAT IT WILL SEEM TO HAVE BEEN SO ALWAYS.[44]

Such writings establish a context for the prairie home designs of Frank Lloyd Wright, first presented in 1901. In his second principle of the prairie home, Wright called for homebuilders "to associate the building as a whole with its site by extension and emphasis of the planes parallel to the ground, but keeping the floors off the best part of the site, thus leaving that better part for use in connection with the life of the house."[45] In fact, it is interesting to note that Wright's first domestic designs were published in *Ladies Home Journal*, *The House Beautiful*, and *American Architect and Building News*, some of the same magazines that presented popular notions regarding the suburban home.

Follow Nature in the Garden
For many American writers on the home, the best way to link a house with its site was with plantings. A typical recommendation was provided by Bryant Fleming in 1902: "Let vines run riot over the veranda and even to the top of the roof, and the shrubs push into the corners of the foundation, thus breaking the hard lines of the building. For what is more barren than a house,—we cannot call it a home,—standing bare and alone in its nakedness."[46] Popular ways to join home and land included covering porches with vine trellises, decorating doorways with arbors and floral plantings, allowing flowering bushes to grow freely over porches and along the walls, and bringing the garden directly up to the back door. Describing a Brookline, Massachusetts, home for *Country Life* in 1903, Sarah Cone Bryant wrote: "The whole garden is treated as an adjunct of the house…[and] the grounds seem but to continue and expand from the house, and the house to concentrate the prevailing thought of its surroundings."[47] Of course, such an approach was not completely new. In his *Cottage Residences* (1842), Andrew Jackson Downing stated that an irregular cottage in the Old English Style must not be "erected on a bare plain," but instead should be "partially hidden, or half concealed by the interlacing and entwining branches and bowers around it." But the home to which Downing referred differed from the simple farmhouse or saltbox admired at the turn of the century, since one of its primary features was "its rich gables breaking out from among the intricacy of tall stems and shadowy foliage."[48]

At the turn of the century, gardens were also perceived as playing an important unifying role in the home grounds, since they could provide a middleground between the domestic sphere and the landscape at large. Old-fashioned gardens that began at the back door, rather than formal gardens that were detached from the home, were considered ideal for this task. These "Grandmother's gardens," including hardy perennials growing in lively profusion, were a perfect intermediary between the controlled aesthetic life of the home and the freedom of nature.

It was not only the garden that should connect nature with the home. As many writers proposed, the home should blend in with its surrounding landscape, ultimately forming a totally unified design comparable to the composition of a painting. In 1903 Bryant summed up this idea, stating that the success of a country place lay "primarily in the artistic judgment which has consistently held house and grounds to be part of one unit—a diverse whole."[49] H. A. Caparn stated in *Architectural Record* in 1903:

IF ANY ONE OBSERVES MANY SUBURBAN AND COUNTRY HOMES WITH AN INQUIRING EYE, HE IS BOUND TO SEE ONE OR MORE WHICH MAKE, WITH THEIR ACCOMPANIMENT OF TURF AND FOLIAGE, A PICTURE MORE OR LESS COMPLETE, HARMONIOUS AND ARTISTIC; IN WHICH THE HOUSE WITHOUT ITS CLIMBERS AND SHRUBBERY WOULD LOOK FORLORN AND NAKED....THESE MATERIALS, THE MASSES OF FOLIAGE AND SURFACES OF TURF ARE ARRANGED WITH NO SYMMETRY, YET WITH AN ORDER THAT APPROXIMATES PERFECTION; THEY DISREGARD AXES AND FORMALITY, AND, IN FACT, ARE INCONSISTENT WITH THEM; YET THEY ARE IN NO WAY INCONSISTENT WITH THE AXES AND REGULARITY OF THE BUILDING, BUT FURNISH A FRAME FOR THEM HARMONIOUS IN ITS VERY CONTRAST.[50]

Focusing on the aesthetic understanding needed to design a piece of property, many writers compared the art of landscape gardening with sculpting and painting.[51] As a writer for the *Independent* noted, the object "of landscape gardening—or gardening the landscape—is carrying art out of the galleries, into the fields."[52] However, in general, the aesthetic proposed was not one of formal design. Instead of transforming the land to make it fit a particular artistic conception, homeowners were advised to accept the intrinsic properties of the terrain and form their arrangements based on what was already there. Again this idea may be traced to Downing, who stated in 1842: "in many of our finest natural situations for residences, nature has done so much here to render the scene lovely, that it would appear that man had only to borrow a few hints from the genius of the place, and the home features would all be rendered equally delightful."[53] Picking up on this notion, turn-of-the-century writers proposed that the artistic contribution of the homeowner should involve enhancing the lines and masses of the existing topography. Clearly the foundation for this approach lay in the English picturesque garden. Writing of the Brookline home of Professor Charles Sprague Sargent, van Rensselaer proposed: "The triumph of landscape-gardening...of the naturalistic as distinguished from the formal branch of gardening art—is to create results which look as though, with very little assistance, nature might have produced them in some particularly gentle and human mood."[54]

In keeping with the longstanding tradition of American "wilderness," which was so important to the earlier frontier aesthetic, the American version of the picturesque gave greater emphasis to wild than to cultivated grounds, suggesting that nature should be disturbed as little as possible. The way to achieve such a "natural" look, writers suggested, was for the homeowner to learn from the patterns found in a landscape. As one author stated in *Country Life* in 1902:

OBSERVE THE PATHWAYS IN NATURE,—THE BROOKS, THE LAKE SHORES, THE MARGINS OF THE FOREST, THE EDGE OF THE SWAMP, THE PATHS OF COWS ACROSS THE PASTURES. NOTE THE GENTLE CURVES AND VARIETY IN PLANTING. CONSIDER WHAT WOULD BE THE EFFECT IF ALL THE CURVES WERE TO BE STRAIGHTENED AND ALL THE INFORMALITIES TAKEN OUT. THEN CONSIDER WHETHER YOU MAY NOT HAVE DERIVED A LESSON FOR YOUR OWN PLACE, IN HOLDING TO THE FREE AND GRACEFUL SPIRIT OF THE WILD.[55]

Indeed, American journal articles recommended that homeowners purposefully create a look of wildness in their home grounds by installing uncultivated gardens, in which wildflowers were planted directly in nature rather than within a garden plot, by augmenting the beauty of an existing terrain with new plantings, and by placing rocks and other natural forms in the landscape in such a way that they appeared to have always been there. *Country Life* in 1901 recommended:

BRING IN THE WILD TREES AND BUSHES. COLONIZE A FEW CLUMPS OF GOLDEN-RODS AND ASTERS AND SKUNK-CABBAGE AND OTHER WILD THINGS THAT YOU FIND ON YOUR RAMBLES....IN SOME COUNTRY PLACES YOU WILL NOT NEED TO PLANT; YOU WILL NEED ONLY TO CUT JUDICIOUSLY. IT IS REMARKABLE WHAT GOOD EFFECTS MAY BE HAD BY LETTING THINGS GO FOR A TIME.[56]

Figure 3.
Front of Twachtman's house, photograph, c. 1902, from Alfred Goodwin, "An Artist's Unspoiled Country Home," *Country Life in America* 8 (October 1905): 627. Courtesy, Archives, Spanierman Gallery, New York.

In a chapter entitled "The Wild Garden," in her book *The Practical Flower Garden* (1911), Helena Rutherford Ely described a Connecticut garden in which "the rock-ledges and boulders are treated as a part of the garden as much as the trees or flowers themselves, and are objects of beauty."[57] Describing her visit to this garden, Ely wrote of "descending the swift slope of fields stretching from the old farmhouse, and crossing a natural ravine" that passed by an old pond. Traveling further, she came upon meadows, wooded areas, sloping fields, a stream "dashing over water-worn boulders," and a "wonderful hemlock glen," "bordered on both sides and banks by ancient hemlocks, through whose great branches the sunshine comes but not gently."[58]

The idea that the garden encompassed not only cultivated blooms, but also freely spreading wild-flowers and natural forms themselves was promoted as uniquely American even though it was popularized initially by the Englishman William Robinson, who published a book on the subject in 1870. Frederic Law Olmsted, the designer of urban parks in New York and other cities had a copy, and perhaps Ely did too.[59] She wrote in 1911: "The term 'wild garden' may be descriptive of the garden made from native material without the cultivation of the soil, and as expressive of natural resources, as the terms English garden or Italian garden, where the yews of England and the cypress of Italy give at once the dominant note peculiar to the country where each is situated."[60] In her 1901 *Garden of a Commuter's Wife*, Mable Osgood Wright criticized her neighbor's expensive Italian garden for pretentiousness and described her more appropriate creation of "a purely American garden" in Fairfield, Connecticut, in which she adapted her plantings to the natural topography, in particular adding the "old fashioned flowers her mother had loved."[61] In "The American Garden," published in *Scribner's Magazine* in 1904, George Cable felt that the quality that distinguished American gardens was "excessive openness." He observed: "our people have…almost abolished the fence and the hedge" and commented "our ordinary American life is…too near nature for the formal garden to come in between."[62]

Central to the viewpoint espoused by many turn-of-the-century writers was the idea that the American landscape was still wilder than that of Europe. This notion was conveyed by van Rensselaer in 1893:

NATURE HERSELF SPEAKS MORE DIRECTLY AND VARIOUSLY IN AMERICA THAN IN EUROPE, AND, ON THE OTHER HAND, MANY OF OUR ARTISTIC PROBLEMS ARE PECULIAR TO OURSELVES. MOST OF OUR COUNTRY HOUSES ARE DIFFERENTLY BUILT, PLACED, AND SURROUNDED FROM THOSE OF OTHER COUNTRIES. OUR LARGE PARKS AND PRIVATE DOMAINS ARE OFTEN LAID UPON VIRGIN SOIL INSTEAD OF UPON SITES WHICH HAVE BEEN USED FOR OTHER PURPOSES, WHILE IN THE WEST OF EUROPE SUCH A THING AS A VIRGIN SITE HARDLY EXISTS.[63]

In 1875 an editor for *Cosmopolitan* expressed the same notion, commenting that suburban homes should be designed with "stateliness enough to comport with the general dignity and breadth of the American landscape."[64] The idea that the American landscape continued to be different from that of Europe was also proposed by the historian Frederick Jackson Turner, who stated in a lecture at the World's Columbian Exposition in Chicago in 1893 that despite the disappearance of a line of settlement, the frontier remained the driving force in the nation. Turner felt that the very fact of the frontier's earlier existence was important because it had established the fundamental values of the nation, creating a society that encouraged fluidity, pragmatism, and an interest in novelty, one that was based in principles of freedom and democracy.[65] Since, as Turner believed, such principles continued to exist in America, the frontier was kept alive in the American mind if not in the landscape itself.

Ideals of Home in Art
Most American Impressionists do not seem to have been especially nationalistic, but there is evidence that they believed the American landscape to be different from that of Europe. Surely referring to old American saltbox homes, Theodore Robinson wrote in his diary in 1893 that he was sorry that he had "done nothing with the little square, box-shaped white houses, often very pretty as notes and even more. Much can be done, I'm sure, by tackling anything and everything, and not avoiding things very typical like our frame buildings."[66] Robinson's attitude was undoubtedly influenced by his communication with Hamlin Garland,

who had become an advocate for an "American" Impressionist art in the early 1890s. In *Impressions on Impressionism* (1894), Garland wrote approvingly of American Impressionist works included in the World's Columbian Exposition and commented that he felt the "next step is to do interesting American themes and do it naturally."[67] Garland sent Robinson a copy of his book, which the artist found "witty and sensible and suggestive—the sort of thing that ought to be good."[68] In his *Crumbling Idols* (1894), Garland went further, promoting the idea that American art should be distinct in subject and expression:

ONE SCHOOL...CANNOT COPY OR BE BASED UPON THE OTHER WITHOUT LOSS. EACH PAINTER SHOULD PAINT HIS OWN SURROUNDINGS, WITH NATURE FOR HIS TEACHER, RATHER THAN SOME DUTCH MASTER, PAINTING THE NEVER-ENDING MISTS AND RAINS OF SEA-LEVEL. THIS BRINGS ME TO MY SETTLED CONVICTION THAT ART, TO BE VITAL, MUST BE LOCAL IN ITS SUBJECT; ITS UNIVERSAL APPEAL MUST BE IN ITS WORKING OUT—IN THE WAY IT IS DONE. DEPENDENCE UPON THE ENGLISH OR FRENCH GROUPS IS ALIKE FATAL TO FRESH, INDIVIDUAL ART.[69]

Perhaps inspired by Garland, in 1895, Robinson was still pondering how to "paint American," and he identified works by his friends John Twachtman and J. Alden Weir as achieving the aim for which he himself was striving, commenting in his diary: "I think the N[ew] E[ngland] Barn is typical...and interesting in several ways. We should paint them as in the old world one paints cathedrals or castles. Weir has done this—Twachtman as well."[70] The idea that the nation's identity was embodied in its architecture was also explored by Childe Hassam in the early twentieth century. On visits to old New England towns, including Gloucester and Newport, Hassam created a series of images of Colonial churches and focused in a number of instances on the saltbox homes that dated from the early days of the nation (pls. 10 and 17). Willard Metcalf also explored the subject of old homes and painted pastoral countrysides that recalled an earlier era (pls. 12 and 16). His images were frequently commended for their "Americanness." For example, Catherine Beach Ely remarked in 1925 that Metcalf's depictions of the New England landscape called "up tender associations which an American can best appreciate....[The] mood of homesickness for the haunts we or our parents loved finds satisfaction in Metcalf's paintings."[71] Also describing Metcalf's work, the critic Royal Cortissoz remarked in 1927: "The indefinable elements which make our brooks and pastures intensely and unforgettably American are curiously eloquent in his pictures. He would do more than paint the portrait of a place. He would so interpret it that it disclosed the essence of our countryside everywhere....He got into his canvases the simple, lovable truths which, perhaps, only an American can feel to the uttermost in our apple trees and our winding streams."[72]

The "Americanness" in American Impressionist landscapes can be seen with special clarity in the parallels between artists' images of home grounds and the recommendations presented in period literature. Echoing the bias against the farm and its labor, American Impressionists created images of home grounds that were quite obviously not meant to be seen as places of work. In this respect, their images differ from those of the Hudson River School, which often showed how homesteaders survived in the wilderness. Hudson River School artists detailed the tree stumps and piles of timber used by log cabin residents for shelter and heat and included figures fishing, returning from the hunt, or working in cultivated fields in order to demonstrate how their subsistence was achieved in the wilderness (figs. 4 and 5). By contrast, American Impressionists portrayed places of repose and leisure, where the pragmatic concerns of survival are not present and where that harmonious middle ground between the conveniences of city life and the quietude and fresh country air was achieved. They often portrayed figures on porches, idling away the time. They gaze out at gardens as in Philip Hale's *The Crimson Rambler* (pl. 3), engage in leisure activities such as the sewing and reading taken up by the young women in Frank Benson's *Afternoon in September* (pl. 1) or the croquet game played by women in a backyard setting in William Paxton's *The Croquet Players* (fig. 6), converse as in Robert Blum's *Two Idlers* (pl. 2), or enjoy the sunlight as in John Twachtman's *On the Terrace* (pl. 5) and Lydia Field Emmet's *Grandmother's Garden* (pl. 6). Even J. Alden Weir's *The Laundry, Branchville* (pl. 25), a rare Impressionist work in which the mundane tasks of home life are depicted, shows the home as a place of rest rather than of labor. The white line of drying clothes is treated as an element of beauty in the composition, its graceful curve linking the angularity of the home with the undulating shape of the green hillside below.

Figure 5.
Frederic Edwin Church, *Home by the Lake*,
1852, oil on canvas, 31 7/8 x 48 1/4 in. (80.9
x 122.5 cm), Jo Ann and Julian Ganz, Jr.
Collection.

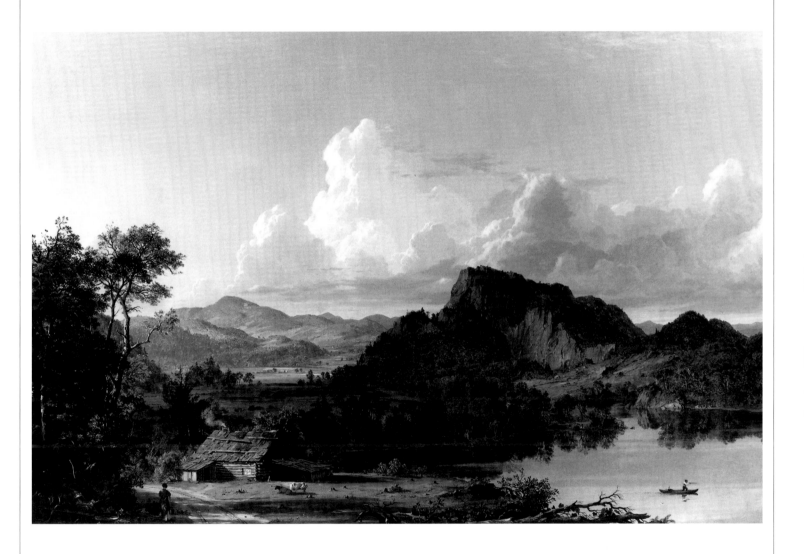

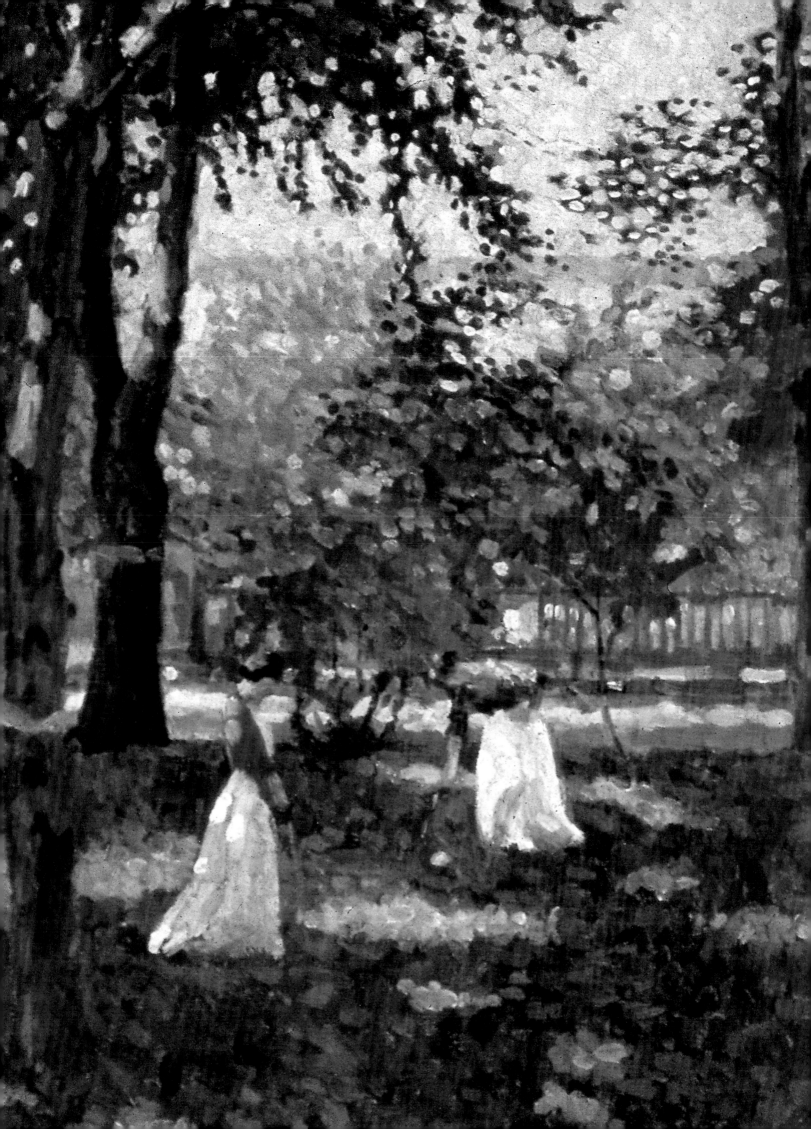

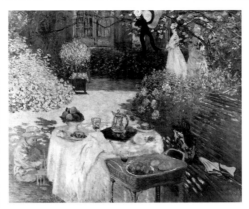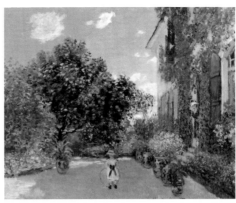

Figure 6. (Preceding Page)
William Paxton, *The Croquet Players*, c. 1898, oil on canvas, 32 x 21 in. (81.3 x 53.3 cm), private collection. Courtesy, Vose Galleries of Boston.

Figure 7.
Claude Monet, *The Luncheon* (Decorative Panel), 1874, oil on canvas, 63 x 79 1/8 in. (160 x 201 cm), Musée D'Orsay, Paris, Giraudon/Art Resource, New York.

Figure 8.
Claude Monet, *The Artist's House at Argenteuil*, 1873, oil on canvas, 23 7/8 x 29 in. (60.2 x 73.3 cm), The Art Institute of Chicago, Mr. and Mrs. Martin A. Ryerson Memorial Collection.

In their images of home leisure, American Impressionists were obviously following the example of French Impressionist views of this subject. William Chadwick's *On the Porch* (pl. 4), where a woman sits at an elegantly set table is clearly in the tradition of works such as Monet's *The Luncheon* (fig. 7). However, a different view of the garden often appears in French and American Impressionist works. For example, in Monet's *The Luncheon* as well as in his *The Artist's House at Argenteuil* (fig. 8), bushes and flowers have been ordered in such a way that they appear more as decoration for the human spaces than as organic forms growing freely in nature. In American Impressionist paintings, by contrast, human structures and spaces often seem to have been accommodated to their sites, continuing the "prevailing thought of their surroundings."[73] Presenting the free and wild type of nature that was recommended in American home journals, American Impressionists favored views of flowers that are blended in with landscape environments, rather than curtailed as in formal gardens.

This approach may be seen, in particular, in views of the renovated farmhouses that were featured so often in American home magazines. In Twachtman's *From the Upper Terrace* (fig. 9), the remodeled farmhouse where the artist and his family lived in Greenwich, Connecticut, is seen from a high vantage point, which makes it appear to hover in the midst of its floral surrounding. Rather than imposing itself on the site, it takes on the lavender and pink colors of the garden, while meandering pathways leading away from it evoke feelings of spontaneity, informality, and freedom reflective of American notions about the optimal suburban landscape. In *My Garden* (pl. 14), Clark Voorhees's low vantage point accentuates the way that flowers and plants seem to sweep upward to embrace the old saltbox with its added porches, rooting the dwelling in nature, and making it "appear as though it could not be moved anywhere else without detriment to its own effect."[74] In Ruger Donoho's *A Garden* (pl. 23), the leaves and bushes of the landscape seem merged with the home, obscuring most of it from view and giving it the appearance of "composing unobtrusively and effectively with the site and surroundings."[75]

The farmhouse and garden also appear integrally linked in *Greenwich Garden* (pl. 20) by Twachtman and his son Alden. White phlox in "big generous masses that catch the spirit of Nature at her best" cascade upward, corresponding with the gabled doorway at the back of the Twachtman home.[76] In *Little Old Cottage, Egypt Lane, East Hampton* (pl. 10), Childe Hassam chose an oblique angle on his subject, demonstrating a "respect for [the home's] natural peculiarities."[77] By featuring the house prominently in the composition, Hassam was able to record the interaction of sunlight and architecture, noting the multihued reflections in the building's shingled walls and roof. In *The Peony Garden* (pl. 24), Daniel Putnam Brinley painted a view of the "little and white" home that he rented in Silvermine, Connecticut, from 1909 to 1913. Omitting "the sheds of a disused mill" which the house faced, Brinley filled the pictorial field with flowers, which seem to flow from the small cottage, conveying the release and bounty that American writers felt a country place should exude. In other works, artists featured the vine trellises, arbors, and dooryard gardens that were supposed to "break the hard lines of the building" and make the house part of its surroundings (pls. 5, 7, 11, and 14). By contrast with Hudson River School works in which there are clear divisions between the cleared ground, where the homesteader's cabin is situated, and the untouched wilderness, in American Impressionist paintings, wild and cultivated landscapes often flow seamlessly together. Such a preference was advocated in 1902 by a writer for *Country Life in America* who stated that "simplicity, freedom, naturalness should be the controlling expressions of the grounds [of a country home]."[78]

Works by Twachtman, Donoho, and Brinley show gardens close to the home that are dominated by freely growing wildflowers (pls. 5, 23, and 24). Wildflowers are also present in Frank Bicknell's *Miss Florence Griswold's Garden* (pl. 21), where low clusters of red and white blossoms spread freely across the ground, while bushes have grown up along the side of a wood shack. In a view of a California garden, Theodore Wores's *Home and Garden Saratoga* (pl. 11), wildflowers create a fringe along building walls and fill a courtyard sheltered by a white pergola. In George Burr's *Old Lyme Garden* (pl. 31), a view of the artist's garden, which was behind his studio in Old Lyme, a grouping of box forms a natural geometric arrangement in a grounds that has not been landscaped. Similarly in Hugh Henry Breckenridge's *White Phlox* (pl. 30), a scene of the artist's garden at his Fort Washington, Pennsylvania, home that he called "Phloxdale," a trellised fence is glimpsed beyond a burgeoning mass of white and pink blooms. It was paintings such as *White Phlox* that made the critic Arthur Hoeber comment that Breckenridge "knows his nature, his tree forms, and for flowers and the wild growth he has a decided leaning."[79]

Figure 9.
John Henry Twachtman, *From the Upper Terrace*, c. 1893, oil on canvas, 25 x 30 in. (63.5 x 76.2 cm), Pfeil Collection. Photograph, courtesy Spanierman Gallery, New York.

Figure 10. (Following Page)
Childe Hassam, *Celia Thaxter in Her Garden*, 1892, oil on canvas, 22 1/8 x 18 5/16 in. (56.2 x 46.5 cm), National Museum of American Art, Smithsonian Institution, Washington, D.C., Gift of John Gellatly.

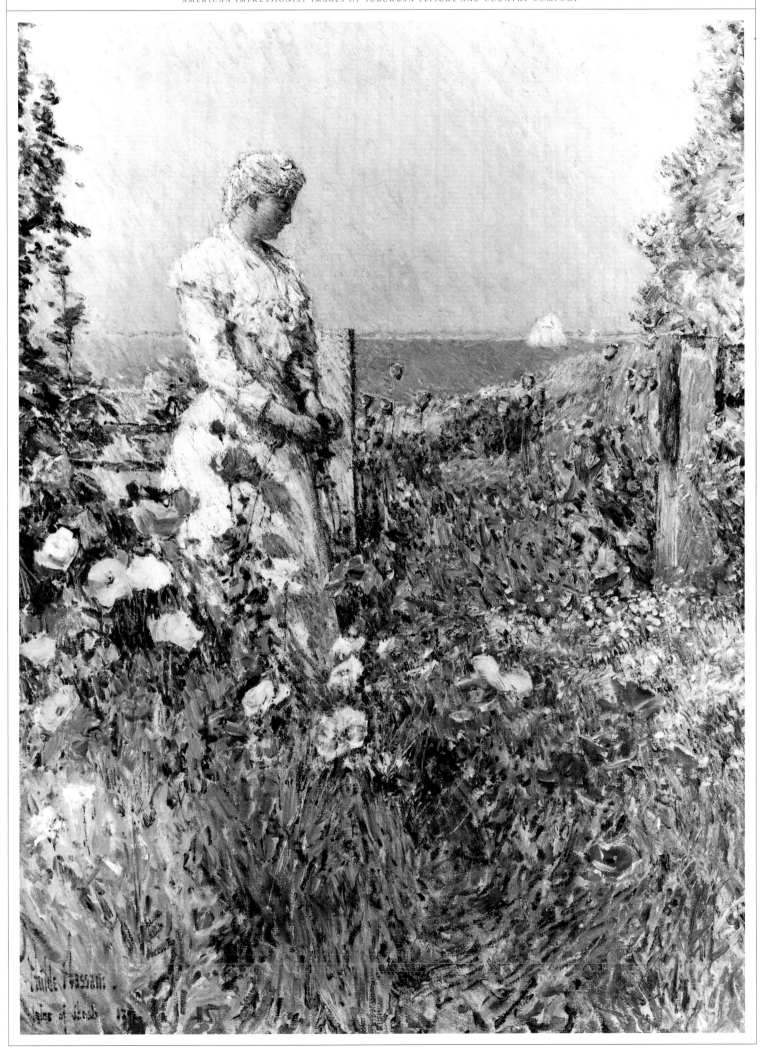

Figure 11.
Childe Hassam, *Celia Thaxter's Garden, Appledore, Isles of Shoals* (detail), 1890-1893, oil on canvas, 13 x 9 7/16 in. (33 x 23.9 cm), The Warner Collection of Gulf States Paper Corporation, Tuscaloosa, Alabama.

Figure 12.
Karl Thaxter, southeast corner of Celia Thaxter's garden, c. 1892. Photograph, courtesy Star Island Corporation.

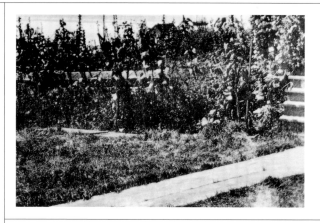

Childe Hassam also explored the wild garden in his paintings of the garden created by the poet Celia Thaxter at her home on Appledore in the Isles of Shoals. In *Celia Thaxter in Her Garden* (fig. 10) Thaxter is shown standing amidst blossoms, which flow in a wave-like fashion through an open fence and bound toward the sea which is visible in the distance. Hassam's delight in the idea of a garden as "a kind of 'betweenity' wherein man has cajoled nature into aiding him in making his house sit comfortably in its midst" is demonstrated in a comparison of *Celia Thaxter's Garden, Appledore, Isles of Shoals* (fig. 11) with a photograph of its site (fig. 12), the piazza at the southeast corner of Thaxter's house from which steps led down to a boardwalk.[80] Hassam omitted the long line of the fence that curtailed the flowers, emphasizing the way that the hollyhocks and hops of the garden merged with the dense leafy vines covering the piazza's columned support. In a view of his home grounds in Setauket, Long Island, William de Leftwich Dodge took his inspiration from the existing landscape, setting a columned arbor in a dip in the land, where he created a "sunken" garden (pl. 29). The white columns appear to meander in accordance with the lay of the land, emphasizing the natural order in the landscape. While the trees seem to take advantage of the architectural structure as a place to rest their leaves, the columns seem to echo the narrow tree trunks in the work's foreground. Nature's freedom is even recognized in Abbott Graves's view of a tended garden in Kennebunkport, Maine (pl. 19), where the plot includes hollyhocks and other perennials that have been allowed to grow in dense profusion.

American Impressionists also demonstrated an awareness of writings that called for homes to exude "personality." In a number of his views of Shinnecock, Long Island, William Merritt Chase included the Colonial revival, Shingle Style home designed by the prominent architect Stanford White where Chase and his family lived during the summers from 1892 until 1902 (fig. 13 and pl. 22). The house had originally been built in 1888 for another client, but Chase personalized it largely by means of interior decoration and the addition of a window in the north wall where his studio was situated. Seen in *Chase Homestead, Shinnecock* (pl. 22), the house is situated prominently at the horizon, its lively gambrel roofs and dormer windows suggesting the animated life within the household, where Chase enjoyed the company of his eight children and worked in his studio. The house reflected the idea given voice by Clarence Martin in 1902 that a "building should bear outward expression suggestive of purpose and of the life within."[81]

In his search for homes with character, Willard Metcalf sought old places that had historical legacies. For each of his views of these homes, he modified his stylistic means so as to bring out the dominant aesthetic qualities of a subject. In *Captain Lord House* (pl. 12), he emphasized the gracious, orderly nature of the Georgian home in Kennebunkport, Maine, built by the wealthy shipbuilder Nathaniel Lord in 1815. Depicting the house in a square canvas that echoes the proportions of the building, he emphasized the way that the tall trees in front of the dwelling paralleled its columned porch and angular lines. In *October* (pl. 16), he portrayed a view of the seventeenth-century saltbox which was the ancestral home of Peletiah Leete III, the grandson of Governor William Leete, who arrived in America in 1639. Again the canvas shape mirrors that of the home, but here trees play a different role, softening and sheltering the old dwelling with a brilliant display of fall foliage. Personality clearly exudes from the East Hampton home of Thomas Moran, painted by Theodore Wores probably in the 1910s. Built in 1884, the house, called "The Studio," was a gray-shingled, two-storied, hip-roofed dwelling set on a steep lot. In his image of this structure (pl. 18), Wores focused on its back side, where screens of trees, hedges, and flowers protected the dwelling from public view.

Wores's painting demonstrates the concern for privacy that was a primary issue for the new residents of the country and suburbs at the turn of the century. Other American Impressionists reflected this desire for seclusion, showing homes that appear closed off from the outside world. Rarely depicting domestic residences on open, cleared hillsides, they preferred to feature private backyards, as may be seen in Emmet's *Grandmother's Garden* (pl. 6), Chase's *The Open-Air Breakfast* (fig. 14), and John Twachtman's *On the Terrace* (pl. 5). They portrayed houses enclosed, shielded, and protected by plantings as in Metcalf's *October* (pl. 16), Brinley's *The Peony Garden* (pl. 24), and Voorhees's *My Garden* (pl. 14). Even when a home is shown facing the road as in Bunker's *Roadside Cottage* (pl. 13), a sense of privacy is suggested, as in the soft shadowed atmosphere that surrounds the dwelling, merging its roof with the overhead trees. In some works such as Childe Hassam's *Little Old Cottage, Egypt Lane* (pl. 10), the side gateways promoted by authors as a way of screening the house from view may be seen.

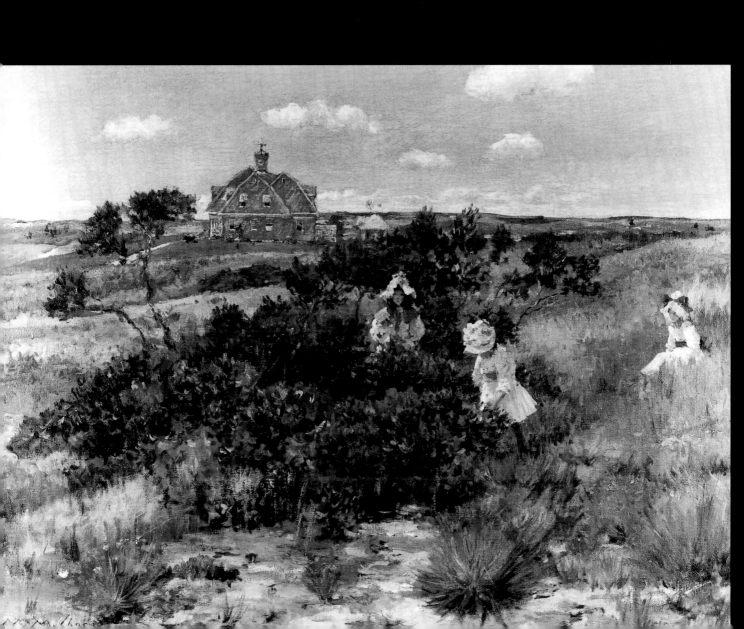

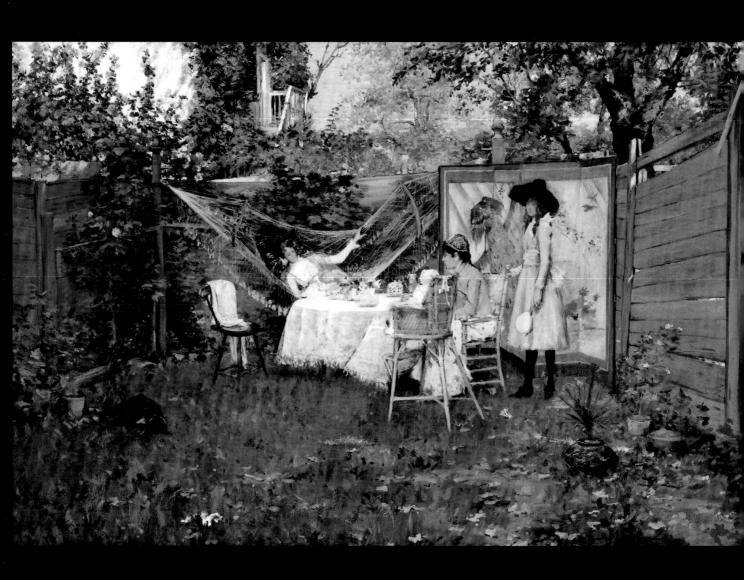

Figure 13. (Preceding Page)
William Merritt Chase, *The Bayberry Bush (Chase Homestead: Shinnecock Hills)*, c. 1895, oil on canvas, 25 1/2 x 33 1/8 in. (64.8 x 84.1 cm), Parrish Art Museum, Little John Collection, Southampton, New York.

Figure 14.
William Merritt Chase, *The Open-Air Breakfast*, c. 1888, oil on canvas, 37 7/16 x 56 3/4 in. (95.1 x 144.3 cm), Toledo Museum of Art, Ohio, Purchase with funds from the Florence Scott Libbey bequest in memory of her father, Maurice A. Scott.

Many of the elements of suburban home grounds as put forth in publications at the turn of the century are united in John Twachtman's *My House* (pl. 9), which features the classical-style portico, designed by the architect Stanford White, that was added to the artist's Greenwich home in the late 1890s. The portico bestows the domestic arena with the spiritual aura associated with an ancient Greek temple and provides shelter, a form of privacy. However, instead of drawing our attention to the interior, Twachtman surrounds the portico with the landscape, so that it seems to open outward onto nature, encouraging us to enjoy the flowing lines and broad masses in the landscape. Thus, both the seclusion and freedom desirable in an American country place are brought together. The intimacy of the point of view and the close cropping of the composition invite the viewer to feel at home in the landscape, seeing it from the point of view of a landowner rather than a visitor, and the golden sunlight that saturates the scene evokes a mood of contentment, peace, and relaxation that were the essence of the American suburban ideal. The painting suggests Twachtman's concurrence with the view expressed in *Country Life in America* in 1901 that "the success of your place will not be measured by its acres nor by its architecture, but by its comfort. Your...home is to lessen the strain, not add to your cares."[82]

Conclusion
The American Impressionists were decidedly cosmopolitan in their outlook. They studied in European academies and spent years working and traveling abroad. Even after returning home to America, they were committed to exploring the stylistic approaches utilized by foreign masters, and many were inspired by exhibitions of French Impressionist art that they saw in this country. Nonetheless, as the paintings that they created of American home grounds in the country and suburbs demonstrate, they clearly responded to a specifically American ideal in the post-frontier era. At this time, the national ideal called for homes in places that seemed remote from the city but were accessible to its benefits and that were cultivated to seem wild. American Impressionist works encapsulate this particular period in the nation's development when the suburbs evoked a harmonious vision of life—an era before the problems in suburban life themselves came to the fore.

In the early twentieth century, American Impressionist works were attacked for their gentility. By contrast with the views of gritty urban scenes painted by the Ashcan School just after the turn of the century, their views of pleasant sunlit landscapes were considered out of touch. However, in the light of the flourishing suburban life movement in America, American Impressionist paintings may be more readily linked to realities of their age than has previously been supposed. They present the other side of life, one opposed to that featured by the Ashcan School. However, since the Ashcan School tended to show only positive aspects of city life, in their images of home grounds, the American Impressionists perhaps demonstrated a more forthright realism than the "realists," although it was one essentially based in an ideal vision of how American home life should be rather than in how it always was.

Lisa N. Peters

NOTES:

1. This approach was proposed by Charles Eldredge in his seminal "Connecticut Impressionists: Spirit of Place," *Art in America* 62 (September-October 1974): 84-90, but it was only in recent years that scholars have pursued a study of American Impressionist works in relationship to social issues. A recent source that takes this vantage point is H. Barbara Weinberg, Doreen Bolger, and David Park Curry, *American Impressionism and Realism: The Painting of Modern Life, 1885-1915*, exh. cat. (New York: Metropolitan Museum of Art, 1994).

2. On adverse reactions to the city, see "The Anti-urban Tradition in American Thought," in Kenneth T. Jackson, *Crabgrass Frontier: The Suburbanization of the United States* (New York: Oxford University Press, 1985), 68-72.

3. On the character of American suburbs in the early nineteenth century, see Henry C. Binford, *The First Suburbs: Residential Communities on the Boston Periphery, 1815-1860* (Chicago: University of Chicago Press, 1985).

4. The most complete study of the growth and character of the American suburbs is Jackson 1985. See also John R. Stilgoe, *Borderland: Origins of the American Suburb, 1820-1939* (New Haven, Conn.: Yale University Press, 1988). On the design of suburban homes, see Alan Gowans, *The Comfortable House: North American Suburban Architecture, 1890-1930* (Cambridge: M.I.T. Press, 1986). Gwendolyn Wright, "Victorian Suburbs and the Cult of Domesticity," in *Building the Dream: A Social History of Housing in America* (New York: Pantheon, 1981), focuses on the role of builder's guides and new technology in the construction of suburban homes.

5. Quoted in Jackson 1985, 68.

6. "As We Sow, We Shall Reap," in Thomas Hill, *Right and Wrong, Contrasted* (1884). Quoted and reproduced in Wright 1981, 98.

7. J. P. Mowbray, "Going Back to the Soil," *World's Work* 1 (January 1901): 267.

8. [Liberty Hyde Bailey], "What This Magazine Stands For," *Country Life in America* 1 (November 1901): 24-25.

9. On the impact of new modes of transportation on suburban life, see Jackson 1985, 87-116 and Sam Bass Warner, Jr., *Streetcar Suburbs: The Process and Growth in Boston 1870-1900* (Cambridge, Mass: Harvard University Press, 1962).

10. Mowbray 1901, 267-268.

11. "The Mission of Country Life Magazines," *Suburban Life*, n. s., I (August 1905): 3.

12. "The Making of a Country Home: Being A Series of Practical Papers on the Possibilities of Home-Making by Persons of Moderate Means—I. Choosing the Site, and General Advice," *Country Life in America* 1 (April 1901): 200-203.

13. See Stilgoe 1988, 209.

14. "Making of a Country Home I," 1901, 200.

15. E. S. Martin, "Random Reading. Miniature Essays on Life: The Country," *Harper's New Monthly Magazine* 104 (April 1902): 825.

16. William Bishop, "Hunting an Abandoned Farm in Connecticut," *Century Magazine* 47 (April 1894): 919.

17. "What This Magazine Stands For," *Country Life in America* I (November 1901): 24-25.

18. Mariana van Rensselaer, "A Suburban Country Place," *Century Magazine* 54 (May 1897): 3.

19. The idea that "landscape" is itself a social construct "forged by the historical processes of a metropolitan-dominated society" is suggested by Michael Bunce, *The Countryside Ideal: Anglo-American Images of Landscape* (London: Routledge, 1994): 2. Bunce suggests that the physical reality of landscapes are themselves shaped by "the mix of ideology and values, myth and stereotype, image and perception, as well as lived experience which has sustained the ideal," and he explores the relationship between the cultural origins of the countryside ideal and its manifestation in contemporary landscapes.

20. J. Alden Weir, Barbizon, France, to his parents, West Point, New York, 6 April 1877, quoted in Dorothy Weir Young, *The Life and Letters of J. Alden Weir* (New Haven, Conn.: Yale University, 1960): 122.

21. John Twachtman, The Players, New York, to Josephine Holley, Cos Cob, Connecticut, 2 January 1902, Archives, Historical Society of the Town of Greenwich.

22. Many sources discuss the closing of the frontier, its impact on American life, and how the frontier thesis and closing are reflected in American literature and thought. Some examples are: Sean Dennis Cashman, "The Closing of the Frontier," in *America in the Gilded Age: From the Death of Lincoln to the Rise of Roosevelt* (New York: New York University Press, 1984), 255-280; Richard Slotkin, *The Fatal Environment: The Myth of the Frontier in the Age of Industrialization, 1800-1890* (Middletown, Conn.: Wesleyan University Press, 1985); Slotkin, *Gunfighter Nation: The Myth of the Frontier in Twentieth-Century America* (New York: Atheneum, 1992); Ray Allen Billington, *America's Frontier Heritage* (New York: Holt, Rinehart and Winston, 1966); Lucy Lockwood Hazard, *The Frontier in American Literature* (New York: Barnes & Noble, 1941). Both of Slotkin's books contain extensive bibliographies.

23. Charles Eldredge was perhaps the first to propose that American Impressionist artists and early twentieth-century fiction writers responded in their works to the changes that occurred in the post-frontier era. See Eldredge 1974.

24. Beatrix Jones, "The Garden as a Picture," *Scribner's Magazine* 42 (July 1907): 3-4.

25. John C. Van Dyke, *Nature for Its Own Sake: First Studies in Natural Appearances* (New York: Scribner's Sons, 1898), 170. Quoted in Hildegard Cummings, "Home is the Starting Place," in *J. Alden Weir: A Place of His Own*, exh. cat. (Storrs, Conn.: The William Benton Museum of Art, University of Connecticut, 1991), 31.

26. I would like to thank Gay Vietzke, Curator, Weir Farm National Historic Site, for information on Weir's commute from Branchville to New York.

27. See Loretta Hoagland et al., *Lawrence Park: Bronxville's Turn-of-the-Century Art Colony* (Bronxville, N.Y.: Lawrence Park Hilltop Association, 1992).

28. J. Alden Weir, "John H. Twachtman: An Estimation," *North American Review* 176 (April 1903): 562.

29. "The Contemporary Suburban Resident," *Architectural Record* 11 (January 1901): 69.

30. John Wright Buckham, "The Making of a Country Home: Being A Series of Practical Papers on the Possibilities of Home-Making by Persons of Moderate Means—IV. Some Architectural Details, as Illustrated by the Doorways of Old Salem," *Country Life in America* 3 (July 1902): 85.

31. On Queen Anne architecture, see Mark Girouard, *Sweetness and Light: The Queen Anne Movement, 1860-1900* (New Haven: Yale University Press, 1984).

32. M[ariana] G. van Rensselaer, "American Country Dwellings. I.," *Century Magazine* 32 (May 1886): 3.

33. "The Contemporary Suburban Resident" 1901, 79.

34. Clarence A. Martin, "The Making of a Country Home: Being A Series of Practical Papers on the Possibilities of Home-Making by Persons of Moderate Means—V. The External Aspect of the House," *Country Life in America* 2 (August 1902): 144.

35. Martin 1902, 144.

36. "The Contemporary Suburban Residence" 1901, 79-80.

37. Van Rensselaer 1886, 3-4.

38. Alfred Morton Githens, "The Farmhouse Reclaimed I," *House and Garden* 17 (June 1910): 217.

39. Robert and Elizabeth Shackleton, *Adventures in Home-Making* (New York: John Lane, 1910), 15.

40. Alfred Henry Goodwin. "An Artist's Unspoiled Country Home." *Country Life in America* 8 (October 1905): 625.

41. [Mariana] van Rensselaer, *Art Out-of-Doors: Hints on Good Taste in Gardening* (New York: Charles Scribner's Sons, 1893), 67-68.

42. "The Contemporary Suburban Residence" 1901, 77.

43. Claude Bragdon, "The Making of a Country Home: Hints on External Treatment," *Country Life in America* 2 (September 1902): 172.

44. Mary H. Northend, *Remodeled Farmhouses* (Boston: Little, Brown, and Co., 1915), 8.

45. "A Home in a Prairie Town," *Ladies Home Journal* 8 (February 1901): 17.

46. Bryant Fleming, "The Making of a Country Home: Being A Series of Practical Papers on the Possibilities of Home-Making by Persons of Moderate Means—III. Planting the Place," *Country Life in America* 2 (June 1902): 47.

47. Sarah Cone Bryant, "A Suburban Place of Four Acres," *Country Life in America* 4 (August 1903): 267.

48. Andrew Jackson Downing, *Victorian Cottage Residences* (1842; New York: Dover, 1981), 128.

49. Bryant 1903: 267.

50. H.A. Caparn, "Informal Outdoor Art: Its Value to Architecture," *Architectural Record* 13 (March 1903): 266.

51. See van Rensselaer 1893, 8; van Rensselaer 1897; *Country Life in America* 1 November 1901; Northend 1915, 168; Jones 1907, 2; Bryant 1903, 267; and "American Gardens." *Independent* 53 (30 May 1901): 1267-1268.

52. "American Gardens" 1901, 1267.

53. Downing 1842, repr. 1981, 79.

54. Van Rensselaer 1897, 7-8.

55. "Making of a Country Home: Being A Series of Practical Papers on the Possibilities of Home-Making by Persons of Moderate Means—II. The Grading of the Land. The Boundaries," *Country Life in America* 2 (May 1902): 7-9.

56. "The Making of a Country Home I" 1901, 202.

57. Helena Rutherfurd Ely, *The Practical Flower Garden* (New York: Macmillan Company, 1911), 179.

58. Ely 1911, 181-192

59. Noted in David Schuyler and Jane Turner Censer, eds., *The Papers of Frederick Law Olmsted: Volume VI—The Years of Olmsted, Vaux & Company, 1865-1974* (Baltimore, Md.: The Johns Hopkins Press, 1992), 551-553.

60. Ely 1911, 165.

61. Mable Osgood Wright, *Garden of a Commuter's Wife* (New York: Macmillan and Co., 1901), quoted in Virginia Tuttle Clayton, "Reminiscence and Revival: The Old-Fashioned Garden, 1890-1910," *Antiques* 137 (April 1990): 899.

62. George W. Cable, "The American Garden," *Scribner's Magazine* 35 (May 1904): 622, 625.

63. Van Rensselaer 1893, 367.

64. Edward C. Bruce, "Our Architectural Future," *Cosmopolitan* 16 (September 1875): 311.

65. On Turner's speech, see Robert H. Wiebe, *The Search for Order, 1877-1920* (New York: Hill and Wang, 1967), 66. Wiebe wrote that "Turner sketched a process by which successive frontiers had continually rejuvenated the nation through infusions of individualism, daring, and democracy. Now, he said, the frontier had closed. His underlying purpose, as David M. Potter has written, 'was to explain the differentiation of the American from the European,' to examine, in other words, the unique qualities of the American character, an involvement that was assuming far less healthy forms among nativists, purveyors of patriotism, and theorists of race destiny."

66. Theodore Robinson diaries, 29 October 1893, Frick Art Reference Library, New York.

67. "A Critical Triumvirate" [Charles Francis Browne, Hamlin Garland, Lorado Taft], *Impressions on Impressionism* (Chicago, 1894). Quoted in William H. Gerdts, *American Impressionism* (New York: Abbeville, 1984), 144-145.

68. Robinson diaries, 19 November 1894.

69. Hamlin Garland, *Crumbling Idols: Twelve Essays on Art* (1894); (Cambridge: Mass.: Harvard University, Belknap Press, 1960), 103-104.

70. Robinson diaries, 2 September 1895.

71. Catherine Beach Ely, "Willard L. Metcalf," *Art in America* 13 (October 1925): 334-336.

72. Royal Cortissoz, "Willard Leroy Metcalf," *American Academy of Arts and Letters Commemorative Tribute*, Academy Publications, no. 20 (1927): 181.

73. Bryant 1903, 267.

74. Van Rensselaer 1893, 67.

75. "The Contemporary Suburban Residence" 1901, 77.

76. Thomas McAdam, "The Gentle Art of Wild Gardening: The Simplest, Most Permanent, Least Expensive and Most Natural-Like Style of Horticulture—An Example of Consummate Skill in Blending Art and Nature," *Country Life in America* 7 (March 1905): 470.

77. Bryant 1903: 267.

78. "The Making of a Country Home II" 1902, 7.

79. Arthur Hoeber, "Hugh H. Breckenridge," *International Studio* 37 (March 1909): xxxvi.

80. Bryant 1903, 75.

81. Martin 1902, 144.

82. "The Making of a Country Home I" 1901, 200.

Old Dwellings,
Traditional Landscapes:

IMPRESSIONIST ARTISTS AND THE REDISCOVERY OF AMERICAN PLACES

IN THE MAY 1889 ISSUE OF *SCRIBNER'S MONTHLY*, Charles Eliot Norton decried the lack of attachment to place and the restless mobility of the American people. Scion of Puritan New England, Norton perceived this most clearly in the few examples of homes passed from generation to generation within a single family, which he considered a "novel and significant feature of American society." As had commentators at least since Alexis de Tocqueville, the Harvard aesthete despaired for the fate of a nation so unconcerned with its past, so eager to abandon familiar places in search of new opportunities and new adventures.[1]

Perhaps ironically, the decades surrounding Norton's cultural jeremiad were a time when many Americans discovered their past and found enchantment in older dwellings and traditional landscapes. The continuing exploration of the West, and particularly illustrated reports of natural wonders such as the Yosemite Valley and Yellowstone, which was dedicated as a national park in 1872, remained a staple of the popular press, but anticipation of the centennial of national independence surely contributed to the celebration of American places closer at hand. William Cullen Bryant's lavishly illustrated *Picturesque America* (2 vols., 1872) included essays on eastern Long Island, the Adirondacks and White Mountains, coastal New England, and the familiar landscapes of the mid-Atlantic and Southern regions, as well as the spectacular scenery of the more remote West. During the early 1870s *Harper's Monthly, Appleton's Journal, Scribner's Monthly*, and other widely circulated magazines introduced readers to the history of old towns such as Portsmouth, New Hampshire, Marblehead, Massachusetts, and Lyme, Connecticut, or of such notable eastern landscapes as Nantucket and the Isles of Shoals off New Hampshire (fig. 15). The tenor was often elegiac, an appreciation of a locale the modern world had long since left behind, or antiquarian, a sentiment Martha J. Lamb expressed in describing Lyme as "this ancient and interesting town."[2] Immediately following the centennial A. S. Barnes & Company commenced publication of the *Magazine of American History*, which featured articles and documents about the colonial and revolutionary eras, while best-selling non-fiction and fiction similarly turned to the nation's past as a source of inspiration. Whether they experienced the landscape through paintings, lithographs, or the printed page, or joined the ranks of tourists, in the years that framed the nation's centennial, Americans rediscovered the New England and Middle Atlantic countryside—old port towns and fishing villages, agricultural communities, and once thriving towns, vernacular landscapes and buildings.[3]

American Impressionist painters at the turn of the twentieth century were similarly captivated by old homes and places. These were not the only scenes they painted, of course: William Merritt Chase depicted several of New York City's public parks with obvious affection; Maurice Prendergast recorded the Drive, Bethesda Terrace, and other scenes in Central Park as well as the Public Garden, Franklin Park, and Revere Beach in Boston; and Ernest Lawson painted several views of the High and Washington Bridges, which linked Manhattan and the Bronx across the Harlem River. Childe Hassam expressed his affection for Boston's urban landscape on several canvasses in the early 1880s, as well as for Washington Square Park, Union Square, and numerous other New York landmarks in later years. Virtually every major Impressionist painter lived and worked at least part of the year in cities, and exhibited his or her work in shows and galleries that existed only in a metropolitan area. Unsurprisingly, these artists found inspiration in the American urban scene.

But if city places represent one genre within American Impressionism, the small town and rural landscape claimed the center of the artists' imagination. In part this was the result of the emergence of plein air painting in the second half of the nineteenth century. Influenced by the works of artists associated with Barbizon, a village south of Paris near Fontainebleau, and by Monet's Giverny and other locales that attracted Impressionist painters, American artists around the turn of the twentieth century sought landscapes, and communities, where they could both sketch out of doors and enjoy the companionship of other painters. These destinations had to be relatively inexpensive and close to subjects deserving of artistic attention. Given the artists' emphasis on qualities of light, almost by definition such places had to be some distance from major cities to avoid the pollution of coal-powered industrial technology—the layers of soot, the ubiquitous grime that gave metaphoric title to Lewis Mumford's classic study of post-Civil War American culture, *The Brown Decades* (1931).[4]

Although the villages that attracted Impressionist painters as places of permanent or summer residence were some distance from cities such as New York and Boston, they were readily accessible by railroad. Indeed, long before painters and tourists rediscovered these communities, the railroad had already arrived. Gloucester, one writer observed, was thirty-one miles from Boston "in a tolerably direct line by rail." The Long Island Railroad reached Greenport, near the eastern end of the North Fork, in 1844, and development

of a rail line along the south shore made the Hamptons "but a few hours' ride" from New York by the mid-1870s. The New Haven & New London line reached Saybrook, across the Connecticut River from Lyme, in 1852, and before the end of the decade numerous other railroads penetrated the interior of New England. By the time American Impressionists went in search of the landscape, there were few places that could not be reached by rail. New transportation technologies had transformed the countryside, making the Northeast, in the words of Frederick W. Coburn, "a land of disappearing provincialism." The railroad, the electric trolley, and improved communications technologies, he observed in 1906, were "eradicating distinctions between city and country."[5]

The impact of the railroad was dualistic. For many of the market towns that once thrived by providing agricultural produce to nearby metropolitan centers, trains initially promised a more efficient link to consumers. Over time, however, the railroad introduced competition from distant places, and the mechanization of farming and larger-scale operations in the Midwest surely contributed to the eclipse of these older eastern market towns in an accelerating national economy. As early as the middle of the nineteenth century, once-prosperous areas in the Northeast were experiencing economic decline and population loss. Solon Robinson, an agricultural reformer, described the landscape of eastern Westchester County, New York, and Fairfield County, Connecticut, as "covered with bushes, or miserable little half-starved patches of cultivation, or with shanties that are a degree, at least, below the western log cabin." As Robinson and other commentators pointed out, parts of the rural Northeast were reverting to pioneer-like conditions, not evolving to a higher state of civilization, and the pattern of abandonment of small farms and the decline of the agricultural economy would continue through the second half of the nineteenth century.[6]

Accessibility by rail did not transform economically quiescent rural communities into centers of artistic activity: it took a change in attitude, in perspective, to appreciate old towns as charming places, subjects worthy of the artist's brush. As late as 1889 a writer in *Atlantic Monthly* described the "poverty of material" available for the landscape artist in rural America and cited precisely those features that, almost simultaneously, Impressionist painters were discovering—old frame buildings of New England towns and Long Island villages. "Weathered clapboards and shingles," Charles H. Moore advised aspiring artists, "exhibit little of that richness that beautifies old walls of stone; and the marks of decay which soon appear in wooden structures built so thinly as those of this country usually are give an unpleasant sense of transientness, and often suggest a degree of discomfort which is no necessary part of the picturesque."[7]

Figure 15.
View of Lyme. Woodcut from Martha J. Lamb, "Lyme. A Chapter of American Genealogy," *Harper's New Monthly Magazine* 52 (February 1876): 315. Courtesy, Shadek-Fackenthal Library, Franklin & Marshall College, Lancaster, Pennsylvania.

Of course, long before publication of this article William Sidney Mount had discovered the pastoral landscapes and vernacular buildings of Long Island, while Luminists Fitz Hugh Lane and Martin Johnson Heade had painted the salt marshes and rocky coast of the North Shore of Massachusetts. Nantucket was rich in the "flavor and atmosphere of the olden time," the old salts and even older buildings, spinning wheels and antique furniture. Eastman Johnson (fig. 16) sympathetically incorporated these elements of the island's heritage in his well-known paintings, which recorded what Lizzie Champney described in 1885 as a "phase of our national life which is fast passing away."[8]

But there was something different about the Impressionists who discovered the charms of coastal New England and eastern Long Island in the closing years of the nineteenth century and the first decade of the twentieth. Most of these artists had studied or worked abroad, and upon their return sought specific types of landscapes and communities for their subjects and for their homes. Instead of working farms or sublime wilderness, the pastoral settings and grand scenery cherished by artists associated with the Hudson River School, this later generation of painters descended upon older settled places, once economically vibrant towns that seemed frozen in time. Fishing had been the dominant industry in Gloucester, Massachusetts, during the first half of the nineteenth century, as it was in Cos Cob, Connecticut, which Lincoln Steffens later described as a "little old fishing-village," while Old Lyme shipped the agricultural surplus of the surrounding area to market in New York.[9] As was true of these communities, East Hampton, an outpost of Puritan New England near the eastern end of Long Island, was an economic backwater that had become a fashionable resort in the 1870s. "Perhaps no town in America," wrote O. B. Bunce in 1872, "retains so nearly the primitive habits, tastes, and ideas of our forefathers as East Hampton." Three years later a writer in the *New York Times* described the dwellings that characterized the village as "cozy cottages and old houses with shingled roofs and sides all overgrown with gray moss." Southampton was "teeming with associations and traditions of our young country's antiquity," and as its popularity as a summer resort increased during the 1870s and 1880s handsome vacation houses began to take shape on the hills of nearby Shinnecock, overlooking Great Peconic Bay. These villages harkened back to a colonial past, and their landscapes bore the impress of generations of settlement. In addition to the requisite physical attributes—rolling countryside, tidal rivers, and coastal inlets—they also possessed historic dwellings and a range of vernacular structures that defined a cultural landscape, its traditional occupations and ways of life, which proved immensely attractive to a rising generation of artists.[10]

Figure 16.
Residence and studio of Eastman Johnson. According to Henry M. Baird, Johnson "transformed two or three old houses that stood on the site into a home, a convenient studio, etc." Woodcut from H.M. Baird, "Nantucket," *Scribner's Monthly* 6 (August 1873): 390. Courtesy, Shadek-Fackenthal Library, Franklin & Marshall College, Lancaster, Pennsylvania.

Part of the appeal of these communities was that they remained virtually untouched by the industrial revolution despite their being located in the most highly industrialized and urbanized region of the United States. New England's economy was defined by its industrial centers, places such as Lynn, Haverhill, Holyoke or Worcester, Massachusetts, or Manchester, New Hampshire, home to Amoskeag, the largest factory complex in the world. By contrast, the villages that attracted Impressionist painters and tourists alike were throwbacks to an earlier time, a different America: the landscapes they sought and painted were places steeped in history and, perhaps, enshrouded in nostalgia. The appeal of communities such as Old Lyme, East Hampton, and New Hope, Pennsylvania, was in part a longing for a simpler time, a conflict-free past, a less complex and demanding civilization. During the last three decades of the nineteenth century, the imagery of rural and coastal New England (and, implicitly, that of eastern Long Island and the mid-Atlantic region as well) conformed to what historian Dona Brown has described as a "fascination some Americans were developing…for all that was not modern, urban, and industrialized." Ironically, what seemed quaint to visitors—faded cedar shingles, moss-covered roofs, the decaying waterfront (fig. 17) or the farmhouse in ruin—was in reality testament to somnolent local economies.[11]

Another element of the appeal of these communities was their remarkable demographic homogeneity. At a time when New England and New York were the most ethnically diverse areas of the nation, when immigrants crowded into the teeming neighborhoods of Boston's North End or Manhattan's Lower East Side, quaint coastal villages such as Old Lyme, with a population in 1900 of 1180 residents, or East Hampton, with 1717 residents, were bastions of an Anglo-American ethnic heritage. The homogeneity of rural America stood in striking contrast to the heterogeneity of the modern city, which William Dean Howells described so vividly in *A Hazard of New Fortunes* (1890). South of Washington Square Basil and Isabel March "met Italian faces, French faces, Spanish faces as they strolled over the asphalt walks under the thinning shadows of the autumn-stricken sycamores. They met the familiar picturesque raggedness of southern Europe." In the streets of lower Manhattan the Marchs confronted "a poverty as hopeless as any in the world, transmitting itself from generation to generation and establishing conditions of permanency to which human life adjusts itself as it does to those of some incurable disease, like leprosy." The Impressionists were clearly aware of the plight of the immigrant poor, the heart-rending conditions of urban life captured in the haunting photographs and searing text of Jacob Riis's *How the Other Half Lives* (1890). As was true of so many of their contemporaries who could afford the cost and had some control over work schedules, these painters chose as their summer retreats or places of residence communities that stood apart from the harsh contours and demographic diversity of the modern industrial city, tranquil village outposts of an Anglo-American past that represented the certitude of an earlier time and the sense of belonging they found, at least implicitly, in a homogeneous society.[12]

Figure 17.
Stavers House, Portsmouth, established as a hotel in 1770, a century later the frame building had become a "very unsavory tenement"; it stood "shabby and dejected, giving no hint of the really important historical associations that clustered around it." Woodcut from T. B. Aldrich, "An Old Town by the Sea," *Harper's New Monthly Magazine* 49 (October 1874): 645. Courtesy, Shadek-Fackenthal Library, Franklin & Marshall College, Lancaster, Pennsylvania.

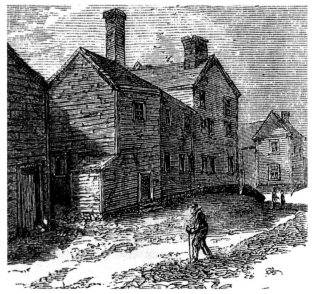

THE HOMES ENVISIONED and painted by the American Impressionists were usually located outside of major cities and in essential ways conformed to a middle-class suburban ideal. This involved both a repudiation of the city as an increasingly alien and dangerous place, as historians such as Kenneth T. Jackson and Margaret Marsh have argued, and a celebration of a new way of life in communities on the urban periphery. Liberty Hyde Bailey, the most prominent horticulturist and agricultural reformer of the early twentieth century, advocated country life as a "release from the city." The ideal existence, he announced in the inaugural issue of *Country Life in America*, "combines something of the social and intellectual advantages and physical comforts of the city with the inspiration and the peaceful joys of the country." Bailey's journal promoted suburban homes as an alternative to the congestion of the city, gardening and agricultural pursuits as means of relief from "the tension of our eager lives." Charles W. Eliot, president of Harvard University, similarly advocated the preservation of natural beauty, especially within and proximate to congested metropolitan centers: "the evils which attend the growth of modern cities and the factory system are too great for the human body to endure," he wrote in 1914, "yet these evils are the consequences, or results, of nineteenth-century civilization." As was true of many of his contemporaries, Eliot believed that life in cities was artificial, and he promoted energetic steps to improve the physical environment of urban areas through the creation of public parks. Opportunities to experience the tranquility of the natural landscape, he reasoned, would "serve as antidotes to the unwholesome excitements and tensions of modern city life."[13]

The summer haunts and suburban homes created by Impressionist painters attempted to provide precisely this alternative to the city, though theirs were private and domestic spaces rather than a public landscape. Collectively, their dwellings differed from the homes and studios of Hudson River School artists in location, age, and stylistic conservatism. Most of that earlier generation of artists' houses were sited at elevated points and commanded extensive views of the Hudson River and adjacent mountains; most were recently constructed and designed following the precepts of contemporary architectural taste. Thomas Cole's Cedar Grove, in Catskill, New York, was a Federal-style house erected in 1815-1816 by Maria Bartow Cole's uncle. Cole, who designed several notable buildings, including the state capitol in Columbus, Ohio, prepared plans for an elaborate Italianate villa that he hoped to build in Catskill, though historians disagree whether this was intended to be a major addition to and alteration of the older home or a completely new residence.[14] He also erected a studio with ornamental barge boards that Louis Legrand Noble described as "somewhat in the Italian villa style." Like Cole, Samuel F. B. Morse acquired an older property, Locust Grove, an 1830 farmhouse near Poughkeepsie. Together with architect Alexander J. Davis, Morse designed a striking Italianate addition to what was undoubtedly a vernacular dwelling. George Harvey erected a Tudor Gothic home, Woodbank, in Hastings-on-Hudson in 1834; Jasper F. Cropsey designed a large board-and-batten home and studio, Aladdin (1869), near Warwick, New York, where he lived until 1885, when he moved to a smaller vernacular Gothic cottage in Hastings-on-Hudson; and Calvert Vaux designed a board-and-batten studio for his brother-in-law, Jervis McEntee, in Roundout, New York. Two of the greatest, most idiosyncratic landmarks of the post-Civil War era were Albert Bierstadt's monumental Malkastan (1865-1866), in Irvington-on-Hudson (fig. 18), designed in a picturesque High Victorian style by Jacob Wrey Mould, and Frederic E. Church's Olana (1871-1872), a Moorish-inspired villa on a spectacular site overlooking the Hudson opposite Catskill (fig. 19).[15]

By contrast, the homes of turn-of-the-century Impressionists tended to be sited within the landscape rather than perched above it. They generally were older dwellings prized because of their history and the simplicity of their forms, or were newer buildings designed according to traditional taste. Abbott Fuller Graves, for example, purchased an eighteenth-century house in Kennebunkport, Maine; Philip Leslie Hale acquired a 1727 farmhouse, Sandy Down, in Dedham, Massachusetts; and like Clark Voorhees, who moved into a c. 1740 gambrel-roofed dwelling in Old Lyme (fig. 52), such other artists as Allen B. Talcott (fig. 20), Frederick W. Ramsdell (fig. 21), George Burr (fig. 64), and Louis Cohen (fig. 22) acquired houses in that Connecticut community which date from the colonial and early national years; in the 1880s J. Alden Weir acquired an old farmstead in Branchville, Connecticut, and painted the farm and surrounding countryside with evident delight (figs. 32, 58, and pl. 25). Childe Hassam continued the tradition in 1919 by purchasing an eighteenth-century house, Willow Bend, in East Hampton (pls. 10 and 17).[16]

Other artists acquired older houses and enlarged or altered them to meet familial needs, or erected modern houses in colonial revival styles. John Twachtman acquired a c. 1840 farmhouse in Greenwich,

Figure 20.
Home of Allen B. Talcott with its terraced garden full of roses and old-fashioned flowers topping a large sloping field, Old Lyme, Connecticut. Photograph, from H.S. Adams, "Lyme—A Country Life Community," *Country Life in America* 25 (April 1914): 48. Courtesy, Florence Griswold Museum, Old Lyme, Connecticut.

Figure 21.
Home of Frederick W. Ramsdell, "an old house by the roadside…left absolutely untouched." The plants above the walls are remnants of an old garden. Photograph, from H.S. Adams, "Lyme—A Country Life Community," *Country Life in America* 25 (April 1914): 50. Courtesy, Florence Griswold Museum, Old Lyme, Connecticut.

Connecticut, which A. H. Goodwin described as a "hopeless old rectangular structure," and transformed it into a handsome dwelling (figs. 3, 46, 48). In the mid-1890s Twachtman commissioned Stanford White to add the graceful classical portico. White also designed the Shinnecock, New York, summer home and studio of William Merritt Chase, a shingle-style colonial revival structure completed in 1892 (fig. 57). Will Howe Foote erected a modern house in Old Lyme (fig. 23), designed by Charles C. Grant, with hipped roof and clapboard siding that complemented the Georgian buildings in the community. Across the continent, in Saratoga, California, Theodore Wores acquired an adobe church and renovated it in the Mission style (fig. 49), which around the turn of the century had become immensely popular as a form of regionalist expression in American architecture even as it became embedded in romantic myths of California's colonial past. The dwelling the much-traveled Wores called home (pl. 11) was still another testament to the search for distinctive American landscapes and for a sense of continuity, of stability in place and time, in a rapidly changing society.[17]

Those artists who did not own summer retreats or suburban homes in metropolitan Boston, or Fairfield County, Connecticut, or Long Island frequented hotels or boarding houses more noteworthy for their age than their accommodations or cuisine. The Thaxter family's Appledore House, on the Isles of Shoals, had opened to the public in 1848, and wings to the north and south were added in 1859 and 1872 respectively, while Miss Annie Huntting's boarding house in East Hampton was a shingled saltbox. The handsome porticoed Florence Griswold house in Old Lyme had been designed by Samuel Belcher in 1817, while the residential center of the Cos Cob colony, the Holley House, was a "great, rambling, beautiful old accident," in Lincoln Steffens's words. The oldest parts of the Holley House dated from the seventeenth century and looked out over the harbor and abandoned buildings that testified to a once-thriving marine industry. Significantly, just as the Impressionists were likely to dwell in old houses, so did the various bridges, barns, and outbuildings they found suitable for their canvasses tend to be old, time-worn, indeed picturesque.[18]

This concern for the old extended to outdoor spaces as well, and in important ways marked a shift away from the kinds of gardens created by Hudson River School artists a generation earlier, which represented a different landscape aesthetic. The grounds of Samuel F. B. Morse's Locust Grove conformed to the picturesque aesthetic of the Italianate dwelling, while George Harvey "amused himself in laying out the grounds" of his twenty-acre property in Hastings-on-Hudson, arranging lawn, paths, trees, and shrubs in what one historian has described as "the English picturesque manner." According to Benson J. Lossing, the historian and sensitive chronicler of the Hudson River landscape, the grounds of Thomas P. Rossiter's

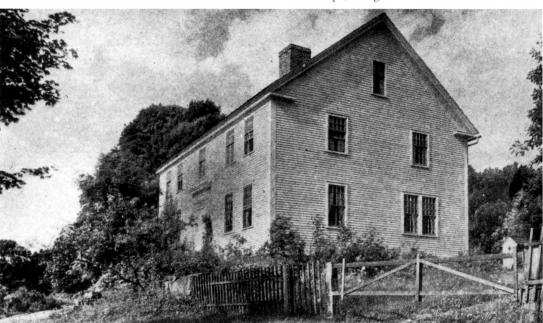

Figure 22.
Home of Louis Cohen glimpsed "through the old orchard, in which a stone tea table has been placed. [The home] is 150 years old and has been remodeled by stuccoing on the wire laid over the original clapboards." Photograph, from H.S. Adams, "Lyme—A Country Life Community," *Country Life in America* 25 (April 1914): 49. Courtesy, Florence Griswold Museum, Old Lyme, Connecticut.

Figure 23.
Home of Will Howe Foote, built "on a hill overlooking the Lieutenant River and Flying Point…one of the most artistic of the new homes designed by Charles C. Grant." Photograph, from H.S. Adams, "Lyme—A Country Life Community," *Country Life in America* 25 (April 1914): 50. Courtesy, Florence Griswold Museum, Old Lyme, Connecticut.

residence in Cold Spring, N.Y. were "in a state of transition from the ruggedness of the wilderness to the mingled aspects of Art and Nature, formed by the direction of good taste." Frederic Church's Olana was an ornamental farm with park-like expanses of lawn, a sheet of water, and winding drives. The emphasis in the design of each of these properties was on landscape and scenery rather than on flowers or highly finished gardens.[19]

By the closing years of the century a new aesthetic had emerged. Histories of American landscape architecture usually emphasize the introduction of the Italian garden, a formal, classical, and often architectonic arrangement of outdoor space, as the hallmark of the era, but as May Brawley Hill has demonstrated, a major and long-neglected theme in the post-Civil War years was the "old-fashioned" garden. "Grandmother's Garden," as it was commonly called, relied on familiar plant materials, beloved flowers such as hollyhocks, poppies, and foxglove, which had been used for generations and which "enlivened the borders of long ago," in Charles Sprague Sargent's words, rather than the exotics that became showpieces of the garden in the aftermath of the horticultural revolution of the early nineteenth century. The plants might be displayed in boxed beds or formal gardens, as they had been during the colonial era, or naturalized in the landscape. But however they were arranged, the gardens evoked a "little of the romance of the past" and produced striking colors that made them so attractive to artists. Heirloom plants and traditional gardens seemed to be part of the fabric of historic buildings, a synthesis of flora and architectural form conveyed in such paintings as Abbott Fuller Graves's *Grandmother's Doorway* (pl. 7), in which the Georgian doorway and facade seem inseparable from the landscape. A writer in 1914 described the grounds of the late Allen Talcott's home in Old Lyme as "a most pleasant old-style garden with stone retaining walls and an utter absence of formality," while Frederick Ramsdell's eighteenth-century house was notable for its "quaint little front dooryard overflowing with what was once a garden." These domestic landscapes undoubtedly appealed to Impressionist artists in part because they represented an older vernacular tradition and evoked a sense of continuity over time.[20]

The image of home and garden presented in Impressionist paintings is an important cultural document, a powerful illustration of a middle-class ideal of the proper familial environment. The significance Americans attributed to the domestic landscape was well established by the time Impressionists looked to the garden at the turn of the twentieth century. Prior to the Civil War, Andrew Jackson Downing, the first important American landscape gardener, had prescribed a rural or suburban way of life as the optimal existence, one particularly suited to women and the family (fig. 24). Catharine E. Beecher and Harriet Beecher Stowe observed that the advice they presented in *The American Woman's Home* (1869) was "chiefly applicable to the wants and habits of those either living in the country or in such suburban vicinities as give space of ground for healthful outdoor occupation in the family service." Other important books published

in the decade after the Civil War, including Frank J. Scott's *Art of Beautifying Suburban Home Grounds* (1870) and Jacob Weidenmann's *Beautifying Country Homes* (1870), similarly recommended a suburban home with ample grounds for gardening as remedy for the "town-sick business man" and his family (fig. 25). Frederick Law Olmsted, the preeminent landscape architect in the United States during the second half of the nineteenth century, and the designer of numerous suburban communities, considered gardens the extension of the home, "*private outside apartments*," and so he thought of the fence or other treatment of the boundary as "a sort of outer wall of the house." As the writings of these individuals demonstrate, perhaps the greatest attraction of a suburban or country house was the space available for a garden and the extension of domestic life into landscaped grounds adjacent to the home.[21]

Impressionist paintings document the degree to which the garden was part of the demarcation of familial roles and spaces by gender. The identification of the garden with femininity was not new, of course: maternal qualities, especially womanly fecundity, have been considered attributes of the land since antiquity, and as critic Annette Kolodny has demonstrated, the European literary imagination has long conceptualized the New World as a maternal garden. By the middle of the nineteenth century, American writers and painters similarly engendered landscape. Edgar Allan Poe's essays "Landor's Cottage" and "The Domain of Arnheim" present contrasting landscapes that exemplify characteristics of the beautiful and the sublime. Like Edmund Burke, whose *Philosophical Enquiry into the Origin of Our Ideas of the Sublime and Beautiful* (1757) linked aesthetic qualities to specific genders, Poe clearly associated the beautiful landscape with the feminine and the sublime with the masculine sphere. A. J. Downing, who popularized this English landscape aesthetic in the United States, also identified characteristics of the garden and scenery in gendered terms. The vignettes he included in the second edition of his *Treatise on the Theory and Practice of Landscape Gardening, Adapted to North America* (1844; originally published in 1841) to illustrate the principle types of landscape represented broader cultural attitudes toward separate spheres: the beautiful or graceful, with its smooth lines, gently undulating lawns, and high degree of finish, was essentially feminine in character, while the roughness and irregularity of the picturesque were qualities more commonly associated with masculinity. Similarly, historian Angela Miller has argued that in the 1850s American landscape painters appealed to a feminine aesthetic in turning away from the "strenuous masculine associations of the romantic mountain sublime to an interest in space as a container of colored air."[22]

By the end of the nineteenth century the separation of spheres had become the cultural norm for upper- and middle-class women, especially those who lived in suburban dwellings. This is evident in the paintings of Impressionist homes and gardens: virtually all of the figures included are female adults and children. Clark Voorhees's *My Garden* (pl. 14), for example, presents the artist's eighteenth-century house, with center stack chimney and gambrel roof, overlooking a garden rich in color. A small child, reaching out toward a flower, stands to the right of the path. The setting is serene, the child's well-being as protected in the garden as the observer would expect it to be in the parlor. Matilda Browne's *In Voorhees's Garden* (1914;

Figure 24.
A feminized landscape. "The Beautiful or Graceful in Landscape Gardening." From A. J. Downing, *A Treatise on the Theory and Practice of Landscape Gardening, Adapted to North America* (1841; 2d. ed., New York, 1844). Courtesy, Shadek-Fackenthal Library, Franklin & Marshall College, Lancaster, Pennsylvania.

Figure 25.
A landscape of leisure. "Art and Nature," engraving by James David Smillie to accompany the first chapter of Frank J. Scott's *Art of Beautifying Suburban Home Grounds* (New York, 1870), 15. Courtesy, Shadek-Fackenthal Library, Franklin & Marshall College, Lancaster, Pennsylvania.

Figure 26. (Following Page)
Matilda Browne, *In Voorhees's Garden*, 1914, oil on canvas, 18 x 24 in. (45.7 x 61 cm.) The Fine Arts Collection of the Hartford Steam Boiler Inspection and Insurance Company, Hartford, Connecticut.

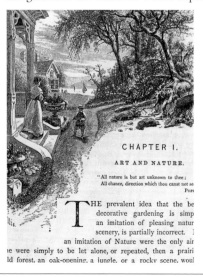

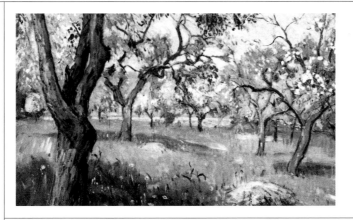

Figure 27.
Lucien Abrams, *The Orchard* (detail), 1916, oil on canvas, 26 1/4 x 32 1/8 in. (66 x 81.9 cm), Courtesy, Florence Griswold Museum, Old Lyme, Connecticut.

Figure 28. (Preceding Page)
John Twachtman, *The Cabbage Patch* (detail), c. mid-1890s, oil on canvas, 25 x 25 in. (63.5 x 63.5 cm), Private Collection. Courtesy, Spanierman Gallery, New York.

fig. 26) presents the artist's home and garden from a slightly different perspective, but again the child in the landscape testifies to a sense of security amid a seemingly natural but carefully controlled environment. John Twachtman's paintings of his Greenwich, Connecticut, home and garden often included figures, especially his wife Martha and their children (pl. 5). Dozens of other paintings illustrate the same pattern: the prevalence of women and children in Impressionist depictions of homes and gardens. Perhaps this was a function of occupation—most of the major American Impressionist painters were males, and they often depicted their wives and children in the garden (though some artists, including Thomas Moran, were photographed in their gardens: fig 55). More likely, these paintings reveal a broad cultural conception of the garden, especially the flower garden, as the special responsibility of women. In any case, the imagery of gendered space in the garden was a representation of reality for most upper- and middle-class women at the turn of the twentieth century, who experienced separate spheres not only in the suburban home but also in clubs and reading groups, as well as in such new downtown spaces as the department store.[23]

Much as the Impressionists portrayed the garden as a gendered space, so did they represent it as a landscape of leisure. In one sense this was evident simply in the persons depicted in the garden, women and children, who were at rest, or at play, not working to support the family. Indeed, at precisely the time Impressionist artists and other middle- and upper-class Americans sought domestic havens in the suburbs, economist Thorstein Veblen characterized leisure as "abstention from productive work" and associated it with women.[24] In another sense the emphasis on leisure was expressed in the colorful beds, shrubs, and flowering trees depicted on the artists' canvasses. There are numerous views of the garden at Florence Griswold's Lyme boarding house, and like William Chadwick's *On the Porch* (pl. 4) or Lucien Abrams's *The Orchard* (fig. 27), they almost invariably focus on the ornamental grounds. The enormous vegetable garden, the working landscape which presumably provided some if not much of the food consumed by summer residents, went unpainted, and so did the gardeners who tended the beds. Even when an Impressionist incorporated the working landscape in a painting, the emphasis was on scenic effects rather than on the labor required to bring forth the bounty of the earth: John Twachtman's *Cabbage Patch* (c. mid-1890s; fig. 28), for example, positions the vegetable garden as a kind of pastoral foreground to the flowers and the rear of the dwelling in the distance.[25] In much the way that nineteenth- and early twentieth-century landscape architects screened the kitchen garden or working landscape from view, Impressionist representations of the garden created the image of a separate space devoted to leisure, a landscape as divorced from the realities of productive labor as the suburban community or rural village was from the downtown business district or tenement neighborhoods.

THE IMPRESSIONISTS' VISION of home, which projected an ideal of a harmonious domestic landscape, was inscribed with the cultural values of the middle class around the turn of the century. These homes and communities were privileged spaces, familial havens set apart from the maelstrom of urban life, the frantic pace and the tremendous cultural diversity of the modern city. The lives of the people who were shaped by or conformed to this middle-class ideal were admittedly full of cultural contradictions—the rigid stratification of society, the physical as well as psychological distancing from the very urban-industrial society that made their way of life possible, the separation of spheres by gender, a celebration of the village at a time when its traditional economic functions were obsolete.[26]

Few Americans, whatever their occupation, could claim the heritage of multigenerational ownership of a manse and a thirty-four acre property such as the one Charles Eliot Norton inherited in Cambridge, Massachusetts. Like the vast majority of their countrymen, Impressionist artists had to create homes and, poignantly, they often acquired older houses or erected new dwellings following colonial revival lines. Their response was part of a broad societal reaction to modernization and the incessant pace of change: an emerging culture of permanence evident in the activities of such organizations as the American Scenic and Historic Preservation Society (established 1895) and the Society for the Preservation of New England Antiquities (1910), as well as in efforts to control the scale of historic cityscapes.[27]

In their choice of homes and communities the American Impressionists surely laid claim to a new heritage, a sense of continuity, of identity in place and time. They were not hopeless romantics nostalgically repudiating the complexities of the modern industrial world, as were some of the urban tourists who traveled to northern New England to experience a farm vacation in the closing decade of the nineteenth century.[28] Instead, the artists' collective decision about the proper location and design of a family home reached back to the past in an attempt to create an ordered life, to establish a sense of belonging, all of which conformed to contemporary ideals of the proper domestic environment at a time of tremendous social and cultural change. So it was for other middle-class Americans around the turn of the twentieth century. And so it was for the next generation of modernists, the American expatriate artists and writers of the 1920s. In the middle of that decade, Malcolm Cowley has observed, the exiles who had returned to New York quickly became dissatisfied with urban life. What followed was a "great exodus toward Connecticut, the Catskills, northern New Jersey and Bucks County, Pennsylvania." Some of these artists and writers purchased farms perhaps a hundred miles from New York and began summering in the country; others, like Matthew Josephson, who acquired an old farmhouse near Katonah, New York, became commuters who made a daily journey from distant homes to places of work in Manhattan or other downtowns.[29] Whether they chose to become permanent or seasonal residents of the countryside, or suburbanites bound to urban jobs but determined to surround their families with a home and garden, the expatriates of the 1920s were seeking what Impressionist painters a generation earlier had found in the American countryside, old dwellings and traditional landscapes, a place to call home.

David Schuyler

NOTES:

1. C. E. Norton, "The Lack of Old Homes in America," *Scribner's Monthly* 5 (May 1889): 636-640.

2. See, for example, Martha J. Lamb, "Lyme. A Chapter of American Genealogy," *Harper's New Monthly Magazine* 52 (February 1876): 313-328 (quotation p. 313); Thomas B. Aldrich, "An Old Town By the Sea," *Harper's New Monthly Magazine* 49 (Oct. 1874): 632-650; John W. Chadwick, "The Isles of Shoals," *Harper's New Monthly Magazine* 49 (Oct. 1874): 663-676, and "Marblehead," *Harper's New Monthly Magazine* 49 (July 1874): 181-202; Henry M. Baird, "Nantucket," *Scribner's Monthly* 6 (Aug. 1873): 385-399. See also Sue Rainey, *Creating Picturesque America: Monument to the Natural and Cultural Landscape* (Nashville: Vanderbilt University Press, 1994).

3. James Richardson, "Traveling By Telegraph: Northward to Niagara," *Scribner's Monthly* 4 (May 1872): 1-23 and (June 1872): 129-157; Benson J. Lossing, "West Point," *Scribner's Monthly* 4 (July 1872): 257-284; George Alfred Townsend, "The Chesapeake Peninsula," *Scribner's Monthly* 3 (Mar. 1872): 513-524; John F. Mines, "New York in the Revolution," *Scribner's Monthly* 11 (Jan. 1876): 305-322 and (Feb. 1876): 457-471; Rebecca Harding Davis, "Old Landmarks in Philadelphia," *Scribner's Monthly* 12 (June 1876): 145-167. See also Dona Brown, *Inventing New England: Regional Tourism in the Nineteenth Century* (Washington, D.C.: Smithsonian Institution Press, 1995).

4. The recent scholarly literature on American Impressionism is remarkable both for its quality and the sheer volume of books and catalogues published, but see especially William H. Gerdts, *American Impressionism* (New York: Abbeville Press, 1984); H. Barbara Weinberg, Doreen Bolger, and David Park Curry, *American Impressionism and Realism: The Painting of Modern Life, 1885-1915,* exh. cat. (New York: The Metropolitan Museum of Art, 1994); and William H. Gerdts, "East Hampton, Old Lyme, and the Art Colony Movement," in *En Plein Air: The Art Colonies at East Hampton and Old Lyme, 1880-1930,* exh. cat. (Old Lyme, Conn.: Florence Griswold Museum, and East Hampton, N.Y.: Guild Hall Museum, 1989), 13-24.

5. Robert Grant, "The North Shore of Massachusetts," *Scribner's Magazine* 16 (July 1894): 3-20 (quotation p. 4); Ronald G. Pisano, *Long Island Landscape Painting 1820-1920* (Boston: Little, Brown & Co., 1985), 2-6; "Long Island Towns," *New York Times* (1 August 1875); "The Tile Club at Play," *Scribner's Monthly* 17 (Feb. 1879): 457-478; Mildred H. Smith, *Early History of the Long Island Railroad 1834-1900* (Uniondale, N.Y.: Salisbury Printers, 1958), 40-41, 57-61; information drawn from the Map of Connecticut, showing location and date of rail lines, reproduced in *Connecticut and American Impressionism,* exh. cat. (Storrs, Conn.: William Benton Museum of Art, 1980), 85; Frederick W. Coburn, "The Five-Hundred-Mile City," *World Today* 11 (Dec. 1906): 1252, 1257.

6. Solon Robinson, "A Flight Through Connecticut" (1849), in *Solon Robinson: Pioneer and Agriculturist, Selected Writings*, ed. Herbert Anthony Kellar, 2 vols. (Indianapolis: Indiana Historical Bureau, 1936), 2: 247-253, 307-310 (quotation p. 247); and "A Day in Westchester County" (1850), in the same collection, 2: 437-440. "Farming Life in New England," *Atlantic Monthly* 2 (Aug. 1858): 334-341, presents a similarly bleak assessment of economy and society in the New England countryside. See also John R. Stilgoe, *Borderland: Origins of the American Suburb, 1820-1939* (New Haven: Yale University Press, 1988), 69-76, and Hal S. Barron, *Those Who Stayed Behind: Rural Society in Nineteenth-Century New England* (Cambridge: Cambridge University Press, 1984).

7. Charles H. Moore, "Materials for Landscape Art in America," *Atlantic Monthly* 64 (Nov. 1889): 670, 672.

8. Lizzie W. Champney, "Summer Haunts of American Artists," *Century* 30 (Oct. 1885): 854; Patricia Hills, *Eastman Johnson* exh. cat. (New York: C. N. Potter and the Whitney Museum of American Art, 1972), 71-103; Weinberg, Bolger, and Curry 1994, 95-102.

9. Grant 1894, 4; Lincoln Steffens, *The Autobiography of Lincoln Steffens*, 2 vols. (New York: Harcourt, Brace & World, 1931), 2: 436; George J. Willauer, Jr., ed., *A Lyme Miscellany 1776-1976* (Middletown, Conn.: Wesleyan University Press, 1977); Gerdts 1989, *passim*.

10. O. B. Bunce, "Scenes in Eastern Long Island," in *Picturesque America; Or, The Land We Live In. A Delineation by Pen and Pencil of Mountains, Rivers, Lakes, Forests, Waterfalls, Shores, Canyons, Valleys, Cuts, and Other Picturesque Features of Our Environment*, ed. William Cullen Bryant, 2 vols. (New York: D. Appleton & Co., 1872), 1: 248-262; "Long Island Towns," *New York Times*, (1 Aug. 1875), (15 Aug. 1875); John Gilmer Speed, "An Artist's Summer Vacation," *Harper's* 87 (June 1893): 3-14; Barbara Dayer Gallati, *William Merritt Chase* (New York: Harry N. Abrams in association with the National Museum of American Art, 1995), 77-88. See also T. H. Breen, *Imagining the Past: East Hampton Histories* (Reading, Mass.: Addison-Wesley, 1989).

11. Brown 1995, 107-109.

12. William Dean Howells, *A Hazard of New Fortunes* (1890; New York: New American Library, 1965), 48, 56.

13. Kenneth T. Jackson, *Crabgrass Frontier: The Suburbanization of the United States* (New York: Oxford University Press, 1985), 45-115; Margaret Marsh, *Suburban Lives* (New Brunswick: Rutgers University Press, 1990), 68-74; L. H. Bailey, "What This Magazine Stands For," *Country Life in America* 1 (Nov. 1901): 24-25; C. W. Eliot, "The Need of Conserving the Beauty and Freedom of Nature in Modern Life" (1914), in Roderick Nash, ed., *The Call of the Wild (1900-1916)* (New York: Braziller, 1970), 46, 48. See also Peter J. Schmitt, *Back to Nature: The Arcadian Myth in Urban America* (1969; Baltimore: Johns Hopkins University Press, 1990).

14. William B. Rhoads believes the sketch was for an addition to Cedar Grove; Donelson Hoopes suggests, however, that Cole's sketch was for a new dwelling. See Rhoads, "The Artist's House and Studio in the Nineteenth-Century Hudson Valley and Catskills," in *Charmed Places: Hudson River Artists and their Houses, Studios, and Vistas*, ed. Sandra S. Phillips and Linda Weintraub, exh. cat. (New York: Edith C. Blum Art Institute, Bard College, and Vassar College Art Gallery in association with Harry N. Abrams, 1988), 79-80, 152 note 20.

15. Rhoads 1988, 77-96; Louis Legrand Noble, *The Life and Works of Thomas Cole*, ed. Elliot S. Vessel (1853; Cambridge, Mass.: Harvard University Press, 1964), 279; Champney 1885, 845-848.

16. Information on these buildings derives from a number of sources, including Gerdts 1989, 13-24; Helen A. Harrison, "East Hampton Artists, in Their Own Words," in *En Plein Air* 1989 (as in note 4), 49-55; May Brawley Hill, *Grandmother's Garden: The Old-Fashioned American Garden 1865-1915* (New York: Harry N. Abrams, 1995); H. S. Adams, "Lyme—A Country Life Community," *Country Life in America* 25 (Apr. 1914): 47-50, 92-94.

17. Lisa N. Peters, "Twachtman's Greenwich Paintings: Context and Chronology," in *John Twachtman: Connecticut Landscapes*, ed. Deborah Chotner, exh. cat. (Washington, D.C.: National Gallery of Art, 1989), 13-47; Alfred Henry Goodwin, "An Artist's Unspoiled Country Home," *Country Life in America* 8 (Oct. 1905): 625-630; Hill 1995, 205-209; on the development of a mythic California past and its relationship to the Mission revival, see Kevin Starr, *Inventing the Dream: California through the Progressive Era* (New York: Oxford University Press, 1985), 64-98, and David Gebhard, "The Spanish Colonial Revival in Southern California," *Journal of the Society of Architectural Historians* 26 (May 1967): 131-147. An exception to the historicism or stylistic conservatism of artists' homes in these communities was the Queen Anne residence of Thomas and Mary Nimmo Moran in East Hampton (fig. 55), which was erected in 1884. While Moran was a major artistic figure in East Hampton, and indeed lent prestige to its claims as an art colony, he did not work in the Impressionist idiom.

18. See David Park Curry, *Childe Hassam: An Island Garden Revisited*, exh. cat. (Denver: Denver Art Museum in association with W. W. Norton, 1990); Susan G. Larkin, "The Cos Cob Clapboard School," in *Connecticut and American Impressionism* (as in note 5), 82-99; Jeffrey W. Andersen, "The Art Colony at Old Lyme," in the same catalogue, 114-137; Steffens 1931, 2: 437.

19. Robert M. Toole, "The 'Prophetic Eye of Taste': Samuel F. B. Morse at Locust Grove," *Hudson Valley Regional Review* 12 (Mar. 1995): 1-48; Harvey and Lossing are quoted in Sandra S. Phillips, "Documents of the Personal Landscape," in *Charmed Places* 1988 (as in note 14), 60 and 69, respectively; Rhoads 1988, 79.

20. Hill 1995, *passim*; Charles Sprague Sargent, "Old-Fashioned Gardens," *Garden and Forest* 8 (17 July 1895): 281-282; Adams 1914, 47-50, 93-94.

21. On Downing, see David Schuyler, *Apostle of Taste: Andrew Jackson Downing, 1815-1852* (Baltimore: Johns Hopkins University Press, 1996); C. E. Beecher and H. B. Stowe, *The American Woman's Home; Or, Principles of Domestic Science* (New York: J. B. Ford & Co., 1869), 24; Frank J. Scott, *The Art of Beautifying Suburban Home Grounds* (New York: D. Appleton & Co., 1870), 29, and *passim*; F. L. Olmsted to

Edward Everett Hale, 21 Oct. 1869, E. E. Hale Papers, New York State Library, Albany, in David Schuyler and Jane Turner Censer, eds., *The Papers of Frederick Law Olmsted*, vol. 6, *The Years of Olmsted, Vaux & Company, 1865-1874* (Baltimore: Johns Hopkins University Press, 1992), 346-347.

22. A. Kolodny, *The Lay of the Land: Metaphor as Experience and History in American Life and Letters* (Chapel Hill: University of North Carolina Press, 1975); A. Kolodny, *The Land Before Her: Fantasy and Experience of the American Frontiers, 1630-1860* (Chapel Hill: University of North Carolina Press, 1984); E. A. Poe, *Collected Works of Edgar Allan Poe: Tales and Sketches, 1843-1849*, ed. Thomas Ollive Mabbott et al. (Cambridge, Mass.: Harvard University Press, 1978), 1267-1283, 1328-1340; Schuyler 1996, 100; Angela Miller, *The Empire of the Eye: Landscape Representation and American Cultural Politics, 1825-1875* (Ithaca, N. Y.: Cornell University Press, 1993), 248.

23. Hill 1995, *passim*; Lisa N. Peters, ed., *In the Sunlight: The Floral and Figurative Art of J. H. Twachtman* (New York: Spanierman Gallery, 1989). The emphasis on middle-class and suburban women is acknowledgment that among a number of immigrant groups, especially from southern and eastern Europe, the garden was a male prerogative.

24. See Thorstein Veblen, *The Theory of the Leisure Class: An Economic Study of Institutions* (1899; New York: New American Library, 1953), 41, and *passim*.

25. A plan of the grounds of the Florence Griswold house, with its outbuildings and extensive garden, is included in *Connecticut and American Impressionism* 1980 (as in note 5), 126; Peters 1989, 62-63.

26. Kenneth T. Jackson (1985, 58-59, 114-115, and *passim*) emphasizes the importance of physical and psychological distancing from the city.

27. Details of the subdivision of Norton's property can be found in Schuyler and Censer 1992, 257-261. For an astute discussion of the cultural uses of history in this period see Michael Kammen, *Mystic Chords of Memory: The Transformation of Tradition in American Culture* (New York: Alfred A. Knopf, 1991). The creation of a permanent cityscape and the beginnings of historic preservation in Boston is the subject of an important book by Michael Holleran, *Changeful Times*, to be published in 1997 by The Johns Hopkins University Press.

28. Brown 1995, 135-167.

29. Malcolm Cowley, *Exile's Return: A Literary Odyssey of the 1920s*, (1951; New York: Penguin Books, 1976), 210-214; Matthew Josephson, *Life Among the Surrealists: A Memoir* (New York: Holt, Rinehart & Winston, 1962), 300-304.

"For the Scent of Present Fragrance
and the Perfume of Olden Times":

THE DOMESTIC GARDEN IN AMERICAN IMPRESSIONIST PAINTING

America's centennial in 1876 stimulated a wide-spread interest in the country's past, including its early gardens. Many members of the educated middle class eagerly embraced all things colonial. Some were motivated by a new aesthetic appreciation for hand- rather than machine-produced objects. For others, a romanticized colonial past was an appealing refuge from the rampant industrialization all around them and from its accompanying labor unrest. Still others found in an affiliation with long-established families a moderation of the unease occasioned by waves of new immigrants and the burgeoning ranks of the new rich, threatening traditions and old values. It became an indication of breeding and background as well as good taste to value old houses, American antiques, and old-fashioned gardens. For many gardeners, as for novelist Anna Bartlett Warner, flower gardens of perennials, self-sown annuals, and native plants based on colonial prototypes offered both "the scent of present fragrance and the perfume of olden times."[1]

The nativist climate of the 1870s and 1880s that demanded American scenes from artists newly returned from European study had a parallel on the home grounds. An old-fashioned garden presented a patriotic alternative to popular carpet beds and ribbon borders, and the newly introduced, brilliantly colored foreign annuals which they required. Art critic Mariana van Rensselaer in her *Art Out-of-Doors: Hints on Good Taste in Gardening* (1893) deplored such "shrieking spots of color, set down here and there" seemingly at random in verdant lawns. She exclaimed, "We want American gardens, American landscapes, American parks and pleasure grounds, not the features of those of a dozen different countries huddled together...."[2] For van Rensselaer the old-fashioned garden, masses of flowers informally arranged in box-bordered beds close to the house, was always in good taste, and a patriotic alternative.

By the 1890s the home and garden had become the focus of attempts to preserve the virtues of what was seen as a simpler and more civilized America where family life was central, community stable, and the values of the early settlers unquestioned. As the home-oriented magazine *The Craftsman* put it, "in home life, in contact with nature and in constructive work, rather than in the mere acquisition of fortune, lie happiness and beauty....It is the real home that brings forth true citizens."[3] American Impressionist painters, establishing themselves and beginning families after study in France and elsewhere, were as susceptible as their less-well-traveled contemporaries to this focus on the home and an idealized colonial past. Both their home grounds and their paintings reflected a taste for intimate, domestic settings, and they settled and worked in locations where traces of earlier, typically American, ways of life, as well as old houses and gardens, still lingered.

John Howard Payne's song "Home Sweet Home," written in 1835, became a leitmotif of the nostalgic longing for a vanished America, and his eighteenth-century home in East Hampton, Long Island, a pilgrimage site (fig. 29). Members of the Tile Club, a convivial group of New York painters, included it in their itinerary of a 1878 sketching trip to investigate this picturesque offshoot of the Massachusetts Bay Colony. Thus began an influx of artists to Long Island that reached a peak in the 1890s.

Thomas Moran and his wife built a Queen Anne-style house at East Hampton in 1884 (fig. 57). Within a few years, as can be seen in Theodore Wores's painting (pl.18), it was enclosed in a garden bursting with old-fashioned blossoms and almost hidden by vines. Such enclosing verdure was considered "an appropriate decoration" by a writer in the influential weekly *Garden and Forest*: "by vine and herbage, flower and fruit, the dwelling is made to seem a growth rather than a construction...hardness of contrast is banished, and sharpness of outline toned into agreeable mystery, and true picturesque effect obtained."[4]

From 1891 to 1893, Lydia Emmet was a teacher at William Merritt Chase's newly opened school for plein air painting in nearby Southampton, the Shinnecock Hills Summer School of Art. Chase's gentlemanly demeanor and impeccable appearance made his classes a haven for genteel young women with serious talent but who could not abandon the constraints of their upbringing. His brilliant technique in portraiture, still-life, and out-of-door landscape painting, in which he was a gifted teacher, was an inspiration. The subject matter of his art held nothing objectionable; indeed, his paintings seemed to infuse glamour and beauty into the daily life of gently nurtured people such as themselves.

Emmet's *Grandmother's Garden* (pl. 6) evokes just such a moment of domestic felicity in the setting of the old-fashioned garden, an outdoor room enclosed in hedges with beds of phlox, delphinium, and other favorites, carefully trimmed box, and an arbor for vines. Such gardens visually established, as did the silver teapot and beautifully dressed figures in Emmet's painting, the atmosphere of cultivation, leisure, and decorum desirable in the home grounds. As Daisy Eyebright (Mrs. S. O. Johnson) proclaimed in her popular

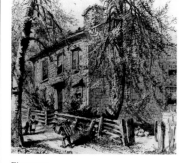

Figure 29.
"Home of John Howard Payne." Woodcut from *The Homes of America*, ed. Mrs. Martha J. Lamb (New York: Appleton and Co., 1879), 54. Courtesy, Library, Spanierman Gallery, New York.

Figure 30.
Kate Freeman Clark, *Idle Ease*, oil on canvas, 37 x 49 in. (94 x 124.5 cm), Kate Freeman Clark Art Gallery, Holly Springs, Mississippi.

Figure 31. (Following Page)
J. Appleton Brown, *Old Fashioned Garden*, before 1889, pastel on paper, 21 7/8 x 17 15/16 in. (55.5 x 45.5 cm), Bowdoin College Museum of Art, New Brunswick, Maine, Gift of Misses Harriet Sarah and Mary Sophia Walker.

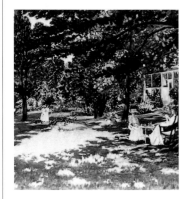

Every Woman Her Own Flower Gardener (1871, with seven editions by 1885), "A beautiful garden, tastefully laid out, and well kept, is a certain evidence of taste, refinement and culture."[5]

Kate Freeman Clark, an aspiring artist from Mississippi, studied with Irving Wiles, a former Chase student who in 1895 had begun a school at Peconic on Long Island's North Shore. Clark's Long Island paintings such as *Idle Ease* (fig. 30) and *Over the Garden Wall* (Kate Freeman Clark Art Museum, Holly Springs, Mississippi) show such flower-filled gardens being used as outdoor parlors, settings for tea parties and other social occasions.[6] (Wiles's own informal garden at Peconic, featuring rhododendrons and other shrubs, occasionally appears in his paintings.)

Gaines Ruger Donoho made East Hampton his permanent residence in 1891. Here, he immersed himself in the creation of a colonial-style home and splendid garden (pl. 23), where old-fashioned flowers such as hollyhocks and phlox shared box-bordered beds with modern Japanese iris and aratum lilies. Unlike the Long Island gardens of artists Alfred and Adele Herter, Louis Comfort Tiffany, or William de Leftwich Dodge, Donoho's looked to the American past for inspiration rather than to Europe. Critic Royal Cortissoz stressed the importance of Donoho's garden to his life and art on the occasion of his memorial exhibition in 1916: "He painted that garden over and over again in the same spirit in which he puttered over its flowers and hedges, loving it all and understanding it."[7]

In 1882, Childe Hassam's first one-man exhibition was of New England scenes, a focus he would maintain even after settling in New York City. When not in Europe, his summers were invariably spent in picturesque locales associated with America's early history where the ancient houses and unspoiled villages he loved could be found. In the 1890s he had spent many productive summers on Appledore, Isles of Shoals, New Hampshire, where he painted poet Celia Thaxter's old-fashioned cottage garden (figs. 10-12).

Appledore House, a hotel run by Thaxter's family, had drawn educated and cultivated vacationers since mid-century, many attracted by the charm and accomplishments of Thaxter herself. Thaxter had studied painting with Ross Turner and J. Appleton Brown during winters in Boston. In the summer months, beginning in the late 1860s, she gardened in the dooryard of her cottage on Appledore, her flowers arranged in plank-bordered beds enclosed with a fence. Thaxter took a deliberate stand against the facile use of English-influenced annual beds or rock gardens; her garden was a traditional American one. In her book *An Island Garden* (1894), she confessed, "I have not room to experiment with rockworks and ribbon-borders and the like, nor should I do it even if I had all the room in the world." She described it as "just a little old-fashioned garden," but its exuberant informality revealed a painterly organization of color and shape that inspired some of Hassam's loveliest watercolors, as well as paintings by Brown (fig. 31) and Turner.[8]

William H. Gerdts in *Down Garden Paths* (1983) has pointed out the preference of American Impressionist painters for such informal gardens as motifs and for a growing appreciation in the 1890s of gardening as an art in itself.[9] Van Rensselaer in *Art Out-of-Doors* had argued that gardening shared principles of "color, lights and darks, and light and shadow" with landscape painting. Horticulturist F. Schuyler Matthews had written, about the same time, that "the garden is a picture in itself," pointing out parallels with painting: "there is such a thing as arrangement which has in it no formal element....the objects which an artist paints in his picture are relatively arranged, but with a studied avoidance of formality." By 1907 landscape designer Beatrix Jones (Ferrand) could state with authority that "a garden large or small must be treated in the impressionist manner."[10] Thus it is hardly surprising that so many American artists in the 1880s and 1890s cultivated old-fashioned gardens; as well as being aesthetically satisfying to create, their masses of brilliant blooms, informally arranged, seemed designed for an Impressionist treatment.

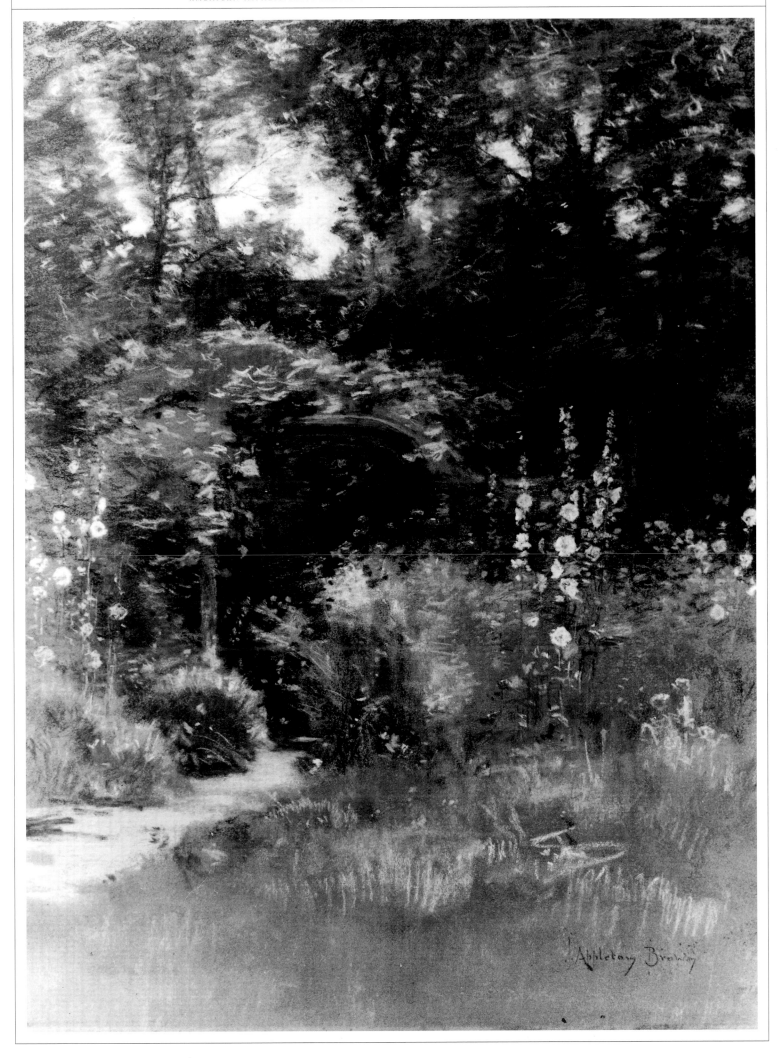

Figure 32.
J. Alden Weir's Garden, Branchville, Connecticut, with the artist's daughter, Dorothy, Private Collection. Photograph, courtesy Weir Farm Heritage Trust, Wilton, Connecticut.

Figure 33. (Following Page)
Willard Metcalf, *Purple, White, and Gold* (detail), oil on canvas, 26 x 18 in. (66 x 45.7 cm), Private Collection. Courtesy, Sotheby's, New York.

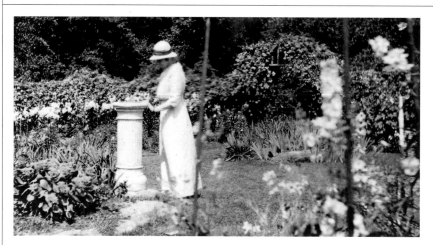

Childe Hassam's good friend J. Alden Weir had settled in 1882 in Branchville (Ridgefield), Connecticut, and another friend, John H. Twachtman, bought a house and seventeen acres in nearby Greenwich in 1890. Here both found the familiar, rural landscapes they sought for their paintings, and both had old-fashioned gardens that were extensions of their homes. The importance of an intimate connection of flower garden and house was stressed by every gardening writer at the time. For H. S. Adams, colonial American gardens had been an integral part of the home, and he felt that "the old colonial rule is the only one worth while…. Let the flower garden expand from the heart of the home outward; then you may be sure that you have made a right start."[11]

The axis of Twachtman's garden, a path from the door, lined with phlox passing beneath a rose arbor, appears in *On the Terrace* (pl. 5). Twachtman favored native plants such as asters, golden rod, and azaleas; his vegetable garden included turk's cap lilies and wildflowers among the cabbages. The use of native wildflowers in a cultivated garden was not at all the same as a wild garden, a very specialized woods or stream planting using indigenous and other hardy plants that would naturalize themselves without cultivation. This sort of gardening had been given currency by Englishman William Robinson in *The Wild Garden* (1870), although it had been practiced long before and was still being advocated in the 1920s by American writers.

The flower garden flanking Weir's studio was begun in 1886 by his wife Anna. Weir seldom painted it, but photographs show an enclosing fence entered through two rustic vine-covered arbors (fig. 32). Beds of peonies, phlox, iris and other old-fashioned flowers surrounded a central fountain circled with low box hedges. Box was a certain marker of the old-fashioned garden. As Elisabeth Woodbridge wrote in one of her popular essays on country living, "box implies…human life on a certain scale: leisurely, decorous, well-considered. It implies faith in an established order and an assured future."[12]

Hassam had first visited Ruger Donoho in East Hampton in 1898 and in 1919 bought from Donoho's widow an adjoining shingled cottage on Egypt Lane. Hassam felt at home with the village's Puritan past; as he stated in an interview for the *East Hampton Star*, "My ancestors were just like yours—New England farmers and sailors."[13] It is possibly Hassam's garden, that of "our most noted Impressionist painter," described in *The Colonial House* as "thoroughly New England…so entirely does the informal formality echo our early gardens."

IT IS A GARDEN DEARLY TO BE LOVED, STRAGGLING UP HILL BEHIND HIS COLONIAL NEW ENGLAND HOUSE, WITH HERE A PEACH ESPALIER ON THE STUDIO WALL RECALLING FRANCE; THERE A LEMON TREE (POTTED) WITH PONDEROUS LEMONS TOO—SLIGHTLY SHADED ON THE EDGE OF THE GRAPE ARBOR—SUGGESTING ITALY; AND HERE A STANDARD GOOSEBERRY, A MINIATURE TREE WITH OPALESCENT GREEN FRUITS…; FIG TREES IN BUCKETS…; A BED OF HYBRID TEA-ROSES…; AND AT THE TOP OF THE GARDEN, AN OLD APPLE TREE…PLATFORMED IN ITS BRANCHES, A SEAT SURVEYING THE CLIMBING GARDEN.[14]

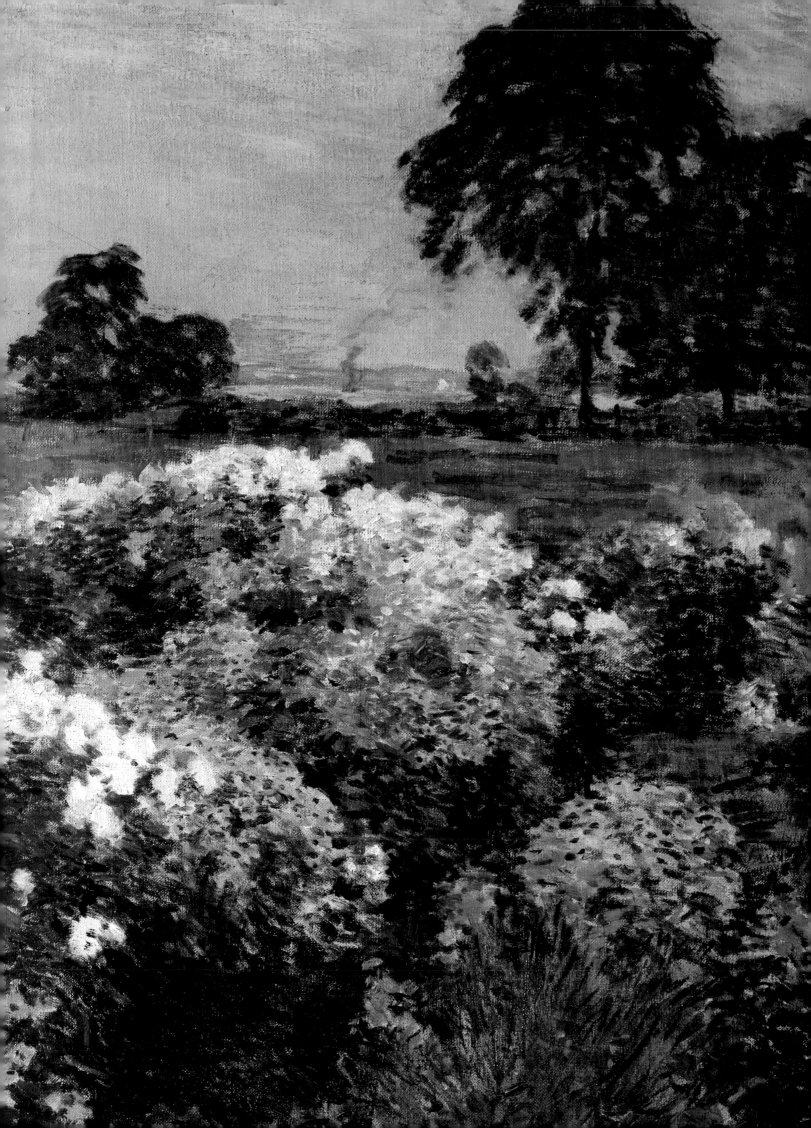

In 1903 Hassam had stayed at Florence Griswold's boarding house in Old Lyme, Connecticut, another colonial village at that time frequented by Barbizon-influenced artists. Hassam's arrival, and that of fellow Impressionists such as Willard Metcalf in 1905, signaled the colony's changed allegiance. The Griswold family had been among the first settlers of Old Lyme and Miss Florence's garden, seen in paintings by Edmund Greacen including *Florence Griswold's Garden, Old Lyme, Connecticut* (pl. 28), was as old-fashioned as was her colonial house.

Many of the artists who stayed with Miss Florence, and subsequently bought houses in the area, followed her lead in their gardens, as did William Chadwick, Clark Voorhees, and George Burr (pls. 4, 14, and 31 and figs. 26, 54, and 66). According to an article on "Lyme—A Country Life Community" published in the prestigious *Country Life in America*, Burr had "some of the best preserved box in all Lyme—one of the few notable remnants of old-time gardens." The profusion of flowers around Voorhees's gambrel roof cottage was considered, "just the sort of garden for the place" (pl. 14). The writer credited Miss Florence for her influence on many of the artists' gardens where she "endeavored to infuse the air of yesteryear through the medium of the good old-fashioned flowers."[15]

Metcalf's *Purple, White, and Gold* (fig. 33), perhaps painted in Voorhees's garden, was used as a color illustration for an article on "The Outdoor Painting of Flowers" in *Palette and Bench* (May 1909). Another illustration was Robert Vonnoh's *The Edge of the Garden* praised for its color, "a riot of nature's strongest pigments—purples, blues, violets vie with vermillion, crimson, golden yellow and many shades of pearly white."[16] Brilliance of hue was accepted by nearly everyone in the context of the old-fashioned American garden, if not in landscape painting. Even Hamlin Garland, an early supporter of the American Impressionists, retained a fondness for "the naturalistic art of those who granted the blue shadows and went calmly on completing a noble transcript of New England's hills, orchards and streams."[17] Gardens thus made compelling motifs for painters seeking a distinctive American subject yet with the spontaneity and light of French Impressionism.

Painters from the Boston area, Metcalf, Theodore Wendel, John Leslie Breck, and Louis Ritter, were the first among American artists in France to have direct contact with Monet, arriving in Giverny in the summer of 1887. Wendel returned to Boston early in 1889. Breck's paintings preceded him, being shown in Lilla Cabot Perry's Boston studio that fall. Breck had painted both in Monet's splendid cottage garden and in Perry's more modest one next door. In 1890 his first one-man show included *M. Monet's Garden* and three paintings titled *In a Garden*. The *A Bit of Detail: Rock Garden at Giverny* and two titled *Garden* (location unknown) shown at the Chase Gallery in 1893 after his return, may have been painted in the gardens of his friends Ross Turner and Dwight Blaney (fig. 34).[18]

In 1885 Ross Turner had married Louise Blaney, older sister of Dwight Blaney and moved to Salem, Massachusetts, a colonial town within commuting distance of Boston. His informal garden there, and those of friends, were the subjects of many watercolors where brushstrokes of brilliant hues suggest rather than delineate a tangle of bloom, although individual flowers are identifiable. In *A Garden is a Sea of Flowers* (fig. 35) for example, a tapestry of hollyhocks is set against trees and sky, with a stately mullein, perhaps self-seeded rather than deliberately planted, occupying the left foreground.

Dwight Blaney had married the heiress Edith Hill in 1893. He became an avid collector of American antiques which filled his Boston and Salem (and later Weston, Massachusetts) houses and spilled over into a cottage on Ironbound Island, Maine. Paintings of his gardens include *Hollyhocks* 1890, *Our Garden, Salem* 1893, *The White Poppy* 1896 (all locations unknown) and a painting of his wife and a friend with hollyhocks beside the Maine cottage.[19] Breck visited in 1896 when he painted the exuberant *Garden, Ironbound Island, Maine* (Collection of the Estate of Daniel J. Terra). Such gardens and their landscape settings could be painted in the pure colors and full sunlight that both Breck and Blaney sought, while still preserving

tangible form. The flowers in Breck's painting are not just dashes of color; they are identifiable as holly-hocks, larkspur, and poppies, markers of the old-fashioned garden.

Philip Leslie Hale, son of eminent Boston clergyman Edward Everett Hale, had studied in France and visited Giverny in 1888. He married painter Lilian Westcott, and took her to France in 1904, writing his father that at Giverny they had gone to "pay our respects to M. Monet."[20] Five years later when the Hales bought an old house in Dedham, Massachusetts, and began their own garden, they may have had Monet's exuberant cottage garden in mind.

Closer at hand, the popularity of the old-fashioned American garden and the parallel growth of the country-life movement had a demonstrable effect. Hale wrote to his father in April 1909, "Lily and I are getting so much pleasure out of that book you sent us about a small country house. Lily inspired, I suppose by that, has filled various boxes with loam and sand and is growing all sorts of things from marigolds to lettuce...." Lilian herself wrote the same month, "marigolds, stock, nasturtiums, cone flowers, hop vines, lettuce, egg plant, squashes are up...we *hope* to have something besides weeds to adorn our garden this year."[21]

The gift may have been a book such as J. P. Mowbray's *Making of a Country Home* (1901) where he pointed out that "to enjoy the unquestioned privilege of easy and uninterrupted railroad facilities, genteel neighbors, macadamized roads, picturesque surroundings, and above all, VIEW, was to become a suburban-ite." He wrote that in such locales it was still possible to find "unmistakable country houses, half hidden by old trees and wearing heavy veils of Virginia creeper and wild trumpet-honeysuckle. Nearly always they were enclosed by old gardens in which phlox and lady's slippers and tansy were conspicuously mixed."[22]

The Hales' home grounds appear in both artists' works (pl. 3). Lilian's fine-grained studies of figures in antique-filled interiors offered within an aestheticized New England past, a visual refuge from the indus-trial present. Lilian's studio was in the house itself; Philip's was within commuting distance. As their daughter wrote, "The only thing that kept my father home from his Boston studio in the daytime was to be at work on a painting of the white hollyhocks in our garden, or of a model in a veiled hat standing beside his favorite white standard rose tree."[23]

Among the garden paintings included in Philip Hale's 1931 memorial exhibition were *Our House*, *Lemon Hollyhocks*, *Flowers in Moonlight*, *Pink Dogwood* (all locations unknown) and the spectacular *Crimson Rambler* (pl. 3). A 1902 article on "The Making of A Country Home" had suggested just such "a crimson rambler to run up over your veranda" and urged gardeners to "try to create a picture...framing the whole by a well-massed border plantation."[24]

The Hales moved in 1912 to "Sandy Down," a 1727 farmhouse also in Dedham. A description of Lilian's garden there makes a telling parallel between its enclosure and exclusion of disturbing elements and that in her painting.

THERE ARE OLD TREES, UNTRIMMED BUSHES, TALL SCRAGGY PLANTS CONCEALING PATHS THAT WIND AND TWIST. THERE IS AN OLD GOD-TERMINUS IN ONE SHADED NOOK; THERE'S A SUN DIAL MARKING THE "HAPPY HOURS," AND ALL AROUND THE HALLOWED SPOT, AN OLD, OLD CHAIN, FESTOONED WITH LAVENDER WISTERIA AND PINK ROSES, SHUTS IN THE GLORY OF THE GARDEN, AND SHUTS OUT ONLY THAT WHICH IS LESS BEAUTIFUL. NO WONDER THAT THE CANVASES WHICH COME FROM HER STUDIO ARE CALM, RESTRAINED, BREATHE LOVELINESS, AND CARRY PEACE.[25]

Dennis Miller Bunker, born in New York, came to Boston in 1885 after academic study in France. His conversion to Impressionism seems to have occurred during the summer of 1888, which he spent with John Singer Sargent at Calcot Mill, near London. Just after his return, the spectacular display of chrysanthemums in Isabella Stewart Gardner's greenhouse provided a motif for his use of brilliant, unblended color in strokes that suggest rather than model leaf and blossom (fig. 36).

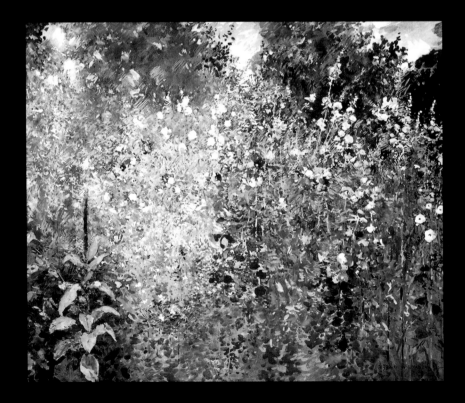

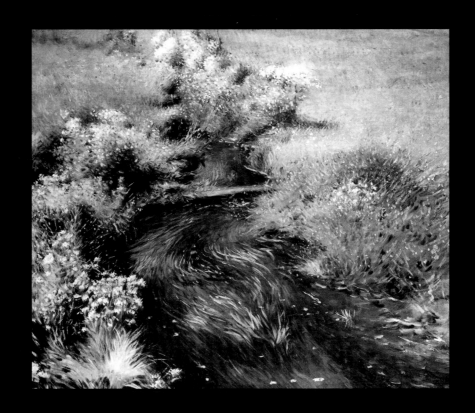

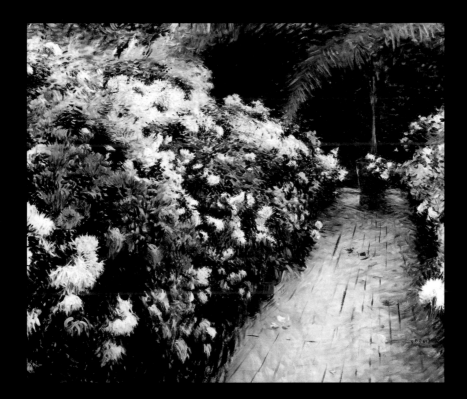

Figure 34. (Preceding Pages, Top Left) John Leslie Breck, *A Bit of Detail: Rock Garden at Giverny*, c. 1894, oil on canvas, 18 1/4 x 22 1/8 in. (46.4 x 56.2 cm), Terra Foundation for the Arts, Daniel J. Terra Collection. 1992.16

Figure 35. (Preceding Pages, Bottom Left) Ross Sterling Turner, *A Garden is a Sea of Flowers* (detail), 1912, watercolor on illustration board, 20 3/4 x 30 5/8 in. (52.7 x 77.8 cm). Courtesy, Museum of Fine Arts, Boston, Gift of the Estate of Nellie P. Carter, 1935.

Figure 36. (Preceding Page, Top) Dennis Miller Bunker, *Chrysanthemums*, 1888, oil on canvas, 35 1/2 x 48 in. (90.2 x 121.9 cm), Isabella Stewart Gardner Museum, Boston.

Figure 37. (Preceding Page, Bottom) Dennis Miller Bunker, *Wild Asters* (detail), 1889, oil on canvas, 25 x 30 in. (63.5 x 76.2 cm), Private Collection.

During the next summer spent at Medfield, Massachusetts, he applied his new Impressionist style to a painting of a garden there, as well as to depictions of the intimate and approachable landscape of hills and meadows. *An Old Garden* (location unknown) and *Wild Asters* (fig. 37) appeared at the Society of American Artists the next spring, and a watercolor *Aster Garden* (location unknown) at the Boston Water-Color Society. Judging from a description of *Aster Garden* in a review of the exhibition, the garden was an informal, old-fashioned one: "this huddled garden corner where great masses of China Asters (painted…for color effect only) grow beneath a hedge of Sweet Peas, with Coreopsis starring the tall grass in front of them, and what seems to be an orchard stretching its shadowy breadth in the background."[26]

The following summer Bunker was invited to Cornish, New Hampshire, to visit his friends Charles Adams Platt and Thomas Wilmer Dewing. He found the landscape there overwhelming and wrote, "I don't like it here at all—and I feel—I think for the first time in my life that I can remember—genuinely homesick.…It is a country of great big hills and mountains and ravines perfectly impossible to paint." Cornish was not yet well known, although the Dewings had summered there since 1886. Platt was busy planning his own house and garden, and the Dewings were hard at work on theirs. Bunker found such domesticity a bit of a strain and complained, "they bore me to death with their houses and their plans and their poor little flower beds." Bunker may not have been comfortable with the sort of self-conscious home-making going on in Cornish (the formidable Mrs. Dewing was the author of *From Attic to Cellar: A Book for Young Housekeepers* as well as books on dress and home decoration), but the intimate association with place was as important to him as it was to his fellow Impressionists. He spent the rest of the summer at Medfield where he felt completely at home and wrote happily to Mrs. Gardner, "I know every bush and bird and bull-frog in the place, and they are all very friendly."[27]

The Cornish colony, a cosmopolitan one, including wealthy amateurs among the established writers, sculptors, and painters, was never identified with Impressionism as was Old Lyme. The spectacular site recalled the hills of Tuscany to the well-traveled residents there and suggested garden designs owing as much to Italian gardens as to colonial ones. Exclusivity could be achieved by extreme aestheticism as well as through association with things colonial, and in Cornish the two went hand-in-hand. The aesthetic refinement of Thomas Dewing's paintings of attenuated New England women in classicized colonial dress probably had a counterpart in his garden design where the colonial was treated as an indigenous variant of the classical. As Neltje Blanchan (Mrs. Nelson Doubleday) wrote in her influential *The American Flower Garden* (1909), "our 'colonial' architecture, adapted after Palladio, and 'colonial' gardening were twin children of the Renaissance."[28]

The Dewings' garden had been created expressly for Maria Oakey Dewing, a plein air painter of flowers (fig. 38). Their experiments to find plants that would be reliably hardy enough for New Hampshire's climate of extremes resulted in a reliance on old-fashioned flowers. Favorite combinations can be seen in her paintings: shrub roses underplanted with dianthus and bordered box, morning glories climbing through Souvenir de Malmaison roses, and Shirley poppies with white mignonette.

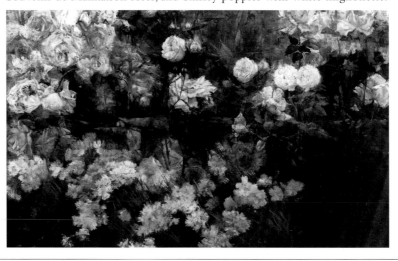

Figure 38.
Maria Oakey Dewing, *Garden in May*, 1895, oil on canvas, 23 5/8 x 32 1/2 in. (59.9 x 82.5 cm), National Museum of American Art, Smithsonian Institution, Washington, D.C., Gift of John Gellatly.

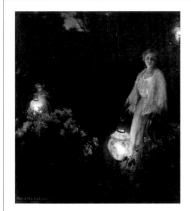

Two Boston Impressionists, Frank Benson and Edmund Tarbell, irrevocably linked in friendship and teaching, although their careers moved in very different directions, both summered on the New Hampshire coast. In New Hampshire and much of New England, with industrialization and the movement of rural workers to cities, farms were being abandoned. While this provided an opportunity for those in the affluent middle class to acquire a summer home, it was disquieting to many. J. B. Harrison in an article on "The Abandoned Farms of New Hampshire," lamented that "the truth is that the old New England civilization and organization of society has here mostly come to an end."[29]

Those who bought the farms emphasized ornament over agriculture. Lecturer Kate Sanborn in her amusing account of remodeling a farm in Massachusetts, *Adopting an Abandoned Farm* (1891), revealed that "the house and barn were painted…an ornamental piazza was added, all the paths were broadened and graveled." The house and garden were designed primarily for domestic pleasure and the entertainment of guests.

THE PIAZZA WAS GAY WITH HANGING BASKETS, VINES,…LANTERNS OF ALL HUES; THERE WERE TABLES, LITTLE AND BIG, AND LOUNGING CHAIRS AND A HAMMOCK…SEVERAL LONG FLOWER BEDS WERE ONE BRILLIANT MASS OF BLOOM, WHILE GIANT SUN-FLOWERS REARED THEIR GOLDEN HEADS THE ENTIRE LENGTH OF THE FARM.[30]

Edmund Tarbell bought a house in Newcastle, New Hampshire, in 1904 and moved there permanently in 1930. Frank Benson, who summered there until 1900, in 1902 rented Wooster farm on North Haven Island, Maine, to which he returned with his family each summer (pl. 1). For both artists, their summer homes were refuges away from the rigors of the city and a locus for the leisurely family life that appears in many of their paintings.

After getting his studio in order, Benson's first improvement at Wooster farm was the construction of a roofless piazza across the front of the house furnished with a green-painted bench built by himself (fig. 45). The piazza was designed as an outdoor parlor—the family gathered there for afternoon tea and tennis watching—but also as a studio; many of Benson's paintings of family members out of doors were done there. For critic William Howe Downes, such paintings were "visions of the free life in the open air with figures of gracious women and lovely children, in a landscape drenched in sweet sunlight….It is a holiday world in which nothing ugly or harsh enters."[31]

Figure 39.
Charles Courtney Curran, *The Lanterns*, oil on canvas, 30 1/4 x 30 1/4 in. (76.8 x 76.8 cm). Courtesy, Berry-Hill Galleries, New York.

Figure 40.
Helen Turner, *Morning*, 1919, oil on canvas, 34 1/2 x 44 1/2 in. (87.6 x 44.5 cm), Zigler Museum, Jennings, Louisiana.

An extensive perennial garden begun by Benson's wife Ellen, was visible from the piazza and the front windows of the house, where, her granddaughter recalled, "Great drifts of colors blended and complemented each other beautifully."[32] Benson had painted the garden at his family home in Boston in 1892 (location unknown). The picture was shown at the Pennsylvania Academy where it was noticed by a writer on Impressionism: "The complete surrender to the new view is apparent in *In an Old Garden*." Benson's conversion to high key, outdoor painting is not thought to have occurred until six years later, but perhaps a colorful, old-fashioned garden provided Benson, as it did other American painters, permission for an Impressionist treatment.

The aesthetic appeal of these old-fashioned perennial gardens, their range of color, variations in silhouette and mass, and abundance of bloom made them compelling motifs even for those not completely won over by Impressionism. Abbot Fuller Graves had been a painter of floral still-lifes in Boston until, in 1895, he bought an eighteenth-century house in Kennebunkport, Maine, where he was to live full time. The architecture and inhabitants of the old town formed the subject matter of his paintings—at first genre scenes of local gathering places, then views of colonial houses and old-fashioned gardens. Graves became identified with paintings of Georgian doorways wreathed in vines and more modest cottages with dooryard gardens (pl. 7). His sun-filled *Near Kennebunkport* (pl. 19), for example, captures the brilliance of color and luxuriance of texture that made these gardens so appealing to American painters, Impressionist or not.

Charles Courtney Curran, though not an impressionist, made a specialty of plein air paintings of young women in gardens. He wrote of such a painting in *Palette and Bench*: "The girl was meant to be as much as possible a flower herself, in the style of her dress, in the lighting of her face and neck, the way the figure loses herself among the flowers."[33] Curran's garden of wildflowers and old-fashioned favorite varieties in the artists' colony at Craagsmoor, New York, was the setting for many of his figure paintings. It was also the location of frequent outdoor entertaining; his *The Lanterns* (fig. 39) shows the garden being illuminated for an evening party.

Helen Turner, another specialist in paintings of women in gardens, arrived at Cragsmoor in 1906. Infected by the Cragsmoor horticultural enthusiasm, she created a charming garden that climbed in three rock-bordered terraces beyond the porch of her cottage. She filled these beds with masses of peonies, delphinium, phlox, and foxgloves which form a brilliant blur in the background of the many paintings, such as *Morning* (fig. 40), done on her porch.

Such informal gardens seemed to be especially popular in turn-of-the-century crafts communities such as Byrdcliffe in Woodstock, New York, or Elbert Hubbard's Roycroft in East Aurora, New York. Minneapolis landscape painter Alexis J. Fournier was attracted to Roycroft in 1903, where he painted murals for the Roycroft Inn. His picturesque cottage there was assembled from a chicken coop and blacksmith shop with an apple tree growing through the roof. This cottage (not a bungalow, but a "Bungle House") and its garden which combined flowers with vegetables can be seen in his *Hollyhocks in the Garden, The Bungle House* (fig. 41).

Hugh Henry Breckenridge and Daniel Putnam Brinley, two painters in the second generation of American Impressionists, supported modernist art while remaining relatively conservative in style, and both painted their own old-fashioned gardens. Brinley, a friend and associate of Alfred Steiglitz and Robert Henri, was among the organizers of the Armory Show of 1913. Two of his garden paintings, *An Old Garden* (location unknown) and *The Peony Garden* (pl. 24), were included in this groundbreaking exhibition. Brinley summered in Silvermine, Connecticut, where he painted the informal gardens there as dense tapestries of colored brushstrokes, although never abandoning the reality of the image. A reviewer for the *Brooklyn Eagle*, quite happy to find Brinley's paintings in Stieglitz's gallery included among ones strongly affected by European modernism, wrote, "his interpretation of nature is saner and clearer in its message."[34]

Hugh Breckenridge, together with Thomas Anshutz, a teaching associate at the Pennsylvania Academy, opened in 1902 a summer painting school in Fort Washington, near Valley Forge, Pennsylvania. Here Anschutz had a studio that, according to a visitor, looked out on an "old-fashioned flower growing garden, which antedates Revolutionary days."[35] Breckenridge's home, "Phloxdale," named after the flower that appears in so many paintings, boasted an equally noteworthy garden surrounding the house (pl. 30).

Figure 41. (Preceding Page)
Alexis Jean Fournier, *Hollyhocks in the Garden, The Bungle House*, after 1903, oil on canvas, 26 1/8 x 40 1/8 in. (66.3 x 101.9 cm), Private Collection. Photograph, courtesy May Brawley Hill.

Figure 42.
Benjamin C. Brown, *The Joyous Garden*, c. 1900, oil on canvas, 30 1/2 x 40 in. (76.2 x 101.6 cm), The Irvine Museum, Irvine, California.

Painters characterized as regionalists, no less so than those with modernist sympathies, sought familiar rural locations for landscape painting and often cultivated and painted their own informal gardens. A group of second generation Impressionists settled around New Hope, Pennsylvania, among them Daniel Garber, who had studied with Anshutz and Breckenridge. The Garbers in 1907 bought a complex of buildings, including an old house, mill, and barn near Lumberville where they lived year round after their children were grown. Garber's barn studio, remodeled using material from the old mill, became the center of life at "Cuttalossa," as well as the setting for many paintings (fig. 61 and pl. 27). Its large north windows overlooked the flower garden which Garber painted as though filled with blinding sunlight.

As did other artists at the time, Garber saw his home and garden as aesthetic creations equivalent to his paintings. As he explained to a cousin in 1929: "To know me now you would have to know the place. Everyone knows it's half of *me*."[36] For many American painters, as for supporters of the Arts and Crafts movement, a beautiful home and garden were morally, as well as aesthetically, satisfying. A writer in the *Artsman*, the official journal of the cooperative Rose Valley crafts community near Philadelphia, could state categorically, "Inartistic homes ruin our manners and morals and wreck our nervous systems."[37]

Theodore C. Steele, the leader of the Hoosier Group of painters, was an early convert to Impressionism who settled in Indianapolis, Indiana, in 1885. There he painted his vine-covered house and cottage garden and that of his summer home "The Hermitage." Following his remarriage in 1907, Steele made a new studio home in rural Brown County. At the "House of the Singing Winds," his wife Selma created an informal garden that featured native plants and old-fashioned flowers and was, as she put it, "interesting enough to be placed on the painter's canvas."[38] Selma Steele's garden was as much a deliberately American and regional creation as were the paintings of the Hoosier Group. William Forsyth, a member of the group, described their aims in 1894 on the occasion of the group's first exhibition in 1894: "To paint their pictures here at home, to express themselves each in his own way and yet hold closely to that local truth characteristic of our particular spot of earth and interpret it in all the varying moods that are its charm."[39]

The Colonial Revival that in the East and Midwest encouraged old-fashioned gardens based on New England models in California spurred an interest in the state's Spanish colonial past. While some gardens followed the New England prototype of perennial beds bordered with box, others incorporated a patio garden enclosed by the traditional adobe house. Pasadena painter Benjamin Brown recorded one garden with box hedges and masses of pink and white phlox, while his own garden studio was vine-covered and entered through a rose arbor (fig. 42). By contrast, Theodore Wores's home in Saratoga, California, remodeled from an adobe church, had a patio garden filled with exotic flowers and was backed with an imposing pergola (pl.11).

Gustave Stickley, doyen of the American Arts and Crafts movement, visited California in 1904 and was impressed by the simple vernacular architecture and the outdoor life possible there. Articles on California and bungalow life came to dominate his *The Craftsman* magazine, extolling a place where "the house, the garden, the terrace, the patio, the open porch are all one domain, one shelter from the outside world."[40] In their homes and gardens, whether colonial-style New England ones or bungalows, American Impressionist painters, together with large numbers of the middle class, found a retreat from disturbing elements of modern life. Here, they were able to create and paint their own visions of a distinctive American environment and way of life that was as appealing to their contemporaries as it is to us today.

Aesthetic choices are now read as political ones by most historians of American Impressionist painting—motives are questioned, hidden agendas sought. We cannot, therefore, comfortably view these seductive visions of family, home and garden solely as transcriptions of experienced reality, however beautifully painted; nor, it should be pointed out, were they always viewed as such at the time. Particularly disturbing to a feminist reading then as now, is the isolation and objectification of women within domestic confines, this at a time when women had at last been granted access to higher education and were beginning to enter the job market in significant numbers.[41] It is perhaps pertinent to ask what it suggests about our own time and our current fixation on home and family that these paintings of idealized and sanitized domestic life presided over by passive, if beautiful, women are again so popular, as is once again the old-fashioned perennial garden.

May Brawley Hill

NOTES:

1. Anna Bartlett Warner, *Gardening by Myself* (New York: Anson D.F. Randolph, 1872), 19.

2. Mariana van Rensselaer, *Art Out-of-Doors: Hints on Good Taste in Gardening* (New York: Charles Scribner's Sons, 1893), 58. Lizzie Champney had written in "Summer Haunts," *Century* 30 (September 1885): 845, "The demand made by the public and the critics that the work of American artists should be American in subject at least, is largely conceded."

3. "A Country Home for the Businessman," *The Craftsman* 9 (October 1910): 66-67.

4. *Garden and Forest* 5 (20 January 1892): 26.

5. Daisy Eyebright (Mrs. S. O. Johnson), *Every Woman Her Own Flower Gardener* (New York: Ladies' Floral Cabinet, 1885), 5.

6. See Cynthia Grant Tucker, *Kate Freeman Clark: A Painter Rediscovered*, exh. cat. (Jackson: University Press of Mississippi, 1981).

7. Royal Cortissoz, "Ruger Donoho," *Tribune* (16 November 1916). Archives of American Art, Smithsonian Institution, Washington, D.C., Macbeth Gallery Collection, roll 2, frame 354. See also Henry A. Saylor, "The Country Home of Mr. Louis C. Tiffany," *Country Life in America* 15 (December 1908): 157-162, and Amy L. Barrington, "A Fielde of Delite, the Country Home of Two Well-Known Artists—Mr. and Mrs. Albert Herter," *The House Beautiful* 45 (April 1919): 189-191, 241.

8. Celia Thaxter, *An Island Garden* (Boston: Houghton Mifflin, 1894), 71. Brown painted Thaxter's garden as early as 1880 in a watercolor now in the Currier Gallery, Manchester, New Hampshire.

9. William H. Gerdts, *Down Garden Paths: The Floral Environment in American Art*, exh. cat. (Rutherford, N.J.: Fairleigh Dickinson University Press [for the Montclair Art Museum, Montclair, N.J.], 1983).

10. Van Rensselaer 1893, 58. F. Schuyler Matthews, "Garden Flowers and Their Arrangement," *Garden and Forest* 7 (27 June 1894): 252. Beatrix Jones, "The Garden as a Picture," *Scribner's Magazine* 42 (July 1907): 6.

11. H. S. Adams, *Flower Gardening* (New York: McBride, Nast & Company, 1913), 2.

12. Collected as Elisabeth Woodbridge, *The Jonathan Papers* (New York: Houghton, Mifflin Co., 1912), 109.

13. Childe Hassam, quoted in Helen A. Harrison, "East Hampton Artists, in Their Own Words," in *En Plein Air* (East Hampton: Guild Hall Museum, 1989), 53.

14. Joseph Everett Chandler, *The Colonial House* (New York: Robert M. McBride & Company, 1924), 202.

15. H.S. Adams, "Lyme—A Country Life Community," *Country Life in America* 26 (April 1914): 92, 94.

16. *Palette and Bench* 15 (May 1909): 217, illustration on page 216.

17. Hamlin Garland, "The Outdoor Painting of Flowers," *Roadside Meetings* (New York: MacMillan, 1930), 32.

18. See Kathryn Corbin, "John Leslie Breck, American Impressionist," *Antiques* (November 1988): 1142-1149.

19. Illustrated in *The Memoirs of Elizabeth Hill Cram* (Boston: private printing, 1992), 12.

20. 5 September 1904, Hale Family Papers, The Sophia Smith Collection, Smith College, Northampton, Massachusetts.

21. Hale Family Papers, April 1909.

22. J. P. Mowbray, *Making of a Country Home* (New York: Doubleday, Page and Co., 1901), 42, 49.

23. Nancy Hale, *The Life in the Studio* (New York: Avon Books, 1957), 198.

24. "The Making of a Country Home," *Country Life in America* 2 (June 1902): 45.

25. Rose V. S. Berry, "Lilian Westcott Hale—Her Art," *The American Magazine of Art* 18 (February 1927): 64.

26. "Flowers at the Water-Color Exhibition," *Garden and Forest* 3 (19 February 1890): 95.

27. Bunker to Eleanor Hardy, June 1890, quoted in Erica E. Hirshler, "The Metamorphosis of Dennis Miller Bunker," in *Dennis Miller Bunker: American Impressionist*, exh. cat. (Boston: Museum of Fine Arts, 1994), 77. Bunker to Isabella Stewart Gardner, 1890 quoted in David Park Curry, "Reconstructing Bunker," in Hirshler 1994, 98.

28. Neltje Blanchan, *The American Flower Garden* (New York: Doubleday, 1909), 41.

29. J. B. Harrison, "The Abandoned Farms of New Hampshire," *Garden and Forest* 10 (27 November 1889): 573.

30. Kate Sanborn, *Adopting an Abandoned Farm* (New York: D. Appleton & Co., 1891): 130, 138. The sequel was *Abandoning an Adopted Farm* (New York: D. Appleton & Co., 1894).

31. Faith Andrews Bedford "Frank W. Benson: A Biography," in *Frank W. Benson: A Retrospective* (New York: Berry-Hill Galleries, 1989), 61.

32. Bedford 1989, 37, 100.

33. Charles Courtney Curran, "A Class in Oil Painting," *Palette and Bench* 14 (December 1908): 52.

34. Quoted in Margaret Burke Clunie, *Daniel Putnam Brinley: The Impressionist Years,* exh. cat. (Brunswick, Maine: Bowdoin College Museum of Art, 1978).

35. Horace T. Carpenter, "An Art School at Valley Forge, Pennsylvania," *New York Herald* (3 September 1905): 8.

36. Kathleen A. Foster, *Daniel Garber 1880-1958*, exh. cat. (Philadelphia: Pennsylvania Academy of the Fine Arts, 1980), 24. As Foster states, Garber "had come to see his home and studio as complex statements of artistic identity."

37. "Ugly Homes and Bad Morals," *Artsman* 3 (December 1905): 73.

38. Selma Steele, Theodore L. Steele, and Wilbur D. Peat, *House of the Singing Winds: the Life and Work of T.C. Steele* (Indianapolis: Indianapolis Historical Society, 1966), 125.

39. William Forsyth, *Art in Indiana* (Indianapolis: H. Lieber Co., 1916), 16.

40. "The California Bungalow," *The Craftsman* 13 (October 1907): 68.

41. One thinks of Charlotte Perkins Gilman's *The Yellow Wallpaper*, the harrowing account of a young woman's mental collapse as a result of domestic confinement within a "colonial mansion" surrounded by a garden with "mysterious deepshaded arbors,...riotous old-fashioned flowers, and bushes and gnarly trees," in *The Yellow Wallpaper and Other Writings* (New York: Bantam Books, 1989), 5.

INTRODUCTION TO THE CATALOGUE:

PAINTINGS IN THE CATALOGUE ARE ORGANIZED ACCORDING TO THE PERSPECTIVES THEY PRESENT, RATHER THAN BY ARTIST OR CHRONOLOGY. THE FIRST IMAGES SHOW HOMES FROM CLOSE-UP VANTAGE POINTS, FEATURING PORCHES AND BACKYARDS. THE LATTER ONES DEPICT THE HOME FROM INCREASINGLY MORE DISTANT ANGLES. REFLECTING THE THEME OF THE EXHIBITION, THE ENTRIES FOCUS ON THE HOME AND GARDEN IN NINETEENTH- AND EARLY TWENTIETH-CENTURY AMERICA. BIOGRAPHICAL DETAIL AND SPECIFICS OF ARTISTS' TECHNIQUES ARE THUS INTRODUCED ONLY AS THEY ILLUMINATE ISSUES RELATED TO THAT THEME. CATALOGUE CONTRIBUTORS ARE IDENTIFIED AS FOLLOWS: JB JACK BECKER; CL CAROL LOWREY; LNP LISA N. PETERS

I

FRANK W. BENSON

(1862-1951, Salem, Massachusetts)

Afternoon in September, 1913
Oil on canvas
25 1/4 x 30 1/4 in. (64.1 x 76.8 cm)
History Collections,
Los Angeles County Museum
of Natural History

Frank Benson established his reputation in Boston during the 1890s for dark-toned portraits that reflected the impact of the training he had received in Paris during the previous decade.[1] At the turn of the century, he adopted a new style. While spending summers on Maine's North Haven Island from 1900 to 1920, he portrayed his wife (Eleanor) and children (George, Eleanor, Sylvia, and Elisabeth) in bright outdoor settings, creating vivid sun-filled canvases in which he explored Impressionism and conveyed the warm feeling of summer leisure that epitomized his family's long vacations at the coast. Indeed, although Benson was busy painting in an old barn converted to a studio, his family's summers in Maine were times of pleasure and recreation. Within range of their home, the Bensons engaged in tennis, croquet, horseshoe pitching, and golf on a "golf course" constructed by the artist and his wife.[2]

On North Haven, the Benson family resided in a square, gambrel-roofed Colonial-era dwelling that overlooked the waterway between North Haven and Vinalhaven Islands (fig. 43). Like many other artists of his era, Benson found satisfaction in his immediate surroundings. Critic Charles Caffin observed in 1909: "This spot of nature, in fact, has been so congenial to Benson that he has never felt the desire or need to revisit the associations of the Old World, in which he spent his student days. He is happy in having found a perennial source of inspiration close at home."[3]

Although Benson did not show his family actively engaged in sports, he conveyed the holiday spirit that prevailed during his summers in North Haven. He portrayed his subjects in immaculate white attire standing alone or in groups on hillsides above the sea or on the back porch, where Benson had installed a large bench that beckoned the family into the outdoors and encouraged them to make nature part of their domestic living space.

By building a porch on his North Haven home, Benson followed a recommendation made frequently during his era in books and magazines that dealt with the home. For example, Mary Northend advised the building of just such a porch, which she called a necessary addition to old dwellings. She explained in *Remodeled Farmhouses* (1915): "In the early days, the porch or veranda did not exist; it may be supposed that our pioneer ancestors were too busy to enjoy any leisurely hours out of doors; at least, they made no provision in connection with their houses for such relaxation." Northend went on to state:

MODERN COUNTRY LIFE DEMANDS PLENTY OF VERANDA ROOM AND, WHENEVER POSSIBLE, SLEEPING-PORCHES. ONE DOES NOT GO TO THE COUNTRY TO SIT INDOORS, EVEN IF THE WINDOWS ARE ALL THROWN OPEN. THERE IS NOTHING THAT WILL SO MATERIALLY IMPROVE THE HEALTH AS OUTDOOR LIFE; TIRED AND JADED NERVES ARE SOON RESTORED BY USE OF A SLEEPING-PORCH, WHERE THE FRESH AIR CAN SOOTHE AND INDUCE RESTFUL SLUMBER.[4]

Figure 43.
Girls on the roof of Frank Benson's farmhouse at Wooster Farm, North Haven Island, Maine, photograph, c. 1910. Courtesy, Faith Andrews Bedford.

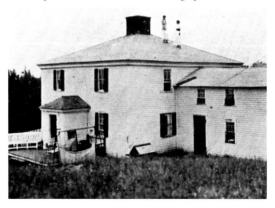

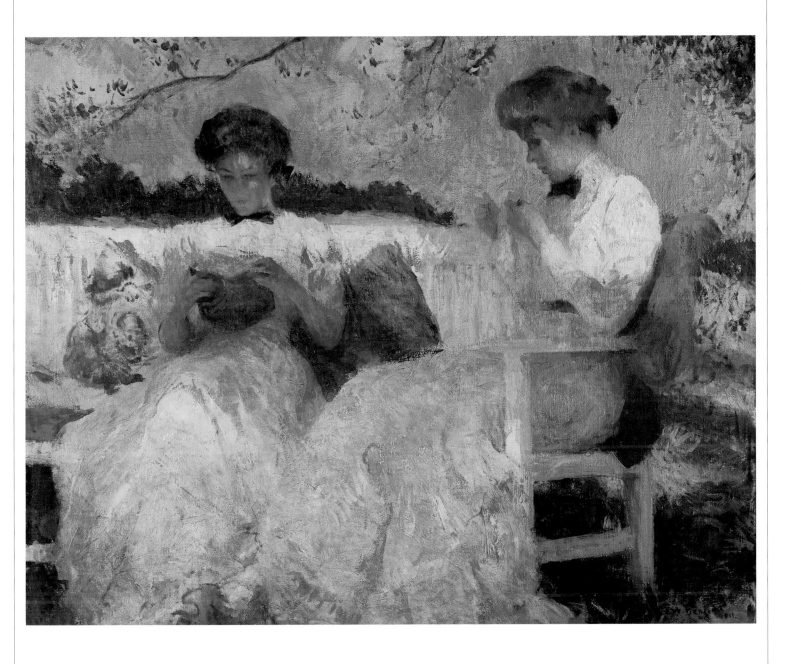

In *Afternoon in September* of 1913, Benson features his daughters Elisabeth (right) and Eleanor (left) seated on the porch bench, the former engaged in reading and the latter in sewing. While demonstrating the combination of leisure and health that the open porch was supposed to promote, the subject provided the artist with an opportunity to study reflections on the white surfaces of his daughter's dresses, which he conveyed by painting the scene vigorously and directly with white impasto tinted with a range of pastel tonalities. The result, as William Howe Downes wrote, was to bathe the figures "in the actual and comfortable sunlight caressed by the balmy summer breezes" in such a way that they become "an inherent part of the open-air scene, a tangible and indispensable asset in the pictorial ensemble."[5] Painting impressionistically while not dissolving the figure into color and light, Benson transformed French Impressionism into a uniquely American style, as was frequently noted by his critics. For example, art reviewer Lila Mechlin wrote that:

HE HAS ABSORBED THE BEST THAT HE FOUND IN THE ART OF OTHER NATIONALITIES AND HAS MADE IT HIS OWN. HE HAS FURTHERMORE, PAINTED THOSE SUBJECTS WHICH WERE CLOSEST AT HAND AND FOUND IN THEM EXCEEDING LATENT LOVELINESS. HIS PAINTINGS OF FIGURES OF WOMEN AND CHILDREN OUT OF DOORS ARE ENCHANTING—NOT WEAKLY PRETTY, BUT CHARACTERFUL AND LOVELY.[6]

The simultaneous wholesomeness and refinement of Benson's figures constituted an American ideal of womanhood at the turn of the century, and the domestic outdoor locale, which joined the security of home with the freedom of the open air, exemplified national landscape ideals. Such works reflected a soothing and reassuring vision linked with traditional American values. As Downes stated in 1911, the artist evoked "a holiday world in which nothing ugly or harsh enters, but all the elements combine to produce an impression of the natural joy of living."[7]

LNP

1. The principal sources on the artist are Faith Andrews Bedford, *Frank W. Benson: American Impressionist* (New York: Rizzoli, 1994); Faith Andrews Bedford, Susan C. Faxon, and Bruce W. Chambers, *Frank W. Benson: A Retrospective,* exh. cat. (New York: Berry-Hill Galleries, Inc., 1989); and John Wilmerding, Sheila Dugan, and William H. Gerdts, *Frank W. Benson: The Impressionist Years,* exh. cat. (New York: Spanierman Gallery, 1988).
2. For details on Benson's family life on North Haven, see Bedford 1994, 82-86.
3. Charles H. Caffin, "The Art of Frank W. Benson," *Harper's Monthly Magazine* 119 (June 1909): 311.
4. Mary H. Northend, *Remodeled Farmhouses* (Boston: Little, Brown, and Co., 1915), 110-111.
5. William Howe Downes, *Paintings, Etchings, and Drawings by Frank W. Benson,* exh. cat. (Washington, D.C.: Corcoran Gallery of Art, 1921), n.p.
6. Lila Mechlin, "Benson Exhibition," *Boston Transcript* (25 March, 1921): 35.
7. William Howe Downes, "The Spontaneous Gaiety of Frank W. Benson's Work," *Arts and Decoration* 1 (March 1911): 195.

2

ROBERT BLUM

(1857, Cincinnati, Ohio-1903, New York City)

Two Idlers, 1888-1889
Oil on canvas
29 x 40 in. (73.7 x 101.6 cm)
National Academy of Design,
New York City

As a student in his native Cincinnati, Robert Blum became fascinated by the art of the Spanish painter Mariano Fortuny and began to emulate his rich coloration and powerful brushwork.[1] Although he continued to derive inspiration from Fortuny's work throughout his career, in 1880 he encountered an artist whose works would hold equal importance for him. While visiting Venice with a group of American artists led by Frank Duveneck, Blum met the American expatriate artist James McNeill Whistler, who was creating etchings and pastels of the city featuring his characteristic delicate compositions and soft tonal juxtapositions. Taking his cue from Whistler, Blum created Venetian images that are distinctly Whistlerian in spirit. However, in most of his art, Blum merged aspects of the approaches of Fortuny and Whistler, formulating a unique style that combined straightforward realism with a sensitivity to tone and design.

Blum is well known for his views of Venice as well as for oils and pastels that he created during a trip to Japan from mid-1890 to late 1892; in fact, he was one of the first native artists to visit Japan.

Between his return from a trip to Venice in 1885-1886 and his departure for Japan four years later, Blum lived in New York, and it was during this period that he painted *Two Idlers*.[2] He appears to have drawn inspiration for this work from an 1884 painting by William Merritt Chase entitled *Sunlight and Shadow* (fig. 44), executed in Holland, for which Blum served as a model. In the painting, Blum, wearing a white suit, is seen holding a teacup before a table in a courtyard, while a female figure lounges nearby in a tasseled hammock like the one in Blum's painting. Similarly, Blum chose to portray an artist companion. His male sitter was his friend William Baer, with whom he had grown up in Cincinnati, while the female subject was Baer's German wife. The couple are seen seated on the porch of a home in Brick Church, New Jersey (now part of East

Orange), near Baer's home and the school where he was teaching art at the time.[3] In Brick Church during the late 1880s, Baer was teaching classes in engraving and black-and-white draftsmanship for illustrators.[4] As Blum indicated in a letter to his parents, he traveled a number of times in the fall of 1888 to Brick Church to work on the painting, which he completed in his studio the following year.[5]

While emulating Chase seems to have been one of Blum's objectives in *Two Idlers*, he may also have been drawing on a genre of contemporary literature in which the travails of city dwellers transported to the suburbs were chronicled and often satirized. As early as 1855, Frederick S. Cozzens detailed the lives of the Sparrowgrasses in *The Sparrowgrass Papers, or Living in the Country,* which was serialized in *Putnam's* magazine.[6] In his tales, Cozzens described a family's delight in the open air as well as their ignorance with regard to country ways after their move to rural Westchester from Manhattan. William Dean Howells also wrote of transplanted city dwellers adjusting to the country in *Suburban Sketches* (1871), while in the 1890s, Henry Augustin Beers and Henry Cuyler Bunner lampooned the etiquette of suburban experience in humorous vignettes.[7]

The figures in Blum's painting evoke the young married couple "who know only city things," as Bunner opined.[8] They appear too well dressed for an afternoon on a country porch, where it is

unlikely that visitors would make the kind of social calls that were routine in the city. While they look toward each other, their gazes do not meet: the man smokes listlessly, while the woman engages in a reverie, her eyes closed. The setting may be comfortable, but a sense of unease pervades the work, perhaps reflecting the monotony and boredom of married life. A further tension is established in the setting itself. Whereas the porch is private and offers a view of a fenced-in lawn, a neighbor's home and lawn are directly visible beyond the leaves of an overhanging tree. The window of the neighbor's house overlooks the porch.

Although portraying two people with whom Blum was acquainted, the painting is not a portrait. He showed the figures informally, concentrating on their relationship rather than their likenesses. Indeed, we are brought in closer to the pair here than in Chase's painting, thus intensifying the paradoxical sense of physical proximity and emotional distance that the work engenders. Shown with a brilliant use of foreshortening, the woman leans forward, while the man leans backward. This back and forth movement of the arrangement heightens its psychological tension. Other American painters, in general, idealized suburban and country life, portraying sunlit porches and vivid flower gardens, in which figures, when they occur, enjoy their tranquility and solitude. By contrast, Blum probed below the surface to hint at the social and psychological disjunction experienced by city dwellers who had migrated to the suburbs.

LNP

1. The primary source on the artist is Bruce Weber, *Robert Frederick Blum (1857-1903) and His Milieu*, 2 vols., Ph.D. diss., City University of New York, 1985 (Ann Arbor, Mich.: University Microfilms International, 1985).

2. A discussion of this painting appears in Weber 1985, 311-315.

3. A letter from Robert Blum to his parents indicates that Blum was not painting Baer's home. He stated: "I am working in another house at a slight distance from Baer." Blum Family Correspondence, cited in Weber 1985, 311-312. Baer later became known as one of the nation's finest miniaturist portraitists.

4. On Baer's teaching in Brick Church and related references, see William H. Gerdts, "The Teaching of Painting Out-of-Doors in America in the Late Nineteenth Century," in Bruce Weber and William H. Gerdts, *In Nature's Ways: American Landscape Painting of the Late Nineteenth Century*, exh. cat. (West Palm Beach, Fla.: Norton Gallery of Art, 1987), 30.

5. Blum Family Correspondence, cited in Weber 1985, 311-312.

6. Frederick S. Cozzens, "The Sparrowgrass Papers, or Living in the Country," *Putnam's* 6 (August-December 1855), 166-169, 299-304, 392-395, 505-508, 629-632; and 7 (February-March 1856), 166-169, 295-300.

7. William Dean Howells, *Suburban Sketches* (1898; Freeport, N.Y.: Books for Libraries Press, 1969); Henry Augustin Beers, *A Suburban Pastoral and Other Tales* (New York: Holt, 1894); and Henry Cuyler Bunner, *The Suburban Sage: Stray Notes and Comments on His Simple Life* (1896; Freeport, N.Y.: Books for Libraries Press, 1969).

8. Henry Cuyler Bunner, *The Runaway Browns: A Story of Small Stories* (New York: Keppler, 1892).

Figure 44.
William Merritt Chase, *Sunlight and Shadow*, 1884, oil on canvas, 65 1/4 x 76 1/2 in. (165.7 x 194.3 cm), Joslyn Art Museum, Omaha, Nebraska, Friends of Art Collection, 1932.

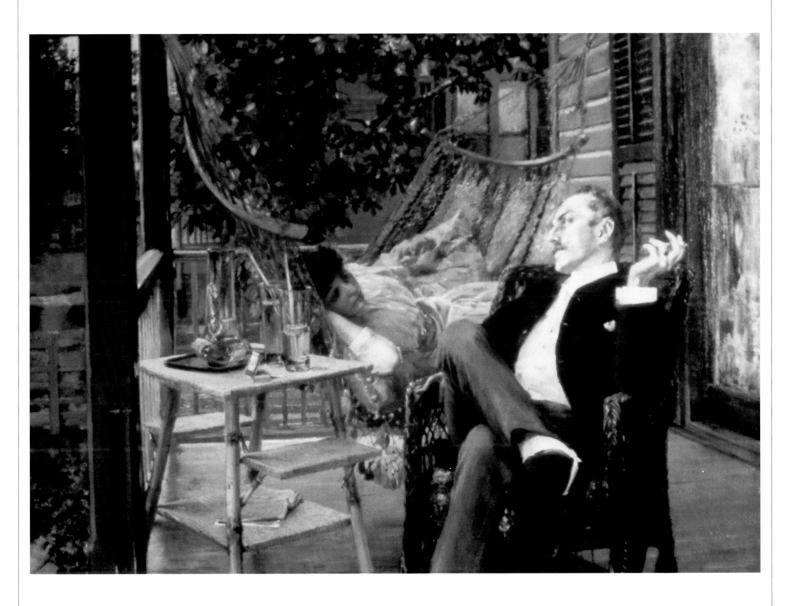

3

PHILIP LESLIE HALE

(1865-1931, Boston)

The Crimson Rambler, c. 1908
Oil on canvas
25 1/4 x 30 3/16 in. (64.1 x 76.4 cm)
Courtesy of the Museum of
American Art of the Pennsylvania
Academy of the Fine Arts, Philadelphia.
Joseph E. Temple Fund
Exhibited only at The Trout Gallery

Philip Hale was an important member of the Boston School of figure painters and one of the most innovative of the American Impressionists. He was also an influential and prolific art critic, recognized for his insightful writings on Impressionism and other aspects of modern art, as well as for his monographs on the seventeenth-century Dutch painter Jan Vermeer. Hale's talents also extended into the realm of teaching: for over thirty years he was one of the most popular instructors at the school of the Museum of Fine Arts in Boston. The son of the Reverend Edward Everett Hale, the acclaimed author, orator and preacher, Hale's notable Brahmin lineage also included the journalist and patriot Nathan Hale, and abolitionist and novelist Harriet Beecher Stowe.

In 1902 Hale married the painter Lilian Westcott of Hartford, Connecticut. The couple subsequently moved into Boston's Fenway Studios, where they lived and worked in two connecting studios.[1] In May of 1908 their one and only child, Ann (known as Nancy), was born. Not wishing to bring her daughter up in the cramped confines of "the Fenway," Lilian had asked the architect Stephen Codman, a family friend, to help them find a home in Dedham, a prosperous suburb near Boston where Codman and his family lived. By July, the Hales had moved into a Queen Anne, shingle-style house on Border Street.[2] Their home, which had several porches and a "lovely garden," was named "Ashcroft" after the section of Dedham in which it was located.[3]

As Lilian Hale explained in a later interview, the couple's Ashcroft years represented "the high point of their life, because they had a house in the country…a baby, . . . [and] a garden."[4] In addition, they "painted some of their very best pictures after they went out there."[5] Lilian, who had her studio at home, depicted her subjects inside the couple's comfortable house, while Philip brought his models out from Boston to pose on his home grounds amidst blossoms associated with old-fashioned gardens, such as hollyhocks, dogwood, and wisteria. As one of Boston's leading Impressionists, he was especially fond of portraying women with roses, a flower that symbolized "perfection."[6] Indeed, following his move to Ashcroft, roses would emerge as a recurrent theme in Hale's painting, presumably inspired by the fact that this luxuriant blossom was readily available in his immediate surroundings. The roses were carefully cultivated by Lilian, who became an enthusiastic gardener.[7]

Recognized as one of Hale's best-known works, *The Crimson Rambler* features a lovely young woman, a healthy "American Girl," relaxing on a sunlit porch at Ashcroft. The sitter wears a long white dress decorated with a colorful sash, whose deep shade of red is repeated in the adjacent crimson rambler—a climbing rosebush with clusters of small, lush flowers. A staple of domestic flower gardens, these vibrant blossoms were deemed an appropriate floral accessory for suburban dwellings by many contemporary writers, including a commentator for *Country Life*, who, writing in 1902, advised readers to allow "a crimson rambler to run up over your veranda" to complete the overall effect.[8]

By titling the painting with the name of the flower, Hale refers to both the type of blossom and alludes to his sitter who, like her floral counterpart, exemplifies ideal beauty.[9] At the same time, Hale also directs his creative energies towards the portrayal of sunlight. Working in the academic Impressionist style he developed after the turn of the century, he combines bright colors and broken brushwork with an emphasis on form and structure, effectively conveying the summer sunshine as it falls across the figure, flowers, and architecture.

Not surprisingly, *The Crimson Rambler* was an instant critical success, for upon its debut at the annual exhibition of the Pennsylvania Academy of the Fine Arts in the winter of 1909 it was purchased for the academy's permanent collection. This idyllic vision of outdoor leisure paved the way for the images of women in sun-drenched gardens that Hale would go on to paint at Ashcroft and later at Sandy Down, his second Dedham home.[10] Indeed, *The Crimson Rambler* underscores Hale's reputation as a painter of floral femininity and identifies him too as an artist who explored the aesthetic possibilities of his home environment.

CL

1. For biographical information, see Nancy Hale, *The Life in the Studio* (Boston: Little, Brown and Co., 1957), Franklin P. Folts, *Paintings and Drawings by Philip Leslie Hale (1865-1931) from the Folts Collection,* exh. cat. (Boston: Vose Galleries, 1966), and Carol Lowrey, "The Art of Philip Leslie Hale," in *Philip Leslie Hale, A.N.A.,* exh. cat. (Boston: Vose Galleries, 1988). Other useful sources include Trevor Fairbrother et al., *The Bostonians: Painters of an Elegant Age,* exh. cat. (Boston: Museum of Fine Arts, 1986) and Greer Hardwicke and Rob Leith, *Two Dedham Artists: Philip and Lilian Hale*, exh. cat. (Dedham, Mass.: Dedham Historical Society, 1987). See also: Philip Leslie Hale Papers, Archives of American Art, Smithsonian Institution, Washington, D.C. and the Hale Family Papers, Sophia Smith Collection, Smith College, Northampton, Massachusetts.
2. For details pertaining to the Hale's Dedham homes in relation to Lilian's paintings, see Erica Eve Hirshler, *Lilian Westcott Hale (1880-1963): A Woman Painter of the Boston School*, Ph.D. diss., Boston University, 1992 (Ann Arbor, Mich.: UMI Press, 1992).
3. Lilian Westcott Hale, interview with Gertrude Hanna, 27 February 1932, typescript, page 9, Philip Leslie Hale Papers, Smithsonian Institution, Archives of American Art, Washington, D.C., microfilm roll D104, frame 304.
4. Lilian Westcott Hale, interview with Gertrude Hanna.
5. Lilian Westcott Hale, interview with Gertrude Hanna.
6. See Annette Stott, "Floral Femininity: A Pictorial Definition," *American Art* 6 (Spring 1992): 72.
7. Hale seems to have first explored the theme of the woman and the rose around 1904 in *White Rose* (location unknown).
8. "The Making of a Country Home," *Country Life in America* 2 (June 1902): 45. I would like to thank May Brawley Hill for bringing this quote to my attention.
9. The sitter is possibly the appropriately named Rose Zeffler, one of Lilian Westcott Hale's favorite models.
10. Such as *Hide and Seek* (c. 1911; location unknown); *Autumn Fruits* (c. 1911-1912; private collection); *White Roses* (c. 1914; The National Arts Club Permanent Collection, New York); *Pink Dogwood* (location unknown); and *Hollyhocks* (c. 1922-1923; Butler Institute of American Art, Youngstown, Ohio).

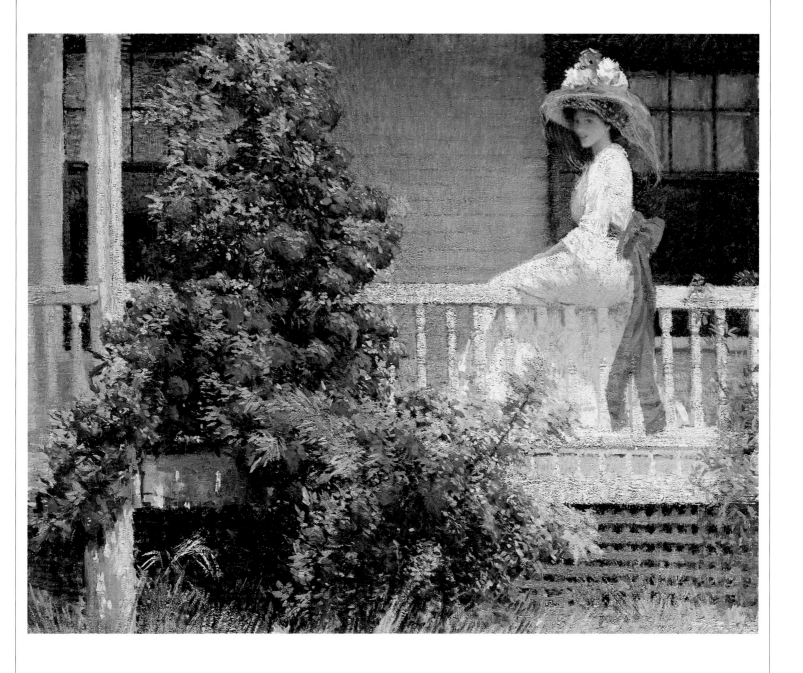

4

WILLIAM CHADWICK

(1879, Dewsbury, Yorkshire, England - 1962, Old Lyme, Connecticut)

On the Porch, c. 1908-1910
Oil on canvas
24 x 30 in. (61 x 76.2 cm)
Florence Griswold Museum,
Old Lyme, Connecticut,
Gift of Mrs. Elizabeth Chadwick
O'Connell

Figure 45.
Artists on the back porch, Florence Griswold House, photograph, c. 1903. Seated at the front table, clockwise from center foreground are: Willard Metcalf, Arthur Heming, Harry Hoffman, Will Foote, two unidentified artists, and Henry Rankin Poore. At the head of the far table is William Henry Howe. Courtesy, Florence Griswold Museum, Old Lyme, Connecticut.

William Chadwick, the son of a textile manufacturer, enjoyed the social privileges and domestic stability associated with the upper-class Victorian household.[1] Showing a talent for painting and drawing as a youth, he enrolled at the Art Students League in 1898 after completing high school, and while a student at the League he visited Old Lyme during the summer of 1903. Up to this point in his career, Chadwick had focused on portraiture and figural subjects; during the first of many summers in Old Lyme at the home of Miss Florence Griswold, however, he began to experiment with landscape painting. Following the lead of other artists at the home of "Miss Florence" as she was affectionately referred to, in particular Willard Metcalf, Childe Hassam, and Walter Griffin, Chadwick developed a restrained Impressionist style. In 1915, Chadwick with his wife Pauline Bancroft settled permanently in Old Lyme, purchasing a Greek Revival home near the shore.

Chadwick painted *On the Porch* around 1908 to 1910, prior to establishing a permanent residence in Old Lyme and before an extended trip abroad. Elements within the picture, as well as a comparison with a contemporary photograph (fig. 45), confirm that the scene depicted is the porch of the Griswold home. In the upper left corner and the upper center of the canvas, one can see the barns beyond the home where Hassam and others had their studios. At this time, the porch had a trellis and an old grapevine at the end of it. The same grapevine and arrangement can be seen in the photograph, as can the similar architectural detail (part of an addition to the house no longer surviving) in the upper right corner of the painting and the photograph. The side porch of the Griswold home served as a dining area for the art colony during the warm weather. Shaded by old vines, the porch provided a cool place to enjoy the midday meal while providing views over the gardens. Known as the "Hot Air Club," Arthur Heming described the origin of the outdoor dining room: "One sultry day four bachelors, revolting against wearing coats while sitting among the ladies in the hot dining room, secured Miss Florence's permission to have a table of their own on the veranda. Then the married men, jealous of the liberty enjoyed by the coatless bachelors, insisted on going out too. A few days later the women—not to be outdone—also followed suit. Thus the men and the women were not divided, and since that day have remained."[2]

In Chadwick's picture, however, everyone except a solitary woman has left, the chairs have been pushed back, and empty glasses are scattered across the white tablecloth. Stacked on the drop-leaf serving table in the background are some plates. A vase filled with geraniums and a bowl of fruit remain on the table.

Employing a lush Impressionist palette, Chadwick conveys the pastoral setting of the Griswold estate. Pink hollyhocks can be seen at the left, grapevines cover the porch, and roses, daylilies, iris, and perennial border can be seen in the distance. The reds, pinks, purples, and other hues in the background suggest the multitude of flowers found growing in Miss Florence's "old fashioned" garden at the rear of the house. The Griswold gardens, located behind the house, were a favorite subject of Old Lyme artists as is demonstrated in Frank Bicknell's painting (pl. 21) and Edmund Greacen's painting (pl. 28). The positioning of these gardens near the house was in keeping with contemporary advice for the home. As one writer commented in 1902, "Let the vines run riot over the veranda and even to the top of the roof, and the shrubs push into the corners of the foundation, thus breaking the hard lines of the building. For what is more barren than a house,—we cannot call it a home,— standing bare and alone in its nakedness."[3] In Chadwick's painting, as in the landscape outside of the Griswold house, the garden is visible from the house. The vine-covered porch links the architecture of the Colonial home with the natural landscape.

While portraying the ideal environment of the Griswold home and gardens, *On the Porch* reflects Chadwick's interest in the image of a solitary young woman. Chadwick's fascination with this theme, shared by many of his contemporaries, developed in part from his own training with the Boston painter Joseph DeCamp. This young woman, with red flowers in her bonnet, may also suggest the influence of the leader of the Old Lyme Colony, Childe Hassam. Chadwick was undoubtedly aware of Hassam's depictions of Celia Thaxter within her garden on the Isle of Shoals. Frequently portrayed within an interior setting looking out a window, or in this instance on a porch, Chadwick's solitary figures mediated the transition between interior and exterior worlds. For Chadwick, the solitary image of a young woman therefore functioned in a manner similar to a porch covered in vines. If the former served as a compositional bridge between the living space of women, the latter united the physical structure of the home with the natural world of flowers and gardens. For the next forty years, Chadwick would repeatedly return to this subject.

JB

1. The primary source on the artist is Richard H. Love, *William Chadwick, 1879-1962: An American Impressionist*, exh. cat. (Chicago: R.H. Love Galleries, 1978).
2. Arthur Heming, *Miss Florence and the Artists of Old Lyme* (Old Lyme: Lyme Historical Society, 1971), 17.
3. Bryant Fleming, "The Making of a Country Home: Being A Series of Practical Papers on the Possibilities of Home-Making by Persons of Moderate Means—III. Planting the Place," *Country Life in America* 2 (June 1902): 47.

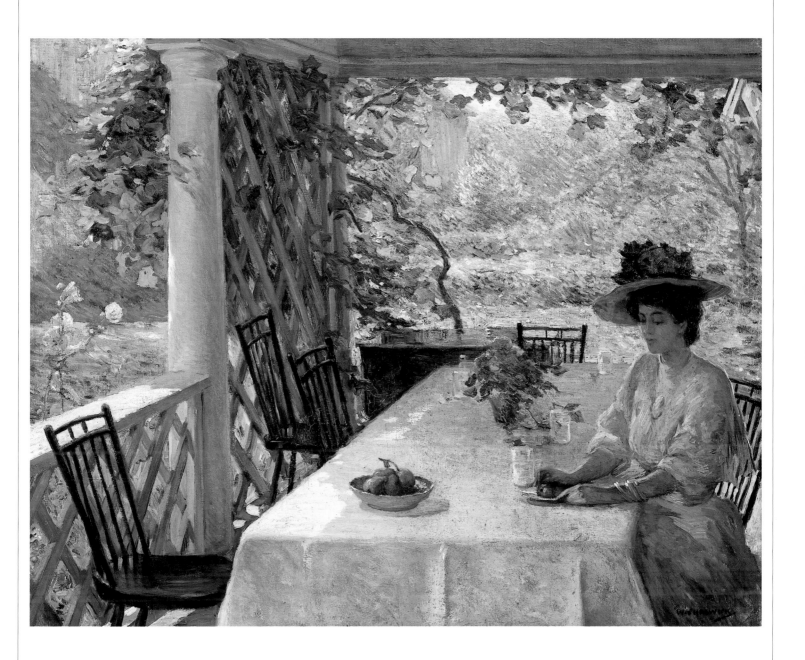

5

JOHN HENRY TWACHTMAN

(1853, Cincinnati, Ohio-1902, Gloucester, Massachusetts)

On the Terrace, 1897
Oil on canvas
25 1/4 x 30 1/8 in. (64 x 76.5 cm)
National Museum of American Art,
Smithsonian Institution,
Washington, D.C., Gift of John Gellatly

Figure 46.
Back of Twachtman's house, c. 1902,
photograph, from Alfred Goodwin, "An
Artist's Unspoiled Country Home," *Country Life in America* 8 (October 1905): 630.
Courtesy, Spanierman Gallery, New York.

In the 1870s and 1880s, John Twachtman was a leading figure among a cosmopolitan generation of artists.[1] Traveling to Europe four times, he studied both in Munich and Paris and worked in popular painting locales, including Venice, Tuscany, Dordrecht, and Normandy. During this period his style gradually changed. In the mid-1870s, he painted with a dark palette and a heavy impasto application similar to that of Munich painter Wilhelm Leibl and Old Masters such as Frans Hals. At the beginning of the next decade, he began to use a thin, smooth application of soft grays and greens, suggesting an affinity with the approach of Jules Bastien-Lepage and James McNeill Whistler.

Twachtman ended his European travels upon his return to America in the winter of 1885-1886. Like a large number of native artists of the time, he decided to remain at home permanently and to paint readily available subject matter. There his style soon changed again. After settling in Greenwich, Connecticut, in 1889, Twachtman began to work in an Impressionist manner influenced by exhibitions of works by French artists in America and by the experiments of friends such as Theodore Robinson, who had firsthand experience of the art of Claude Monet, during summers spent in Giverny, France. However, the Impressionist style that Twachtman devised was unique. Varying his technique according to the particular qualities of his motifs, he applied his paint with rhythmic vigor, at times rapidly maneuvering dry brushes to build up thick layers and, at other times, laying down thin glazes to create atmospheric effects. With this method, he expressed the sensuous qualities of his sites, capturing the poetic nature of hazy days or the potent reality of landscapes, where the ground was caked with old snow and laden with patches of melting ice.

Greenwich was in transition during Twachtman's years of residency, changing from a quiet farming community to a wealthy suburb sought out by affluent New Yorkers escaping the city. Twachtman settled in an area two miles from the town known as Hang Root which was yet to become gentrified. There he delighted in the unspoiled, varied seventeen acres of undulating hillsides and grassy glens that he purchased over time. Situated on the edge of Round Hill Road, the home where he lived with his wife and five children was a small farmhouse, built around 1840, which the artist expanded gradually to accommodate his family and to create an aesthetic composition linking his home with the land. Due to his modifications, the small upright box eventually became a long, low, horizontal structure wedded to the land. A western extension to the building was constructed into the side

of a hill, while at the back of the house, two porches stretched into a garden of hardy perennials that created a transitional zone between the domestic sphere and the landscape at large (fig. 46).

During his years in Greenwich, Twachtman found infinite satisfaction in familiar motifs, returning over and over to the same subjects. He painted the brook that wound through the countryside and a waterfall and small pool found on its course. He also gave a significant amount of attention to his home and garden, painting both from a variety of angles and often capturing their interactions. In *On the Terrace*, he combined the motifs of his garden and home with a figural group comprised presumably of his wife and three of his children, who sit on the porch at the back of his residence. Dressed in white, the figures enjoy sunlight and relaxation, while the phlox flowers of the garden rise gracefully around them. Although the flowers grow freely, they are arranged in a geometric L-shape, which extends from the back of the house and borders the patio. Indeed, the flowers act as mediators between the architectural and natural aspects of the grounds, creating the sort of interchange between the garden and home that period writers recommended. For example, Sarah Cone Bryant suggested treating the garden "as an adjunct of the house" so that "the grounds seem but to continue and expand from the house, and the house to concentrate the prevailing thought of its surroundings."[2] Connected to the garden's plantings is a vine-covered trellis which arches over the small gable at the back of the home. "Breaking the hard lines of the building and tying it to the ground," this trellis also roots the home in the landscape.[3]

While painting the image in a realistic manner using Impressionist means, Twachtman imbued it with a spiritual connotation. Seen over the doorway and the figures, the arched trellis has a halo-like appearance, while the traditional grouping of the figures calls to mind Renaissance depictions of the Madonna and Child. Indeed, while Twachtman captured specific aspects of his Greenwich life, in *On the Terrace*, he reflected on the ideals of his era with regard to family togetherness and country living.

LNP

1. The principal sources on Twachtman and the art he produced in Greenwich, Connecticut, are Lisa N. Peters, *John Twachtman (1853-1902) and the American Scene in the Late Nineteenth Century: The Frontier within the Terrain of the Familiar*, Ph.D. diss., City University of New York, 1995 (Ann Arbor, Mich.: University Microfilms International, 1996); John Douglass Hale, *The Life and Creative Development of John H. Twachtman*, 2 vols., Ph.D. diss., Ohio State University, Columbus, 1957 (Ann Arbor, Mich.: University Microfilms International, 1958); Deborah Chotner, Lisa N. Peters, and Kathleen A. Pyne, *John Twachtman: Connecticut Landscapes*, exh. cat. (Washington, D.C.: National Gallery of Art, 1989); Lisa N. Peters, John Douglass Hale, William H. Gerdts, and Richard J. Boyle, *In the Sunlight: The Floral and Figurative Art of J. H. Twachtman*, exh. cat. (New York: Spanierman Gallery, 1989); and Richard J. Boyle, *John Twachtman* (New York: Watson-Guptill, 1979).
2. Sara Cone Bryant, "A Suburban Place of Four Acres," *Country Life in America* 4 (August 1903): 266-267.
3. Bryant Fleming, "The Making of a Country Home: Being A Series of Practical Papers on the Possibilities of Home-Making by Persons of Moderate Means—III. Planting the Place," *Country Life in America* 2 (June 1902): 47.

6

LYDIA FIELD EMMET

(1866, New Rochelle, New York-1952, New York City)

Grandmother's Garden, c. 1912
Oil on canvas
32 x 43 in. (81.3 x 109.2 cm)
National Academy of Design, New York

Lydia Field Emmet came from a family of important women artists.[1] Her sisters, Jane Emmet de Glehn and Rosina Emmet Sherwood, and her first cousin, Ellen Emmet Rand, were all professional painters who had distinguished careers. In 1884 Lydia received her first training in Paris at the Académie Julian as well as with William Adolph Bougereau. On her return home, she studied at the Art Students League in New York, receiving instruction from William Merritt Chase, Robert Reid, H. Siddons Mowbray, and Kenyon Cox. Of these teachers, the one who had the greatest impact on her was Chase. Emmet not only studied for many years with him at the League, but also attended his summer school in the hills of Shinnecock, Long Island, where she organized many of the school's social events and taught during the summers of 1891, 1892, and 1893.

Emmet is best known for her candid portraits, often depicting children. She only created a few landscapes, among them an unlocated painting entitled *The Deserted Garden*, which was shown at the National Academy of Design in 1894. *Grandmother's Garden* was probably created several decades later.[2] Emmet gave the canvas to the Academy in 1914 as her diploma painting when she became an Academician. Since artists usually gave recent works when bestowed with this honor, the date of about 1912 seems appropriate.[3] Given this dating, it is likely that the work is a representation of Stockbridge, Massachusetts, where Emmet spent summers at her home Strawberry Hill from 1905 until the end of her life.

In the painting, a well-dressed woman and a young girl enjoy the sunlight on a porch overlooking an old-fashioned garden. The elegant china tea set laid carefully on a white tablecloth brings the domestic sphere into the outdoors, making the porch appear "fitted up as a living-room overlooking the home garden," as authors such as Mary Northend recommended.[4] The painting calls to mind images by French Impressionists that depict figures drinking tea in the outdoors. However, the garden appears to be an American rather than the French style. The old-fashioned flowers, adorned vine trellis, and patches of open lawn are arranged with relative freedom rather than the formal control typical of French gardens, and the garden's plantings flow into a wooded landscape where distant purple hills —probably of the Berkshires— are in view. The painting's subject illustrates the advice of George Cable, who wrote in 1904:

THE GARDEN SHOULD NEVER BE MORE ARCHITECTURAL THAN THE HOUSE OF WHICH IT IS THE SETTING, AND THIS IS WHY THE GARDEN SHOULD GROW LESS AND LESS ARCHITECTURAL AND ARTIFICIAL AS IT DRAWS AWAY FROM THE HOUSE. TO SAY THE SAME THING IN REVERSE, THE GARDEN, AS IT APPROACHES THE HOUSE, SHOULD ACCEPT MORE AND MORE DISCIPLINE—DOMESTICATION—SOCIAL REFINEMENT, UNTIL THE HOUSE ITSELF AT LENGTH SEEMS AS UNABRUPTLY AND NATURALLY TO GROW UP OUT OF THE GARDEN AS THE KEYNOTE RISES AT THE END OF A LADY'S SONG.[5]

Although we cannot see the house, its gentility is announced by the gracious tea set, the breadth of the patio, and the fashionableness of the figures.

Emmet's *Grandmother's Garden* puts forth an image of American outdoor life in which tastefully refined living and the freedom of nature come together in the backyard.

LNP

1. The main source on the artist is Martha J. Hoppin, *The Emmets: A Family of Women Painters*, exh. cat. (Pittsfield, Mass.: The Berkshire Museum, 1982).
2. Hoppin conjectured that the painting could be dated c. 1894 on the basis of a possible relationship to *The Deserted Garden*. See Hoppin 1982, 22.
3. See Hugh R. Crean, "Lydia Field Emmet," in *From All Walks of Life: Paintings of the Figure from the National Academy of Design* (New York: National Academy of Design, 1979), 42.
4. Mary H. Northend, *Remodeled Farmhouses* (Boston: Little, Brown, and Co., 1915), 9.
5. George W. Cable, "The American Garden," *Scribner's Magazine* 35 (May 1904): 621-622.

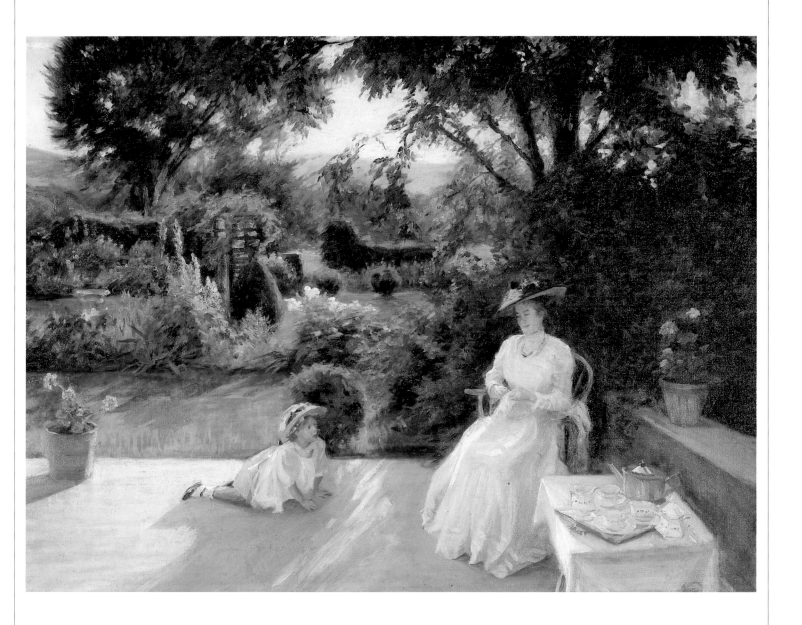

7

ABBOTT FULLER GRAVES

(1859, Weymouth, Massachusetts-1936, Kennebunkport, Maine)

Grandmother's Doorway, c. 1900
Oil on canvas
40-1/8 x 50 in. (101.9 x 127 cm)
Courtesy of the Strong Museum,
Rochester, New York

Throughout a long career devoted to painting flowers and gardens, Abbott Fuller Graves often portrayed the flower-adorned doorways of New England homes.[1] Depicting this subject in *Grandmother's Doorway* of 1900, he united the subjects of the old-fashioned garden and the Colonial house, both of which evoked considerable national pride and nostalgia in turn-of-the-century America. A caption describing one of Graves's paintings of a doorway that appeared on the cover of *The Literary Digest* in 1927 stated: "It looks like a doorway in Salem [Massachusetts], tho [sic] it might be anywhere in the old comfortable New England towns where colonial architecture abounds, and is still cared for. It reminds us of the days of grace and leisure that have in recent years slipt [sic] away from us."[2] In 1924 George Alfred Williams made a similar comment in *Ladies Home Journal*, proposing that in order to complete the New England flower garden

WE NEED ONLY ADD THE TYPICAL WHITE COTTAGE OR COLONIAL HOUSE, WITH GREEN BLINDS AND BROAD WHITE DOOR ADORNED BY THE HOSPITABLE BRASS KNOCKER. THE FLOWERS THAT GREW IN THESE GARDEN SPOTS WERE THE POETRY OF LIFE, WHILE THE WHITE HOUSES WITH THEIR BROAD DOORWAYS WERE THE HUMAN NOTE OF HOME AND HEARTH. IT IS, PERHAPS, THE CLOSENESS OF THE GARDEN TO THE HEARTH THAT HAS SO ENDEARED NEW ENGLAND GARDENS TO OUR MEMORIES.[3]

The house shown in Graves's painting is a typical Georgian-style residence from the mid-eighteenth century, when such pedimented doorways adorned with columns were promoted widely in builder's manuals. The garden is filled with the free masses of jumbled blooms that were reminiscent of the nation's first gardens, and, in his painting, Graves accentuated the connection between flowers and architecture. While the flowers rise in dense clusters, they yield to the sunlit pathway leading to the door, and only a single blossom-laden branch obstructs our view of the home. The flowers stop short of the green-shuttered windows, while hanging foliage relieves the facade's white expanse. In turn, the white building sets the flowers in relief and

allows their tones to be reflected in its surface. Dappled sunlight casts a glow on the pathway below the house, but the brightest illumination is reserved for the polished plain wood door where a brass knocker invites entry.

Rendering his scene on a large canvas, Graves draws us toward the door by means of a strong perspectival recession. On the threshold of the home, flowers, often associated with the female image in nineteenth-century American paintings, prepare us for the feminine world of tranquility and spiritual renewal to be found within. Williams acknowledged the importance of flowers as a transition to the domestic realm in Graves's paintings, stating:

IF WE HAVE NEGLECTED TO PLANT FLOWERS ABOUT OUR HOUSES, WE HAVE BEEN REMISS IN FAILING TO TAKE ADVANTAGE OF ONE OF THE LOVELIEST ATTRIBUTES TO PEACE AND CONTENTMENT THAT THE HOME CAN KNOW. WHO CAN NEGLECT FLOWERS AND FAIL TO MAKE OF THEM PART OF THE HOME, AND . . . BRING PEACE AND CONTENTMENT TO THE LIVES NURTURED WITHIN.[4]

LNP

1. The principal source on the artist is Joyce Butler, *Abbott Fuller Graves, 1859-1936*, exh. cat. (Kennebunkport, Me.: Brick Store Museum, 1979).
2. Caption for Abbott Graves, *A Sunny Doorway*, reproduced on the cover of *The Literary Digest* 94 (9 July 1927): 28.
3. George Alfred Williams, "New England Gardens," *Ladies Home Journal* 41 (May 1924): 14.
4. Williams 1924, 14.

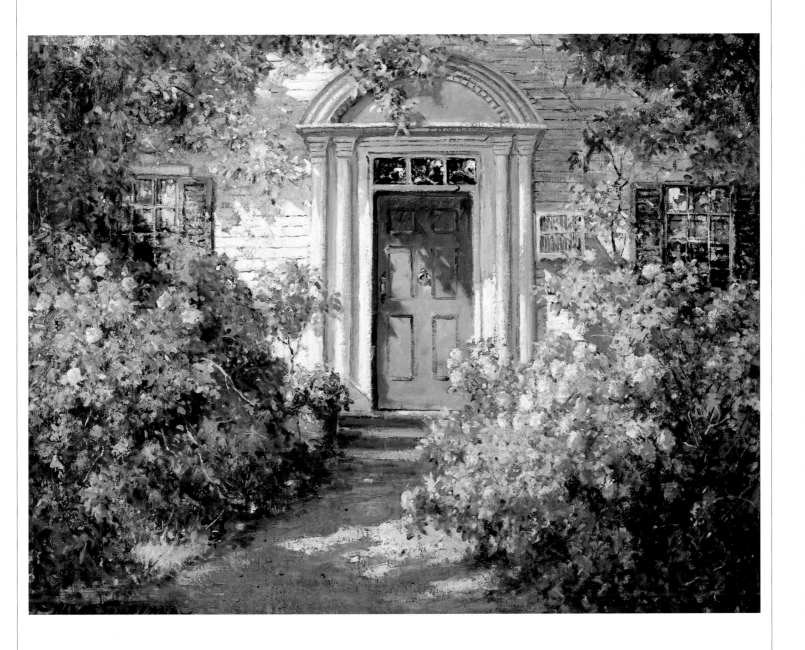

8

CHARLES W. HAWTHORNE

(1872, Lodi, Illinois-1930, Provincetown, Massachusetts)

Tiffany's Estate, Laurelton, c. 1910s-1920s
Oil on panel mounted on masonite
30 x 24 in. (76.2 x 61 cm)
The Museums at Stony Brook,
New York

Figure 47.
Entrance and Bell-tower of Laurelton Hall, Louis Tiffany's home at Oyster Bay, Long Island, photograph, c. 1900s. Courtesy, Robert Koch.

A descendant of New England Puritans, Charles Hawthorne grew up in Maine and studied art in New York.[1] His teachers at the Art Students League included Frank Vincent Dumond and George de Forest Brush, but the instructor to whom he was most indebted was William Merritt Chase. In 1896 Hawthorne became a pupil at Chase's school at Shinnecock, Long Island. In the following year, he helped Chase organize his New York School and served as Chase's assistant at Shinnecock in the summer of 1897. Two years later, Hawthorne opened his own school, the Cape Cod School of Art in Provincetown, which he ran until the end of his life.

Primarily a portraitist, Hawthorne is known for realist images of hearty New Englanders, especially the fisherfolk of the Cape. One of his few extant landscapes, *Tiffany's Estate, Laurelton* depicts Laurelton Hall, the home of the stained-glass artist, architect, and painter Louis B. Tiffany (1845-1933). Designed and built by Tiffany in 1905 on his property in Oyster Bay, Long Island, New York, and overlooking Cold Spring Harbor, the home was constructed in an eclectic style combining elements of

Moorish and Mission architecture (fig. 47). A stream ran through the center of the home's enclosed courtyard, and the coal-burner that heated the residence was enclosed in a tower made to look like a Moorish minaret. On his property, Tiffany created an extensive hanging garden that included exotic tropical plants and a stream, whose series of falls culminated in a Chinese-dragon fountain. The beauty of Tiffany's home (which burned down in 1957) was noted in many contemporary newspaper and magazine articles, including *House and Garden, International Studio, Town and Country*, and *House Beautiful*; many authors pointed out how the artist had applied principles of painting to the design of his home and property.[2] As Samuel Howe stated in *House Beautiful*:

MR. TIFFANY IS NO MERE NATURALIST, REALIST, OR IMPRESSIONALIST [SIC]. ONCE AGAIN DOES HE PRESENT EVERYDAY MATERIAL AS AN ELEMENT OF THE DECORATIVE KINGDOM, PAINTING, AS IT WERE, WITH A BIG BRUSH IN HIS SYSTEMATIC STUDY OF THE HILLSIDE, THE APPROACH, THE FRONTAGE OF THE HOUSE, THE BACK OF IT AS WELL AS THE LANDSCAPE. HE IS CONCERNED WITH THE REFLECTED LIGHTS, THE MELLOWING INFLUENCE OF THE DISTANCE UPON EVERYTHING, THE LOCAL AND COMPARATIVE COLOR, THE COLOR NOTE WHEN THE JUNE SUN IS BOILING UPON IT AND THE TONES IN THE MOONLIGHT AS WELL AS THE WITCHERY OF THE NIGHT SCENE. CONCERNED IS HE ALSO WITH THE TEXTURE OF THINGS, THE SHADOWS WHICH ARE INTENSE AND THOSE WHICH ARE THIN AND TRANSPARENT, AND ABOVE ALL WITH THE DELICATE QUESTION THAT BEAUTIFUL AS A FLOWER MAY BE IN ONE PLACE, IT MAY LOOK ALTOGETHER DIFFERENT ELSEWHERE.[3]

Committed to realist painting, Tiffany was outraged by the 1913 Armory Show, which introduced the Cubists, Futurists, and Surrealists to American audiences. After the show, Tiffany systematically invited those artists and intellectuals with views akin to his own to visit his Long Island home. Hawthorne, whose conservative work undoubtedly appealed to Tiffany, was probably one of the guests at this time.

In his view of Laurelton Hall, Hawthorne featured the main entrance at the home's upper level, which led into the court, with the minaret/coal-burner silhouetted against the sky, its vertical form echoed in the canvas format. At the threshold of the home, we can glimpse the concrete Moorish columns topped with floral capitals that stood before glass doors, while the curved stucco walls of the facade fill the horizontal axis of the composition.

In his painting, Hawthorne brought out the color harmonies that Tiffany achieved in his stained-glass. Both architectural and natural forms are treated as soft masses of lavender, green, and gold. The shadows and sunlight that Tiffany emphasized in his design are revealed by Hawthorne with thin color glazes that convey both the gleam of sunlight on the moist lawn and the dark green reflections from trees in the lavender pool situated at the front of the house. The pale blue tone of the sky is reflected in the tower as well as in the building's stucco walls. Landscape and architectural forms flow together in Hawthorne's picture, revealing the compositional unity that Tiffany sought to attain.

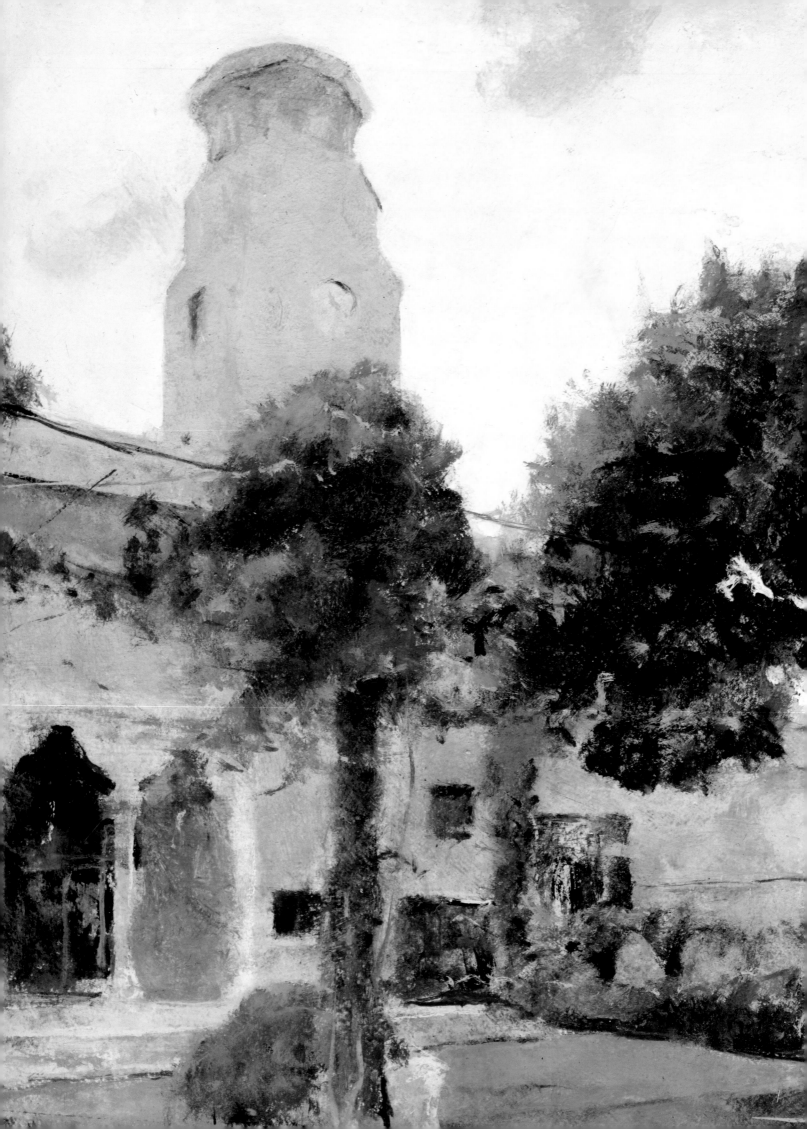

Tiffany's Estate, Laurelton, c. 1910s–1920s
(Detail of Plate 8)

Tiffany's property as well as Hawthorne's painting of it demonstrate the close alliance between painting and landscape design that turn-of-the-century authors recommended. For example, in 1893 Mariana van Rensselaer stated that "the painter worked not with actual colors, but with 'illusions of form' and the…landscape gardener took from Nature not only his models but his materials and methods." She also wrote that what distinguished the fields was only their particular mediums and techniques since the artistry remained the same.[4] Whereas Tiffany had applied painting composition rules to design his home and property, Hawthorne appropriately returned the setting to painted form.

LNP

1. The main sources on the artist include Marvin S. Sadik, *The Paintings of Charles Hawthorne*, exh. cat. (Storrs, Conn.: The University of Connecticut, 1968); Joseph Hawthorne and E. P. Richardson, *Hawthorne Retrospective*, exh. cat. (Provincetown, Mass.: The Chrysler Art Museum, 1961); and Elizabeth McCausland, *Charles W. Hawthorne: An American Figure Painter* (New York: American Artists Group, Inc., 1947).
2. The magazine articles include: Samuel Howe, "The Dwelling Place as an Expression of Individuality," *Appleton's Magazine* (February 1907): 156-165; Howe, "An American Country House," *International Studio* 33 (1907-1908): 294-296; Howe, "The Long Island Home of Mr. Louis C. Tiffany," *Town and Country* (6 September 1913): 24-26, 42; Howe, "A Country Home with a Human Appeal," *Long Island Home Journal* (March 1914): 40-42; Howe, "The Garden of Mr. Louis C. Tiffany: A Significant Handling of Color," *House Beautiful* 35 (January 1914): 40-42; Henry H. Saylor, "Indoor Fountains," *Country Life in America* (August 1908): 366; Saylor, "The Country Home of Mr. Louis C. Tiffany," *Country Life in America* (December 1908): 157-162; and Minna Caroline Smith, "Louis C. Tiffany—The Celestial Hierarchy," *International Studio* 33 (1908): 96-99.
3. Howe 1914, 40-41.
4. Van Rensselaer 1893, 8-9.

9

JOHN HENRY TWACHTMAN

(1853, Cincinnati, Ohio-1902, Gloucester, Massachusetts)

My House, c. 1899
Oil on canvas
30 1/8 x 25 in. (76.5 x 63.5 cm)
Yale University Art Gallery,
New Haven, Connecticut
Gift of the Artist

Guided by the same aesthetic concerns that he explored in his art, John Twachtman constantly made changes to his home and land in Greenwich, Connecticut, during the 1890s (see cat. 5).[1] In his paintings, he created compositions that appear casual, but that reveal the underlying beauty and order in nature. Similarly, he made modifications to his home and property that were meant to appear unplanned, but that served to accentuate the unique and special qualities intrinsic to the countryside.

At the west side of his house, Twachtman built an addition that was adjusted to the rise of the hillside, while at both the south and north sides of the building, he extended the roof eaves downward, orienting the home to the land. Dormer windows relieved the structure of its angularity, associating it with the irregularities of the terrain. The most formal change that Twachtman made to his residence was the addition in the late 1890s of a classical portico at the front of the dwelling that was designed by the prominent architect Stanford White (fig. 48). Although such a traditional entryway certainly gave the remodeled farmhouse a new, distinguished look, the small temple-front gable set on Tuscan-style columns did not overwhelm the architecture; it merely added a civilized note to the home, as if to provide a quiet reminder that this is its public side.

In *My House*, Twachtman featured the columned entryway to his home from the side, making it appear almost as a small Greek temple in a pastoral landscape. Applying sweeping strokes of impasto blended with a range of pastel tonalities, he noted how sunlight created a variety of reflected soft colors in the white building. The hues in the architecture are echoed only in slightly stronger colors in the landscape, linking the structure with its setting. Although Twachtman lived in Greenwich through-

out the year, in *My House* he expressed the feeling of the harmony, warmth, and comfort of a vacation home in the summer. Indeed, probably referring to the work, a critic in 1899 noted its "vivacity" and described it as "a sunlit white porch surrounded with greenery [that] was as gladsome and spontaneous as could be."[2] In 1901 a *New York Times* reviewer also recognized the feeling of tranquility that Twachtman achieved in *My House*, calling it a view of "a white house — very deliciously painted is its portrait, too — and through the arbors and porch sunlight falls in broad yellow streaks but even so, sunlight though it be, not too yellowy or too hotly."[3]

During Twachtman's era, his Impressionist images of his home such as *My House* were frequently associated with Claude Monet's images of his own homes in the French countryside. For example, a critic for the *Art Amateur* pointed out in 1893 that Twachtman "seems to have taken a hint from [Monet's] preference for commonplace subjects made beautiful by light, and has given us several views of his house (more picturesquely situated, it is true) in summer and in winter."[4] True to this writer's statement, in *My House* Twachtman captured the way that sunlight elevated a humble motif gracefully situated in the landscape into a form of beauty and serenity.

LNP

1. For sources on the artist, see cat. 5, note 1.
2. "Ten American Painters," *The Artist* 28 (June 1899): xii-xiii.
3. "A Trio of Painters: Pictures by Three Americans in Three Fifth Avenue Galleries," *New York Times* (7 March 1901): 8.
4. "French and American Impressionists," *Art Amateur* 29 (June 1893): 4.

Figure 48.
Front of John Twachtman's house featuring the portico, c. 1902, photograph from Alfred Goodwin, "An Artist's Unspoiled Country Home," *Country Life in America* 8 (October 1905): 628. Courtesy, Spanierman Gallery, New York.

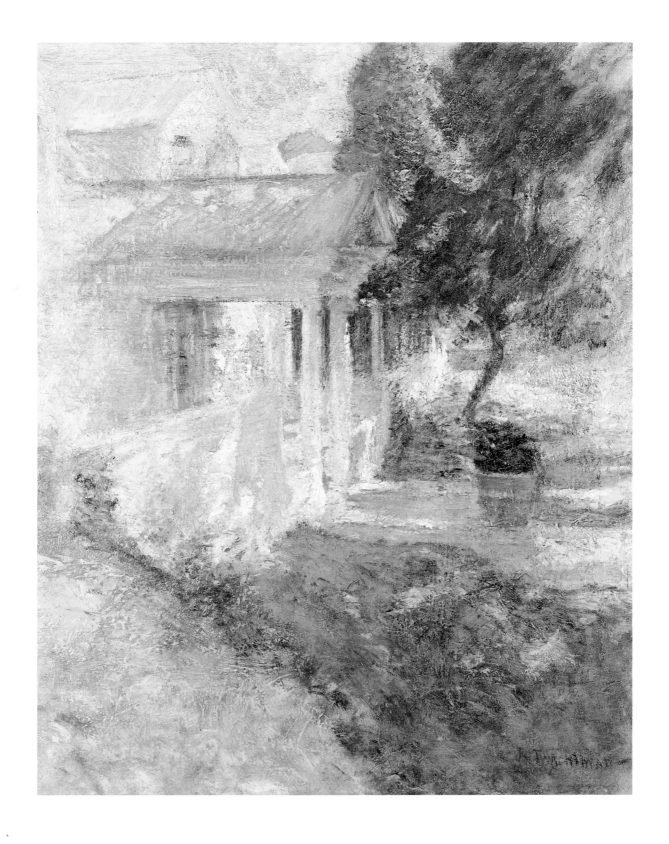

IO

CHILDE HASSAM

(1859, Dorchester, Massachusetts-1935, East Hampton, Long Island)

Little Old Cottage, Egypt Lane,
East Hampton, 1917
Oil on canvas
32 3/4 x 45 1/2 in. (83.2 x 115.6 cm)
Guild Hall Museum, East Hampton,
New York, Gift of Mrs. Chauncey
B. Garver (in memory of her
great uncle and great aunt, Mr. and
Mrs. Childe Hassam)
Exhibited only at The Trout Gallery

A descendant of Revolutionary War patriots, Childe Hassam grew up in Boston, where he began his career as an illustrator, working for journals such as *Harper's, Century,* and *Scribner's.*[1] Upon deciding to become a painter, he studied at the Boston Art Club and privately with Dr. William Rimmer and Ignaz M. Gaugengigl. He made his first trip to Europe in 1883. On a second trip abroad from 1886 to 1889, Hassam spent most of his time in Paris, where he painted views of the city and began to use Impressionist broken brushwork and vivid hues. The brilliant light and flickering dabs Hassam employed earned him a reputation as the most "French" of the American Impressionists.

Although he painted a number of floral and figurative works, Hassam's primary subject matter was the landscape. His sites were broad-ranging. For twenty years he painted scenes of Appledore, in the Isles of Shoals off the New Hampshire coast. He also worked in Cos Cob and Old Lyme, Connecticut, Provincetown, Rhode Island, and Gloucester, Massachusetts. Despite his interest in coastal and suburban scenes, Hassam was perhaps best known for his views of New York City. Indeed, Hassam was one of the only American Impressionists to focus on urban imagery.

Another subject that Hassam portrayed frequently was the old home. He depicted this motif as early as 1884, when he painted *Old House, Dorchester* (Montgomery Museum of Art, Alabama), which reflects the influence of the French Barbizon School. At the turn of century, Hasssam created a number of oil paintings and pastels representing the facade, porches, and interior of the Holley House in Cos Cob, where many artists gathered and boarded, and in at least one image, *The Stone Cottage, Old Lyme* of 1903 (location unknown), he featured a small dwelling in this Connecticut artists' colony, which he frequented periodically between 1903 and 1912.[2] Nevertheless, Hassam's focus on the old home occupied him most frequently during the years he spent in East Hampton, Long Island, where he painted the town's shingled cottages, most of which dated from the Colonial era.

Hassam first visited East Hampton in 1898, but it was not until 1917 that he began to take a serious interest in the Long Island landscape.[3] In 1919 he purchased "Willow Bend" from the widow of Ruger Donoho. This home on Egypt Lane in East Hampton, which Hassam described as "one of the first houses ever built by one of the earliest English settlers," was a shingled structure constructed in 1725 and restored in the early twentieth century on one of the town's most charming streets.[4] Hassam was fond of the overgrown landscape of waving meadow grasses, huckleberry and blackberry bushes, and wildflowers near his home.[5] When there was an attempt to clear away the scruffy vegetation on the street faced by his cottage, he objected: "East Hampton could very easily be made into a combed and manicured suburb—a New Rochelle—but it must not happen!"[6]

In *Little Old Cottage, Egypt Lane, East Hampton* of 1917, Hassam depicted the home of fisherman Sylvester W. Hulse, which in 1900 had been moved from its original location at Three Mile Harbor, a few miles north of East Hampton to its current site at 127 Egypt Lane. Showing the small cottage prominently in this closely cropped composition, Hassam captured the multitudinous colors he observed in the shadows and reflections on the building's shingled walls and roof and in its leaf-strewn yard (which exemplifies the untidy look that Hassam favored). The overall effect is lithe and sparkling, suggesting the impact not only of French Impressionist methods but also of the decorative approach of Post-Impressionists such as Pierre Bonnard and Georges Seurat. The enclosed yard with its two chairs set out for conversation and discrete side-entry gate reveals a private and intimate setting made welcoming by its subtle richness of color.

LNP

1. The principal sources on the artist are Adeline Adams, *Childe Hassam* (New York: American Academy of Arts and Letters, 1938); Donelson Hoopes, *Childe Hassam* (New York: Watson-Guptill, 1979); Kathleen Burnside, *Childe Hassam in Connecticut,* exh. cat. (Old Lyme, Conn.: Florence Griswold Museum, 1987); and Ulrich Hiesinger, *Childe Hassam: American Impressionist* (Munich: Prestel, 1994).
2. Illustrated in Adams 1938, opp. page 34.
3. On Hassam's East Hampton life and art, see Judith Wolfe, "Childe Hassam in East Hampton—A Note," in *Childe Hassam, 1859-1935,* exh. cat. (East Hampton, N.Y.: Guild Hall Museum, 1981) and William H. Gerdts, "East Hampton, Old Lyme and the Art Colony Movement" and Helen A. Harrison, "East Hampton's Artists, in Their Own Words," in *En Plein Air: The Art Colonies at East Hampton and Old Lyme, 1880-1930,* exh. cat. (Old Lyme, Conn.: Florence Griswold Museum, 1989), 13-24 and 49-56.
4. Hassam, quoted in Wolfe 1981, 13. Hassam's address was listed in the East Hampton social guide of 1931 on Egypt Lane, no. 446. This information was generously provided by the East Hampton Free Library.
5. The wild beauty of East Hampton is described in "A Plea for Old East Hampton," *East Hampton Star* (23 June 1938), n.p., from "The Nature Trail," scrapbook vol. 53, 305, Archives, Long Island Collection, East Hampton Free Library.
6. Quoted in Harrison 1989, 53.

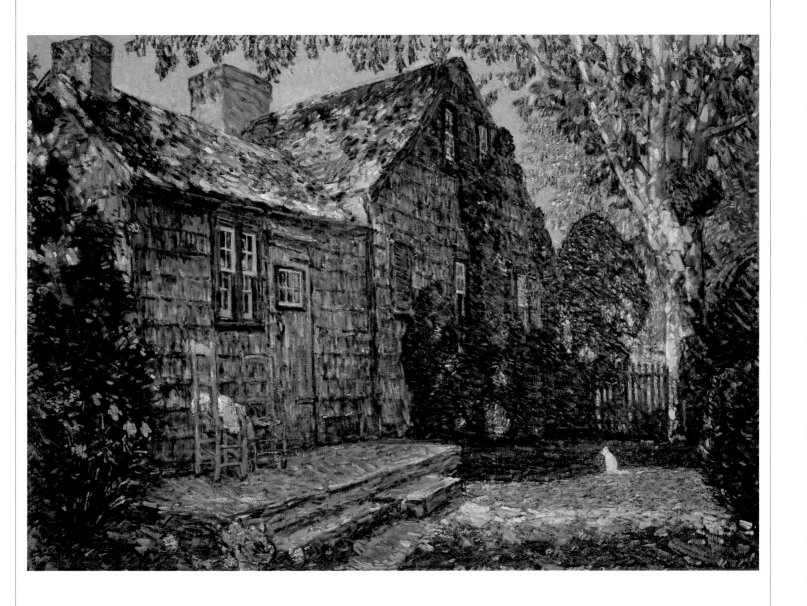

II

THEODORE WORES

(1859-1939, San Francisco)

Home and Garden, Saratoga, c. 1926-1931
Oil on canvas
16 x 20 in. (40.6 x 50.8 cm)
A. Jess Shenson, M.D.

Throughout his career, Theodore Wores had a love of travel.[1] His first voyage abroad occurred in 1874, when he left his native San Francisco for Munich. There, he studied at the Royal Academy and associated with the American artist Frank Duveneck. During a stay in Venice with the "Duveneck boys," Wores met James McNeill Whistler, who spoke to him about the art of Japan. In the years that followed, Wores took several voyages to Asia and the South Pacific. He visited Japan twice, in 1885 and 1892, and he also toured Spain, Samoa, and Hawaii between 1889 and 1903.

Although he continued to travel, around 1907 Wores established his base in the Bay Area, becoming director of the Mark Hopkins Institute of Art in San Francisco. Within a few years, he became increasingly interested in the local landscape, focusing his attention on the blossom-covered hills and valleys near San Francisco. This scenery had an impact on Wores's art, encouraging him to abandon the restrained realist style he had used previously and to adopt Impressionist high-key tonalities and animated brushwork. Wores led the way for the generation of artists who similarly used Impressionist modes to capture the luminescent beauty of the California landscape.

In 1926 Wores moved to Saratoga, California, which, due to its position in the mountains twenty miles south of San Francisco, allowed him immediate access to the subject matter he favored. The artist described his discovery of the area:

WE ARRIVED ONE BEAUTIFUL DAY IN THE LITTLE TOWN OF SARATOGA, WHERE THOUSANDS OF ACRES OF FRUIT TREES WERE IN BLOOM. WE WERE QUITE OVERPOWERED BY THE BEAUTY OF THIS MAGNIFICENT SPECTACLE. AS SOON AS I COULD ARTICULATE, I EXCLAIMED TO MY WIFE, "WE HAVE REACHED THE END OF OUR JOURNEY! HERE WE WILL PITCH OUR TENT AND TARRY A WHILE."...HAVING ARRIVED AT THIS DECISION, WE PROMPTLY PROCEEDED TO PUT IT INTO EXECUTION. WE WANDERED ABOUT THE VILLAGE SEEKING A SITE FOR OUR "TENT," AND IT ENDED WITH THE DISCOVERING OF AN OLD ABANDONED METHODIST CHURCH

WHICH WE FOUND WAS FOR SALE AT A BARGAIN. . . . WITH THE ADVICE AND ASSISTANCE OF AN UNDERSTANDING CARPENTER, WE CONVERTED THE CHURCH INTO A PICTURE GALLERY, "A TEMPLE OF RELIGION INTO A SHRINE OF ART." BACK OF THE CHURCH WAS WHAT WAS FORMERLY THE HITCHING SHED OF THE CONGREGATION IN THE "HORSE AND BUGGY AGE." THIS WE MADE OVER INTO AN ARTISTIC STUDIO, AND AFTER ADDING A FEW COMFORTABLE ROOMS, PRESTO BEHOLD! WE HAD A MOST ATTRACTIVE LITTLE STUDIO HOME.[2]

Wores's home was built in the Mission style (fig. 49), which saw a revival like that of the Colonial on the East Coast, and, like his counterparts who resided in Colonial homes in New England, Wores planted an old-fashioned garden, which became the basis for a number of his paintings. In *Home and Garden, Saratoga,* he painted a view of the garden that he planted in the courtyard of his home (which was also his studio). While he rendered art indoors, Wores also created work outdoors, arranging a free-form garden, where lively flowers were gently curtailed by pathways and enframed by a white pergola supported by classical columns that was open to the sky. Indeed, such pergolas were common features of California homes. In 1907 an article in *The Craftsman,* the voice of the arts-and-crafts movement in America, stated:

OUR APPRECIATION OF THE POSSIBILITY OF THE USE AND BEAUTY OF THE PERGOLA HAS DONE MUCH TO AWAKEN A CHANGE OF HEART TOWARD OUTDOORS, FOR PERGOLAS FURNISH THE SECLUSION OF A LIVING PORCH AT THE SAME TIME THAT THEY GATHER TOGETHER THOSE WHO HAVE GROWN TO APPRECIATE THE LURE OF OUTDOOR LIFE. IN SOUTHERN CALIFORNIA, WHERE THE CLIMATE IS MILD AND PEOPLE LIVE MORE CONTINUOUSLY IN THE OPEN, THE PERGOLA HAS REACHED ITS HIGHEST DEVELOPMENT. . . . WHATEVER KIND OF PERGOLA IS CONSTRUCTED THEY ALL TELL THE SAME STORY OF OUR INCREASING LOVE OF OUTDOOR LIFE AND DESIRE TO ENJOY INTIMATELY THE NATURAL BEAUTY ABOUT OUR HOUSES AND IN OUR GARDENS.[3]

In *Home and Garden, Saratoga,* Wores captured the way that the pergola facilitated the synthesis of flowers with architecture. With sunlight gathering in its latticed beams, the structure provides a link between the enclosed walls of the artist's home and the openness of the garden. In this painting, the horizontal lines of the pergola are also aligned with the roofs of buildings set into Saratoga's hills above Wores's residence. Here we can see evidence of settlement in a countryside that was still essentially wild. At his Saratoga home, Wores, who stated that California "ranked first as a land of sunshine and flowers, both wild and cultivated," created a setting that took advantage of the natural offerings of his home state.[4]

LNP

Figure 49.
Theodore Wores's studio and garden, Saratoga, California, photograph, date unknown. Stanford University Archives, Gift of Dr. A. Jess Shenson.

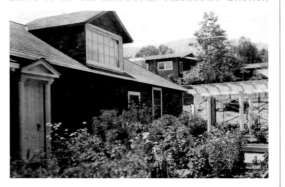

1. The principal source on the artist is Lewis Ferbraché, *Theodore Wores: Artist in Search of the Picturesque* (San Francisco: David Printing, 1968).
2. Theodore Wores, "An Artist's Tale," *Women's City Club Magazine,* San Francisco (March 1938). Quoted in Ferbraché 1968, 57-58.
3. "How Pergolas Add to the Appreciation and Enjoyment of Outdoor Life," *Craftsman* 17 (November 1907): 202.
4. Quoted in Ferbraché 1968, 57.

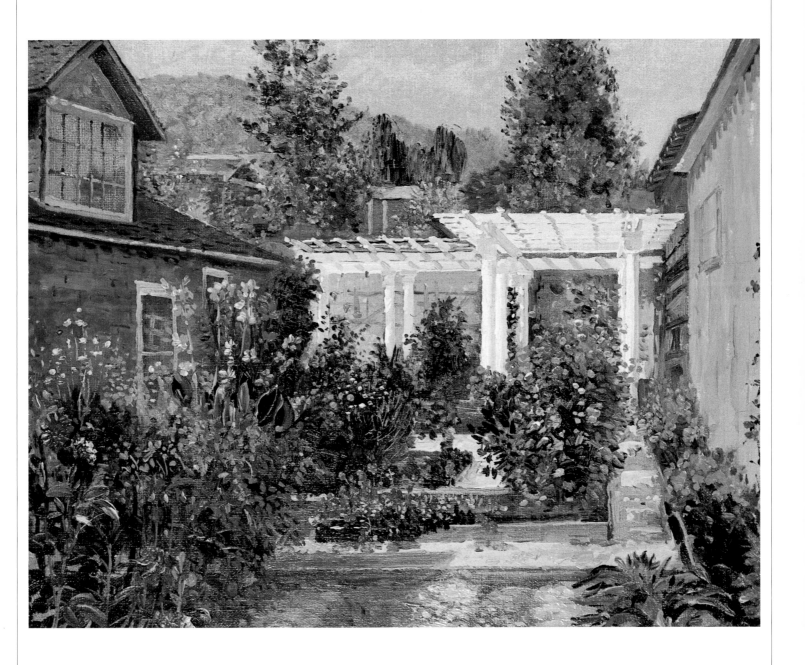

I2

WILLARD LEROY METCALF

(1858, Lowell, Massachusetts–1925, New York City)

Captain Lord House,
Kennebunkport, Maine, c. 1920
Oil on canvas
36 x 36 in. (91.5 x 91.5 cm)
Florence Griswold Museum,
Old Lyme, Connecticut,
Gift of Mrs. Willard Metcalf

Fusing his knowledge of French Impressionism with a more traditional approach to painting, Willard Metcalf created a unique style well suited to conveying the beauty of the New England countryside and to pleasing American audiences.[1] Often working within square canvases, Metcalf created ordered compositions, with a subdued rather than brilliant palette, that evoke the changing seasons and atmospheric affects of the landscape. During the first decades of the twentieth century, Metcalf was perceived as the artist who could best capture the character of the landscape for which he earned the title "poet laureate of the New England hills."

Tied to his involvement with the New England countryside, Metcalf developed a strong interest in old homes from the Colonial era. Frequently he depicted these structures set within a natural environment of trees, flowers, and grounds, as exemplified by his 1908 *October* (pl. 16) where a whitewashed dwelling with green shutters sits picturesquely in a colorful fall landscape. Metcalf painted a number of other distinguished Colonial homes, including that of Nathaniel Lord in Kennebunkport, Maine (fig. 50). During the War of 1812, Nathaniel Lord, a wealthy merchant and shipbuilder, profited tremendously from having the last salt shipment arrive before the British blockade halted commerce. Lord used these funds to erect what still is one of the most magnificent homes in Kennebunkport. The house remained in the family and became the summer residence of Lord's grandson, Charles P. Clark, president of the New York/New Haven Railroad at the end of the nineteenth century. Metcalf painted a number of pictures in Kennebunkport during the summer of 1920 while staying at the home of Booth Tarkington. At the time that Metcalf painted this work, the home had probably been passed on to Clark's daughter Sally, and her husband Edward Buckland.[2]

Several large old trees and shrubs enclose the house on all sides casting dramatic shadows upon the three-storied house. The house has an elaborate door surround and a fanlight over the front door and windows are arranged vertically and horizontally in symmetrical rows reflecting neoclassical taste. A yellow house with white trim, several chimneys and a cupola protrude from the top of this Federal mansion. Set against a blue sky and surrounded by a white picket fence, this stately home is situated within an expansive green lawn which led down to the Kennebunk River. In 1898, as part of a series of renovations, Clark had three homes in front of the mansion demolished to create an unobstructed view of the Kennebunk River and the family boat house.[3] He also extended the building, added a third story to the rear half of the structure, and transformed the original kitchen into a Victorian dining room. A barn located near the house was also moved. A photograph from the early 1970s shows the house from a similar angle as Metcalf's painting, complete with the white fence and several of the large elms surrounding the house (fig. 50).

Employing yellow, red, pink, white, purple, and green, Metcalf suggests a densely massed arrangement of flowers blooming in the lower left hand corner of the picture. The large shadow cast on the foreground suggests that other trees are located near the flower patch, probably similar to those seen in the lower left corner of the photograph. Thinly painted, with only slight impasto in the flowers, the viewer can discern the weave of the canvas in several areas of *Captain Lord House*, and the restrained style of this picture relates to other works from the later years of Metcalf's career.

Metcalf unites the old mansion, which is engulfed by ancient trees, with the lawn and flower gardens. The harmonious union of home with the grounds and gardens echoes recommendations found in American publications of the same period. In addition, *Captain Lord House* reflects the interest of Metcalf and his contemporaries with the Colonial past. Since the turn of the century, Americans were fascinated with the sense of history reflected in the landscape and villages of New England. Maintained by the same family for several generations, old estates such as the Lord house, bore the impress of the passage of time. Enshrouded in nostalgia, images of Colonial homes convey a distinctly American sense of place and history which is linked to the landscape and villages of New England.

JB

Figure 50.
Captain Lord Mansion, photograph, c. 1972. Courtesy, Florence Griswold Museum, Old Lyme, Connecticut.

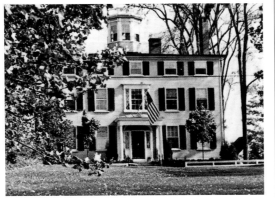

1. The principal source on the artist is Elizabeth De Veer and Richard J. Boyle, *Sunlight and Shadow: The Life and Art of Willard L. Metcalf* (New York: Abbeville Press, 1987).
2. Telephone conversation with the home's current owner, Rick Litchfield, 12 December 1996.
3. Conversation with Litchfield, 1996.

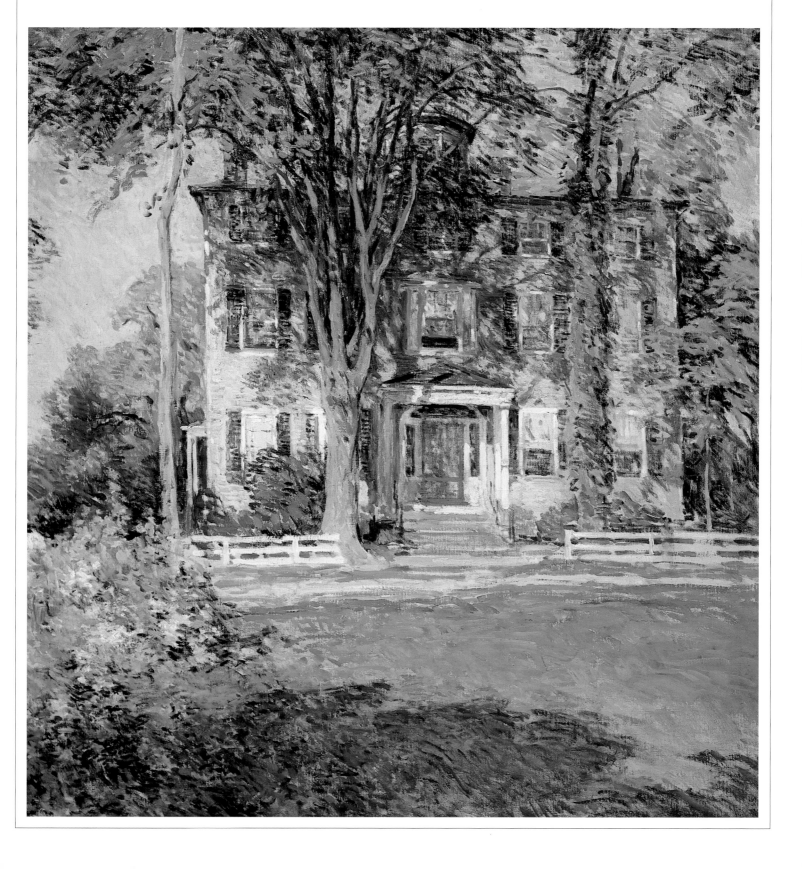

13

DENNIS MILLER BUNKER

(1861, Garden City, Long Island, New York-1890, Boston)

Roadside Cottage, c. 1890
Oil on canvas
18 x 24 in. (45.7 x 61 cm)
Art Complex Museum, Duxbury,
Massachusetts

Figure 51.
View of the former caretaker's cottage at
Tannery Farm, Medfield, photograph,
1995. Courtesy, Lisa N. Peters.

Dennis Miller Bunker is known for his sensitive and precisely rendered portraits which reflect the impact of his academic studies in New York and Paris during the 1870s and 1880s, but he also created some highly adventurous and intriguing landscapes.[1] In 1883 and 1884, he created views of Brittany that reveal the influence of the French Barbizon School, while demonstrating Bunker's interest in strong contrasts of light and shadow. By the end of the decade, Bunker was exploring Impressionism. He became familiar with the French style during the summer of 1887, when he stayed with John Singer Sargent in the English town of Calcott Mill. Having recently visited with Claude Monet, Sargent was himself experimenting with Impressionist techniques for the first time, and probably encouraged Bunker to follow suit. However, it was not until the next summer that Bunker did so.

Bunker delved into a study of Impressionist methods during the summers of 1889 and 1890, which he spent in the town of Medfield, Massachusetts, located eighteen miles southwest of Boston. Escaping the city appears to have been Bunker's primary motivation in traveling to Medfield, and he delighted in the town's peaceful isolation. He wrote to his friend, the art patron Isabella Stewart Gardner:

YOU SHOULD SEE THE CHARLES RIVER HERE—IT HAS DWINDLED ALMOST TO [A] BROOK—AND HAS LOST ALL ITS BOSTON CHARACTER. IT IS VERY CHARMING—LIKE A LITTLE ENGLISH RIVER—OR RATHER A LITTLE LIKE AN ENGLISH RIVER. IT RUNS HERE THROUGH THE MOST LOVELY GREAT MEADOWS—VERY PROPERLY FRAMED IN PINE FORESTS—AND LOW FAMILIAR LOOKING HILLS—ALL VERY MUCH THE REVERSE OF STRIKING OR WONDERFUL OR MARVELOUS BUT VERY QUIETLY WINNING AND ALL WEARING SO VERY WELL, THAT I WONDER WHAT MORE ONE NEEDS IN ANY COUNTRY.[2]

Earlier, the quiet pastoral character of Medfield had attracted another important American artist. While living there from 1860 to 1864, and again in 1873 and 1877, George Inness painted a number of his finest works. Like Bunker, Inness was inspired by the area's glistening, dewy meadows (many of which are protected wetlands today), the meandering river, and the variable skies. Both artists were attracted by Medfield's serenity, but they probably were also glad of the town's accessibility to Boston. As early as 1860, Inness stated his desire to "plant himself in one of the pleasant villages in the vicinity of Boston."[3] By the 1870s, the town was linked to Boston by the train that ran on the Framingham and Mansfield Railroad, but Bunker, who lived further away from the center of the village than

had Inness, enjoyed the company of only a small group of friends. In Medfield, he resided at Tannery Farm, a boarding house run by Miss Alice Sewall, who was the daughter of a prominent and educated minister. There Bunker was joined by musician, Charles Martin Loeffler, Loeffler's fiancée Elise Fay, and her brother Temple Fay.[4]

In Medfield, Bunker painted essentially the same subject matter that had been depicted by Inness. Yet there are great differences in approach. Reflecting his new interest in Impressionism, Bunker took an intimate perspective on the marshes; he thereby captured the sparkling sunlit patterns on the velvety green fields where dry grasses were strewn (as they are today). Paintings such as *Wild Asters*, 1889 (fig. 37) have remarkable parallels with the view that may be seen today across the street from the boarding house (which is now a private home).

In at least two paintings, Bunker featured the small caretaker's cottage on the Sewall's property that faced the road (fig. 51).[5] Built in the seventeenth century, the small clapboard cottage (which today is also a private home) was a relic of the Colonial past, and Bunker may have chosen it as a subject in response to a vogue for places that recalled the pre-industrial era in America. He depicted the structure accurately. We can see stone steps that led down to the road, the two red-brick chimneys, the windows, and four white strokes near the road in the right foreground which may have been a hitching post for horses. However, Bunker took liberties with the scene so as to emphasize the home's harmonious connection with its site. Sunlight filtering through trees casts dappled pink, lavender, and green reflections on the white facade and falls in glowing patterns on the grass and street. The shadowed forms of leaves merge with the roof's shadows, while a large brown trunk is aligned with the right front corner of the building as if to root it to the site. A tree branch similarly follows the contour of the home's gable. At the left, bushes soften the edge of the dwelling, blurring the line between architectural form and nature. The home appears to "fit the surroundings and do it in such a way that it . . . [seems] to have been so always been there," revealing a sense of the stability that the artist found "quietly winning."[6] Unfortunately, Bunker was unable to further his investigation of Impressionist light and color due to his sudden death from heart failure in December 1890.

LNP

1. The most comprehensive source on Bunker is Erica E. Hirshler, *Dennis Miller Bunker: American Impressionist*, exh. cat. (Boston: Museum of Fine Arts, 1994).
2. Bunker, Medfield, to Gardner, n.d. [1889]. Gardner papers, Archives of American Art, Smithsonian Institution, Washington, D.C., microfilm reel 394.
3. *New York Tribune* (16 June 1860), quoted in Nicolai Cikovsky, Jr. and Michael Quick, *George Inness*, exh. cat. (New York: Harper & Row, Publishers, Inc., 1985), 86.
4. See Hirshler 1994, 65.
5. The other view of the subject is *Roadside Cottage*, c. 1889, oil on canvas, 25 1/16 x 30 in. (63.6 x 76.2 cm), collection of Mr. and Mrs. Raymond J. Horowitz.
6. Mary H. Northend, *Remodeled Farmhouses* (Boston: Little, Brown, and Co., 1915), 87.

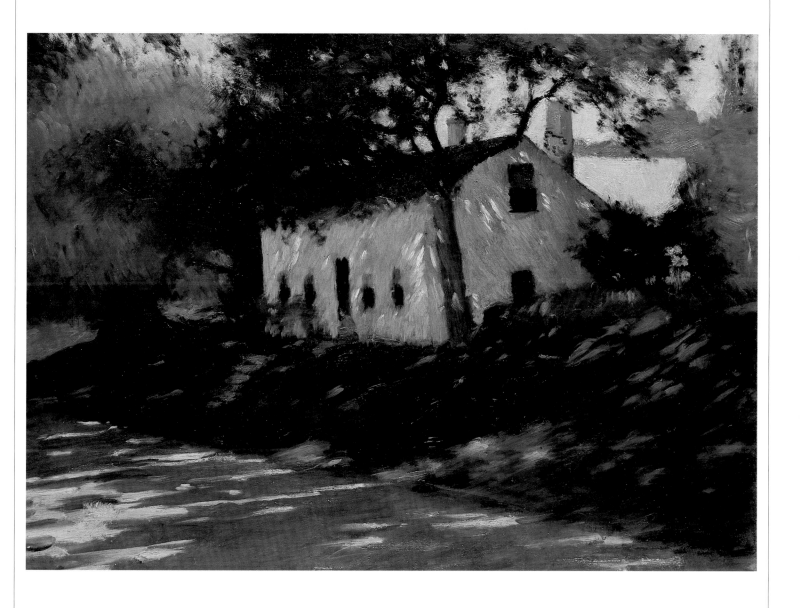

14

CLARK GREENWOOD VOORHEES

(1871, New York City-1933, Old Lyme, Connecticut)

My Garden, c. 1914
Oil on canvas
28 3/4 x 36 in. (73 x 91.4 cm)
Michael W. Voorhees

In the summer of 1896, Clark Voorhees was bicycling through the Connecticut countryside when he came upon the town of Old Lyme.[1] At the time, the art colony had not yet emerged there, and Voorhees did not linger. He returned to New York City, where he had only recently given up plans to become a chemist in order to embark on a career in art. He received his art training in New York at the Art Students League and the Metropolitan School of Fine Arts, as well as with Irving Wiles at Peconic, Long Island. In 1896, shortly after visiting Old Lyme, he left for Europe where he stayed for four years, studying in Paris at the Académie Julian and staying in the towns of Barbizon, France, and Laren, Holland.

Voorhees returned to the United States in 1900, and two years later he again visited Old Lyme. By this time, the town had changed significantly, having become the center of a dynamic gathering place for artists who were working primarily in the style of the French Barbizon School. In the years that followed, Voorhees became a leading figure in the colony. He purchased a home there in 1903, and, after his marriage to Maud Christine Folsom in 1904, he split his time between Old Lyme and Lenox, Massachusetts, his wife's hometown.

Voorhees's first Old Lyme works demonstrate the influence of the Tonalist painter Henry Ward Ranger. However, like other Old Lyme artists, Voorhees gradually adopted an Impressionist style, inspired by the art of Childe Hassam and Willard Metcalf, who joined the colony in 1905.

Voorhees took an active role in both Old Lyme's artistic community and its social life in general. He participated in exhibitions at the Lyme Art Association and was a founding member of the Old Lyme Country Club. Known for his hospitality, he often invited fellow artists to visit the home he purchased in 1903.

Indeed, Voorhees's house was distinctive. Situated on the Connecticut River, this residence, which Voorhees and his wife called "Ker Guen" (Dutch for White House), was a 1740 gambrel-roofed cottage that once belonged to a sea captain (fig. 52). In the interior, the artist hung Japanese prints, displayed eighteenth-century antiques, and arranged historical souvenirs. Around the house, Voorhees planted a garden that rose up to the walls of the old saltbox, giving it the privacy and connection with its site that were recommended by writers on the home during the period. Located on the back side of the house, the residence's front portico faced a steep slope that led down to the river. Here, in the summer, a lively garden bloomed, softening the steepness of the drop, while from the garden's center, a view across the river was afforded. As H. S. Adams reported in a 1914 article in *Country Life in America* magazine entitled "Lyme—A Country Life Community":

THE HOUSE IS ENTERED FROM THE SIDE LAWN, AND THERE ARE ARTEMISIAS ON EACH SIDE OF THE DOOR AND ALSO SOME HARDY PRIMULAS THAT MRS. VOORHEES DUG UP IN ITALY AND BROUGHT TO LYME. A SINGLE SPECIMEN OF BOX BY THE LIVING-ROOM WINDOW HAS ITS AGE FIXED BY THE KNOWN FACT THAT IT GREW FROM A SPRIG THAT DECORATED A WEDDING-CAKE SIXTY YEARS AGO.[2]

In *My Garden* of 1914, Voorhees captured the harmoniousness of his home grounds. Vivacious blooms and leafy foliage envelope the white cottage, which reaches out toward nature with its canopied porch and columned portico. The exuberant portrayal is augmented by the presence of the young child picking flowers. Concurrently, Voorhees's lithe Impressionist strokes create an overall animated surface, engaging the viewer in the exuberant vision.

LNP

Figure 52.
Clark Voorhees's house overlooking the Connecticut River, photograph, from H. S. Adams, "Lyme—A Country Life Community," *Country Life in America* 25 (April 1914): 50. Courtesy, Florence Griswold Museum, Old Lyme, Connecticut.

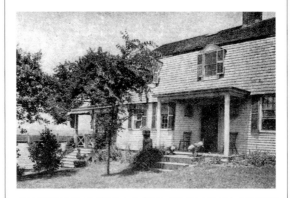

1. The primary source on the artist is Jeffrey W. Andersen and Barbara J. MacAdam, *Clark G. Voorhees, 1871-1933*, exh. cat. (Old Lyme, Conn.: Lyme Historical Society, Florence Griswold Museum, 1981).
2. H. S. Adams, "Lyme—A Country Life Community," *Country Life in America* 25 (April 1914): 92, 94.

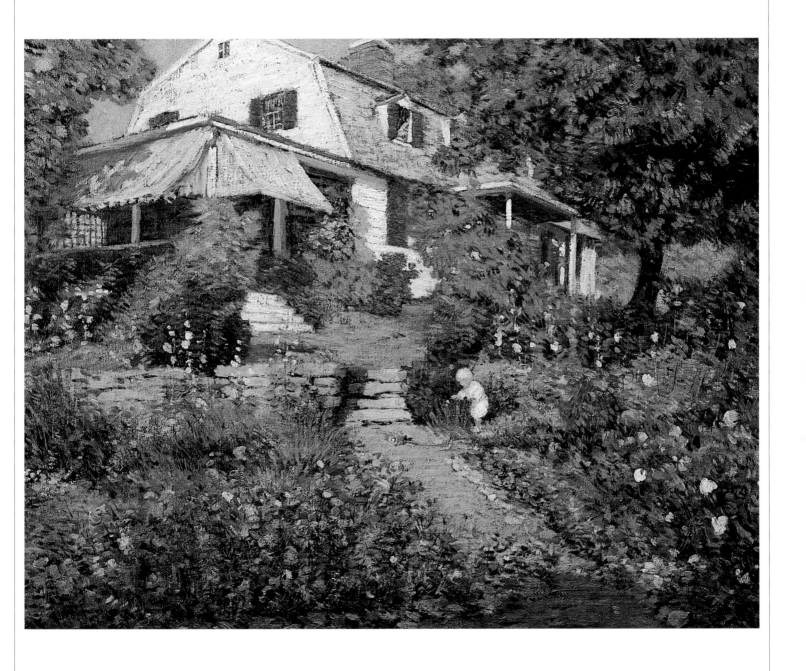

15

EVERETT LONGLEY WARNER

(1877, Vinton, Iowa-1963, Bellows Falls, Vermont)

The Guardian Elm, c. 1912
Oil on canvas
40 x 32 in. (101.6 x 81.3 cm)
The National Arts Club Permanent
Collection, New York

Everett Longley Warner made his first trip to Old Lyme, Connecticut, in the summer of 1909, possibly at the suggestion of his friend and fellow artist Harry Hoffman.[1] Situated at the mouth of the Connecticut River, Old Lyme had emerged as a popular summer art colony around 1900, eventually attracting a coterie of American Impressionist painters that included Childe Hassam, Willard Metcalf, and Frank Bicknell. Easily accessible by train from New York City, the village and its environs provided artists with a range of motifs that included gently rolling countryside, flower gardens, and picturesque Colonial architecture.

Old Lyme subsequently played a vital role in Warner's aesthetic development, for it was there, inspired by Hassam's example in particular, that he abandoned his former Tonalist style and adopted the bright colors and fluent brushwork associated with Impressionism. Indeed, Warner became a regular summer visitor to the Lyme colony, going on to paint intimate views of surrounding hills, woods, and pastures under varying weather conditions. He also combined his landscape concerns with an interest in local architecture, depicting such well-known landmarks as the First Congregational Church and Bow Bridge.

As revealed by *The Guardian Elm*, Warner was also drawn to the old salt-box houses scattered throughout the village. These charming dwellings first made their appearance in New England during the seventeenth century when, as Mariana G. van Rensselaer pointed out, "the traditions of classicizing art died out, when our early forms and ideals were abandoned even by the most conservative, the most provincial."[2] Built on wide green lawns and surrounded by trees, these modest houses had plain, clapboarded exteriors and simple, low-ceiled interiors, and were deemed "distinctively American, thoroughly original in effect....Their universal white paint, unbroken save by green blinds and gray shingled roofs, increased the air of cheerfulness and purity, and was not discordant with the omnipresent foliage and with the bright blue of our sky."[3]

The house featured in *The Guardian Elm* is possibly the Justin Smith House (erected in the 1700s), which still stands today on Lyme Street (fig. 53).[4] The scene also includes a woman and a small girl enjoying this tranquil country setting, seemingly protected by the white picket fence that surrounds the property as well as by various shade trees, including a tall elm that towers over the gambrel roof. The presence of the adult female, the various architectural forms, and the "guardian elm," evoke feelings of security, comfort, and domesticity—qualities that typified American Impressionist images of home.[5]

Working in a modified Impressionist manner, Warner captures the myriad fluctuations of sunlight on the architecture and landscape by means of loose, flickering brushwork, eschewing individual detail and specificity. At the same time, he conveys the sense of "cheerfulness and purity" discussed by van Rensselaer by using a palette dominated by fresh greens and blues, augmented by touches of red, yellow, and various earth tones.

Warner was obviously pleased with *The Guardian Elm*, for he exhibited the painting in New York, Philadelphia, Chicago, and elsewhere prior to presenting the work to the National Arts Club in 1915. Not surprisingly, contemporary critics responded favorably to both his style and his choice of subject matter, among them a writer for the *Hartford Courant*, who deemed it a "typical Connecticut picture...the tall and stately tree in its emerald wealth of summer foliage o'erspreading a white country house upon which the sun shines with dazzling effect."[6] The reviewer went on, declaring the painting a "vision of homeliness and quaint charm." Certainly, his remarks were apt, for in *The Guardian Elm* Warner reveals his skills in rendering the effects of outdoor light. He also provides us with an image that underscores the appeal of country living at the turn of the century, and, at the same time, pays homage to New England's distinctive architectural heritage.

CL

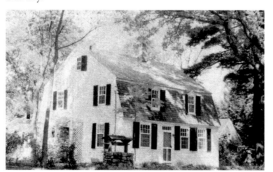

Figure 53.
Justin Smith house, photograph, from *Landmarks of Old Lyme, Connecticut* (Old Lyme, Conn.: The Ladies Library Association of Old Lyme, 1968): 17. Courtesy, Florence Griswold Museum, Old Lyme, Connecticut.

1. See Helen K. Fusscas, *A World Observed: The Art of Everett Longley Warner, 1877-1963*, exh. cat. (Old Lyme, Conn.: Florence Griswold Museum, 1992), 14.
2. M[ariana] G. van Rensselaer, "American Country Dwellings. I," *Century Magazine* 32 (May 1886): 5.
3. Van Rensselaer 1886, 6.
4. I would like to thank my colleagues, Dr. Lisa N. Peters and Jeffrey W. Andersen, Director of the Florence Griswold Museum in Old Lyme, for their kind assistance in the identification of the house. For further information on the Justin Smith House and other related structures in the village, see *Landmarks of Old Lyme, Connecticut* (Old Lyme, Conn.: The Ladies Library Association of Old Lyme, 1968).
5. According to Jeffrey W. Andersen, the house was once owned by Matilda Browne (1869-1947), the first woman painter associated with the Old Lyme colony. However, in her listings in the annual exhibition records of the National Academy of Design during the 1900s and 1910s, Browne gave Greenwich, Connecticut, as her residence. In all likelihood, she rented the Justin Smith House for her summer sojourns in the colony, and was possibly its occupant when Warner painted *The Guardian Elm*.
6. "Art News of the Week," *Hartford Courant* (26 June 1915), Scrapbooks, The Records of The National Arts Club, Archives of American Art, Smithsonian Institution, Washington, D.C., microfilm roll 4266.

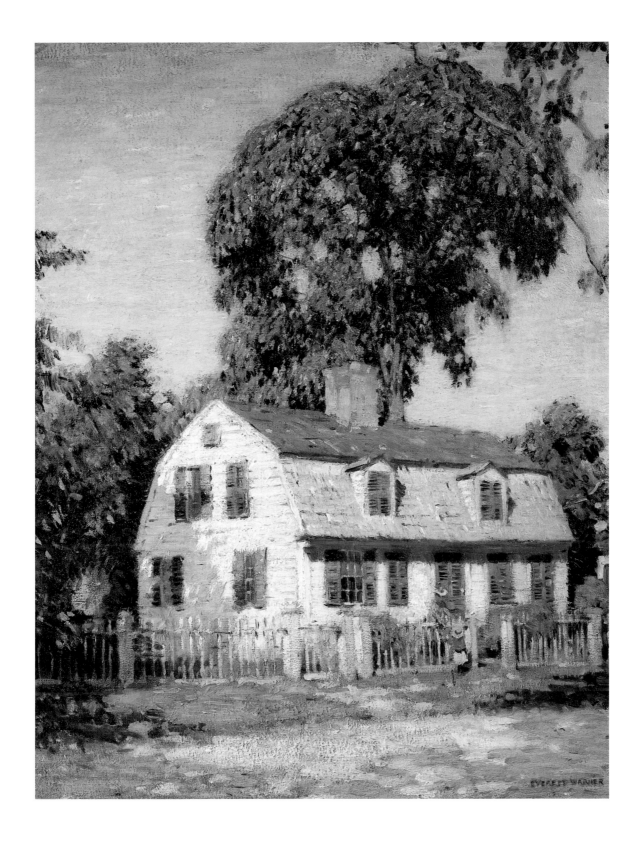

16

WILLARD LEROY METCALF

(1858, Lowell, Massachusetts-1925, New York City)

October, 1908
Oil on canvas
26 x 29 in. (66 x 72.8 cm)
Museum of Fine Arts, Springfield,
Massachusetts, Gift of the
Grandchildren of Frederick Harris

After having established a career as a wood engraver and figure painter, Willard Metcalf left Boston, in 1883, for France (see cat. 12).[1] During his five-year stay abroad, he studied in Paris at the Académie Julian and spent summers in popular artists' colonies in Brittany and Normandy, where he painted images of peasants and silvery tonal landscapes that reflected the influence of the French pleinairiste Jules Bastien-LePage. Metcalf was an early visitor to the town of Giverny, which was the home of Claude Monet, but the influence of Impressionism would not surface in his art until he returned home.

Back in America in 1888, he settled initially in Boston, but by 1891 he had moved to New York. Soon he was focusing on the New England countryside, painting sites in old villages and rural communities that evoked memories of the nation's pastoral past. In 1912 a writer for the *New York Sun* commented on Metcalf's commitment to American scenery. The critic further argued that Metcalf's decision to relinquish French Impressionist methods was based on his new subject matter, which induced him to formulate a style uniquely suited to his sites:

WILLARD L. METCALF BELIEVES THAT A LANDSCAPE ARTIST PAINTS BEST ON NATIVE SOIL. COSMOPOLITANISM IS ALL VERY WELL IN ITS WAY, BUT IT IS ONLY SKIMMING THE SURFACE WHEN AN AMERICAN DELINEATES GERMAN, FRENCH, OR ITALIAN SCENERY....THUS FAR AMERICAN PAINTERS HAVE GIVEN US THE HAPPIEST VERSIONS OF OUR LANDSCAPE, AND THOSE MEN ARE SUPERIOR WHO HAVE BEGUN TO FORGET THEIR GALLIC OR TEUTONIC WAY OF ENVISAGING LIFE AROUND THEM; WE MEAN BY THIS NOT ALONE TECHNICAL METHODS BUT THE SPECIAL VISION OF AN ARTIST TRAINED IN PARIS OR MUNICH. MR. METCALF IS A CASE IN POINT. WHEN HE RETURNED TO NEW YORK IN 1890 AFTER YEARS OF STUDY IN PARIS HE PAINTED TO ALL INTENTS AND PURPOSES LIKE A FRENCHMAN AND A FRENCH IMPRESSIONIST. HE HAS MODIFIED DURING THE LAST TWENTY YEARS HIS MORE RADICAL OUTLOOK AND EXPRESSION OF NATURE, AND BY DINT OF PAINTING ONLY AMERICAN SCENERY HE HAS EMANCIPATED HIMSELF FROM A SCHOOL AND HAS HIS OWN PERSONALITY WITH ABSOLUTE CLEARNESS.[2]

The style Metcalf developed, characterized by short, wiry strokes, vibrant warm but not brilliant tones, and cleanly ordered arrangements in which distances are clearly articulated, expressed his positive and joyful response to his sites. Metcalf's straightforward and sincere approach (often associated with the poetry of Robert Frost) was exactly

Figure 54.
Peletiah Leete III house, Leete's Island, Connecticut, photograph, 1995. Courtesy, Lisa N. Peters.

suited to the comfortable rusticity of the New England countryside, and his works convey his appreciation of these sites in all seasons of the year.

Among Metcalf's favorite subjects were old homes dating from the Colonial era that were set picturesquely in nature, a choice that reflects the revival of interest in these dwellings. They were championed, in particular, by the prominent art and architectural writer Mariana van Rensselaer, who pronounced in 1886 that such buildings represented the "neat, cheerful, pretty domesticity" of the old New England village where "poverty, squalor, and unthrift" were kept out and where homes were widely spaced, creating "a succession of green lawns, gay garden-plots, and broad grassy streets, over which the thick-set elms and maples arched their vaults of verdure." Writing of saltbox dwellings, van Rensselaer stated:

BEAUTIFUL THEY CERTAINLY WERE NOT; AND YET WHEN THEY WERE BUILT THE NEW ENGLAND VILLAGE PUT ON THE ASPECT WHICH MADE ITS NAME PROVERBIAL FOR A NEAT, CHEERFUL, PRETTY DOMESTICITY....

As noted in the discussion of Warner's *Guardian Elm* (cat. 15), van Rensselaer also commented on the ubiquitous white paint and green shutters of the New England saltbox home which create a harmonious foil to the trees and sky surrounding them: "[They] gave a negative sort of satisfaction by their utter modesty and frank simplicity."[3]

As if illustrating van Rensselaer's description, Metcalf's *October* shows a trim, cheerful whitewashed dwelling with green shutters set picturesquely in a blazing fall landscape. The canvas was painted on a six-week trip Metcalf took to Leete's Island in Guilford, Connecticut (southeast of New Haven), where he was a guest of Judge Calvin Leete and his wife Mary. The home in the painting (still maintained as a private residence and now returned to its original unpainted state), is the ancestral saltbox dwelling of Peletiah Leete (the grandson of Connecticut Governor William Leete who arrived in America in 1639), built between 1730 and 1760 (fig. 54). In Metcalf's painting, the white facade of the home sets the sparkling vivacity of the golden-yellow and burnt-orange leafage into relief, while the trees soften the lines of the house, linking it organically with its site. Boulders and a meandering stone wall add to the look of a place where time has gradually brought the manmade and the natural into harmony with each other. Metcalf's crisp, exuberant colors express his positive outlook toward the American landscape, while his ordered composition connotes the sense of stability and continuity desired by a populace experiencing the sudden and dramatic changes occurring in the nation during the modern era.

LNP

1. The principal source on the artist is Elizabeth De Veer and Richard J. Boyle, *Sunlight and Shadow: The Life and Art of Willard L. Metcalf* (New York: Abbeville Press, 1987).
2. "Things Seen in the World of Art," *New York Sun* (7 January 1912): 4.
3. Both quotations are found in M[ariana] G. van Rensselaer, "American Country Dwellings. I," *Century Magazine* 32 (May 1886): 5.

17

CHILDE HASSAM

(1859, Dorchester, Massachusetts-1935, East Hampton, Long Island)

East Hampton House
(*Old Mumford House*), 1919
Oil on canvas
21 3⁄8 x 30 in. (54.2 x 76.2 cm)
New Britain Museum of American Art,
New Britain, Connecticut
Charles and Elizabeth Buchanan
Collection, Bequest of
Mrs. Charles Buchanan.
Exhibited only at the Florence
Griswold Museum

During World War I, Childe Hassam painted a se-ries of flag images.[1] Portraying the banners that hung from the windows of New York's tall buildings, these works conveyed his support for the war effort and for American involvement in the Allied nations. Uniting the flag with the skyscraper, the symbol of American ingenuity, enterprise, and technological achievement, Hassam fortified his patriotic stance. In addition, his vivid Impressionist technique served to enhance his message, conveying an uplifting positive statement about the country and its par-ticipation in the war.

Concurrent with his flag imagery, Hassam created a number of views of American buildings dating from the Colonial era. In these works, he expressed nationalist sentiments as well, but instead of focusing on contemporary events he celebrated the country's past. Like other American Impres-sionists who also painted Colonial homes, Hassam evoked nostalgia for an earlier time, one of greater stability and simplicity in American life before the rise of the modern city and the spread of industrial-ization. Narrowing his interest in architecture al-most entirely to old buildings, he painted a series of images of the whitewashed Colonial churches of New England, in which he used the formal struc-ture of his buildings to create strong, simple designs.

Hassam also painted many views of old homes. He focused on this subject especially dur-ing the years he spent in East Hampton, New York (see cat. 10). Near the residence on Egypt Lane, where he resided from 1919 until his death in East Hampton in 1935, there were many old clapboarded and shingled dwellings dating from the seventeenth and eighteenth centuries, which provided ready material for his art.

The home that Hassam portrayed in *East Hampton House* has been identified as the "old Mumford House," although there is no documenta-tion of a house with this name in East Hampton records from the period.[2] Clearly the dwelling was one of the typical Colonial homes of the area. While a portion of the yard in front of the house and an extension at its side are in view, characteristically Hassam's focus is on the building's principal facade, which is seen parallel with the picture plane. Omit-ting the distractions of the surrounding landscape, Hassam concentrates on the patterned qualities of the building's walls. Perhaps responding to the modern art that he could have seen at the Armory Show of 1913, his emphasis is on color and design as much as on the subject itself. Blue, red, and orange tonalities are intermingled in his depiction of the home's shingled walls and roof, while his strokes are textural and firmer than in earlier canvases where he adhered more consistently to the tiny broken strokes typical of the Impressionist approach.

Hassam conveyed the quaint charm of his subject through his choice of perspective. Instead of centering the composition on the building as he did in his views of Colonial churches, here Hassam placed the building to the right of the canvas's cen-ter. The asymmetry of the design calls our atten-tion to the uneven spacing of windows, the high proportions of the facade in relation to its roof, and the narrow doorway adorned with a cluster of orange flowers. Basing his composition on the irregular and quirky qualities of his subject, Hassam expresses his nostalgia for the homespun and craftsman-built products of a pre-technological America.

LNP

1. For sources on the artist, see cat. 10, note 1. On Hassam's flag paintings, see Ilene Susan Fort, *The Flag Paintings of Childe Hassam*, exh. cat. (Los Angeles: Los Angeles County Museum of Art in association with Harry N. Abrams, Inc., New York, 1988).
2. The documentation on the house is noted in the curatorial records of the New Britain Museum of American Art, but no source is given for this attribution.

18

THEODORE WORES

(1859-1939, San Francisco)

Thomas Moran's House, East Hampton, Long Island, c. 1890s
Oil on canvasboard
9 x 12 in. (22.9 x 30.5 cm)
A. Jess Shenson, M.D.

Despite frequent travels to foreign lands, Theodore Wores lived and worked during most of his career in his native San Francisco and its surroundings (see cat. 11).[1] However, during one phase of his life, he was based in New York. In 1891 he had an apartment on West 55th Street, and, from 1896 to 1898, he maintained a studio at Carnegie Hall, where a number of other prominent artists were also in residence.[2] Although Wores was often on foreign sojourns during these years, he also took part in the New York art scene. He exhibited at the National Academy of Design and was a member of the Salmagundi Club and the Century Association. It was probably in the context of these clubs that he met the artist Thomas Moran, who had a leading role in both. Indeed, although the styles of the two artists were vastly different, they may have felt a kinship: both were drawn to exotic subjects. Whereas Wores chronicled life in Asia and the South Pacific, Moran focused during much of his career on painting the dramatic wonders of the American West, especially Yellowstone Park. More to the point, both artists also enjoyed painting landscapes near their homes: Moran often depicted sites in East Hampton, where he lived from 1882 until 1922, while Wores focused on the wildflower-laden hillsides of the Bay Area from the early 1900s until the end of his life.

It was probably during his years of activity in New York City that Wores visited Moran at his East Hampton home (fig. 55). Constructed in 1884, this shingled, hip-roofed dwelling was called "The Studio" by Moran and his wife, the artist Mary Nimmo Moran.[3] With corner towers and gabled dormers, the structure (a national historic site today) was built in the Queen Anne style whose excessiveness would be attacked in American journals by the turn of the century.[4] Over time, the lively garden and creeping vines harmonized the dwelling with its site.

As Moran's biographer Thurman Wilkins commented:

AS SOON AS THE SHINGLES WEATHERED AND VINES CREPT UP THE WALLS, THE HOUSE ASSUMED…"A MELLOWED CHARM." ALONG ITS BROAD LAWN STOOD ROWS OF HOLLYHOCKS, CHRYSANTHEMUMS, AND OTHER FLOWERS WHICH [THE ARTIST'S WIFE MARY] PLANTED EVERY SPRING, FOR SHE WAS A TIRELESS GARDENER. AND HERE, UNLESS UPON THEIR TRAVELS THE FAMILY WAS GLAD TO SPEND SIX MONTHS OR SO OF EVERY YEAR, ARRIVING EARLY IN MAY AND RETURNING TO THE CITY IN OCTOBER, OR EARLY NOVEMBER.[5]

In his painting, Wores expressed the home's "mellowed charm." Seen across an open lawn, the picturesque building rises from a dense network of floral plantings, its corner tower and columned porch enveloped by burgeoning blooms.

Although Moran designed his home and garden with an aesthetic eye, he did not choose to depict them in his paintings. The reason, according to Moran scholar Phyllis Braff, is that Moran would not have considered the subject to be spiritual or uplifting enough to be painted.[6] As an Impressionist, Wores would not have had the same hesitation. Taking his motifs from everyday life, Wores delighted in the bold colorful patterning created by the interaction of flowers and architectural form.

The spirit of Moran's home and garden had a lasting impact on Wores. In 1926, when Wores converted a former Methodist Church in Saratoga, California, into a home and studio, he similarly designed a superabundant and luxurious garden that he featured in a number of his own works (see cat. 11).

LNP

Figure 55.
Thomas Moran at his East Hampton Home, photograph, c. 1900. Courtesy, East Hampton Free Library, New York.

1. For sources on the artist, see cat. 11, note 1.
2. These addresses appear in catalogues for the National Academy of Design.
3. On Moran's home, see Phyllis Braff, *Thomas Moran, 1837-1926: A Search for the Scenic: His Paintings of the American West, East Hampton, and Venice,* exh. cat. (East Hampton, N.Y.: Guild Hall Museum, 1980), 22-33 and N. Sherrill Foster, "Thomas Moran's 'Studio'": Its Architectural Sources," in Braff 1980, 34-35.
4. See the author's essay in this journal, page 9.
5. Thurman Wilkins, *Thomas Moran: Artist of the Mountains* (Norman, Okla.: University of Oklahoma Press, 1966), 176.
6. Author's conversation with Phyllis Braff, 3 December 1996.

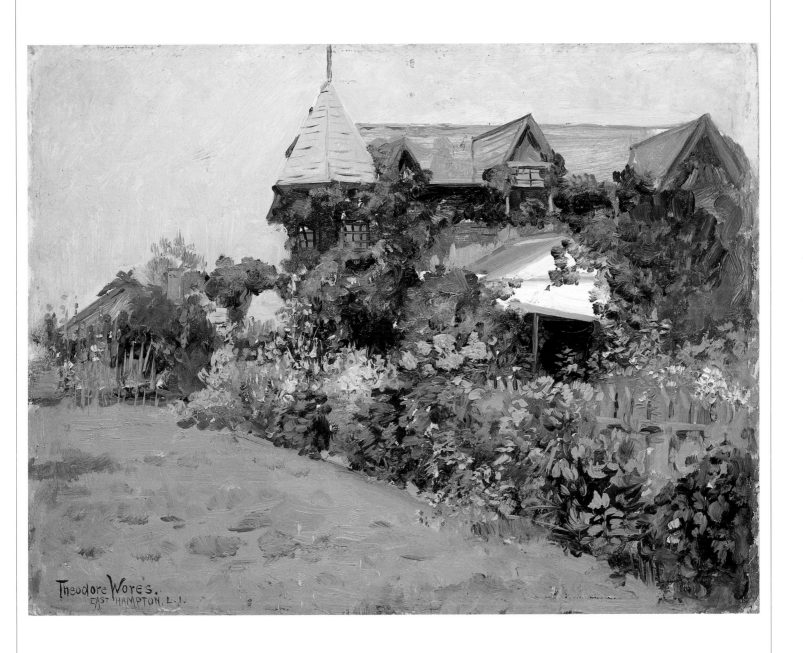

19

ABBOTT FULLER GRAVES

(1859, Weymouth, Massachusetts–1936, Kennebunkport, Maine)

Near Kennebunkport, c. 1900
Oil on canvas
20 x 27 in. (50.8 x 68.6 cm)
Mr. and Mrs. Abbot William Vose,
Vose Galleries of Boston, Inc.

Abbott Graves was fascinated by flowers and gardens throughout his life.[1] While studying in Boston at the Massachusetts Institute of Technology School of Design in the late 1870s, he supported himself by working in a greenhouse. He again pursued his interest in flowers during an extended stay in Paris from 1884 to 1891, where he received instruction from the French painter of floral still lifes, Georges Jeannin. On this sojourn, Graves executed *Flowers of Venice* (location unknown), a large canvas depicting a gondola overfilled with blossoms and flowering plants.

Upon returning to Boston in 1891, Graves became a teacher of flower painting at the Cowles Art School. That summer, he was introduced to the vacation community at Kennebunkport, Maine. The town's old-fashioned gardens set out behind white Colonial cottages were his principal imagery for the rest of his career.

Graves initially spent only summers in Kennebunkport, but after 1895, when he purchased his first home in the village, a small gray cottage on a river bank, he stayed year round. In *Near Kennebunkport,* rendered around 1900, Graves captured the lively freedom of an old-fashioned backyard garden filled with wildflowers such as hollyhocks, baby's breath, and poppies, which are planted behind a green-shuttered clapboard cottage. Although there is evidence of tending in the watering can, the overturned pots, and the presence of the gardener, this is still an informal garden. Graves sought to express its exuberance, not its cultivation. Directly applying high-keyed colors in unmixed dabs onto canvas, he transcribed the effects of strong, overhead sunlight directly engaging with the brilliance of the tangled blossoms.

The scene as a whole evokes the nostalgic appeal of old-fashioned New England gardens, where natural plots of thriving perennials were often associated with rustic cottages. The poet Margaret Deland (whose Kennebunkport garden was painted by Graves) wrote that Graves's "pictures take me back to my [childhood] garden with its roses and hollyhocks and sunshine tempered by the south winds and over it all the flickering shadows of my little birch tree."[2] In 1924 George Alfred Williams further suggested that by recalling the Colonial past, Graves's images could remind us of the American rural heritage:

THE NEW ENGLAND FLOWER GARDEN HAS BECOME A NATIONAL INSTITUTION. CLOSELY WOVEN INTO OUR RACIAL CONSCIOUSNESS OF BEAUTY [IS] THE LOVE OF FLOWER PICTURES [ESPECIALLY OF] OLD-FASHIONED GARDENS AND THEIR POSIES....IT IS, PERHAPS, THE CLOSENESS OF THE GARDEN TO THE HEARTH THAT HAS SO ENDEARED NEW ENGLAND GARDENS TO OUR MEMORIES....WE NEED—NO LESS TODAY THAN DID OUR ANCESTORS IN THE YEARS GONE BY—THE DECORATIVE NOTE OF PEACE WHICH THE LOVELY GARDENS GAVE TO THE SURROUNDINGS OF THOSE WHITE, HOMELIKE HOUSES.[3]

LNP

1. The principal source on the artist is Joyce Butler, *Abbott Fuller Graves, 1859-1936,* exh. cat. (Kennebunkport, Me.: Brick Store Museum, 1979).
2. George Alfred Williams, "New England Gardens," *Ladies' Home Journal* 41 (May 1924): 165.
3. Williams 1924, 14.

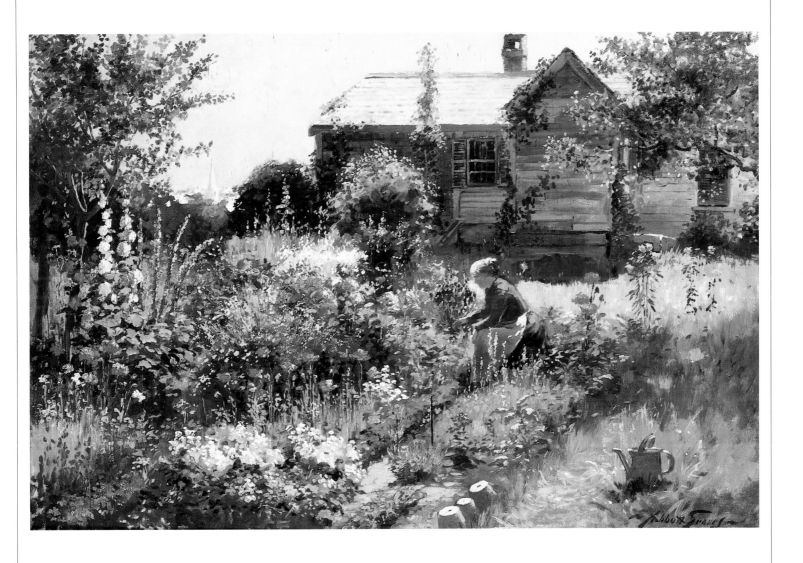

20

JOHN HENRY TWACHTMAN
JOHN ALDEN TWACHTMAN

(1853, Cincinnati, Ohio-1902, Gloucester, Massachusetts)
and (1882, Cincinnati, Ohio-1974, Greenwich, Connecticut)

Greenwich Garden, begun late 1890s
Oil on canvas
30 x 30 in. (76.2 x 76.2 cm)
Spanierman Gallery, New York

During his years in Greenwich, Connecticut, from 1889 to 1902, John Henry Twachtman found infinite inspiration in the familiar landscape.[1] During all seasons of the year, he returned constantly to the same motifs: Horseneck Brook, which wound through his property and the waterfall that cascaded from it; the barn that stood behind his house; and the house with its front portico and its backyard garden (fig. 56). Here flowers grew in unconstrained profusion in accordance with the day's vogue for abundant old-fashioned gardens.

In his images of his garden, Twachtman at times featured the paths that passed divided thick rows of blooms, but his favorite garden image was one in which the viewer was thrust into the midst of dense plantings. Omitting a foreground and a horizon line, in these works, we are not allowed distance. Our concentration is thus on the textures and colors of the flowers rather than on their specific botanical forms.

In *Greenwich Garden*, Twachtman viewed the flowers against the backdrop of his home. Instead of showing the gardens and the architectural structure as separate entities, he demonstrated his eye for the unusual and unconventional by capturing the way that the two could be seen in unison. Indeed, the phlox blossoms of the garden appear to cascade upward in response to the gabled doorway at the back of the house, while the branches of a broad tree, still existing on the property, reverse the flow of the flowers. As may be seen in other works such as *Wild Cherry Tree* of c. 1901 (Albright Knox Art Gallery, Buffalo)— where the harbor of East Gloucester, Massachusetts, is viewed through the leaves and branches of a tree—Twachtman explored the idea of seeing elements from different spatial zones on one plane. However, the modernity of his approach does not disguise his obvious joy in the

sensory pleasure of a wildflower-filled garden where, as W. R. Butler noted in *Architectural Digest* in 1903, nature is brought "up to the threshhold of the house" and the garden "becomes the outdoor house as the building is the indoor house of the home."[2]

Greenwich Garden reveals the physical energy that Twachtman exerted in painting his garden. His pigments are applied thickly and directly on canvas, producing a varicolored tapestry. Although the painting bears all of the hallmarks of John Henry Twachtman's art, it was, at least in part, a collaborative venture since it was signed by his son, J. Alden Twachtman. Trained as a painter by his father and later at Yale University School of Art, Alden adopted some characteristics of his father's style in the paintings he created in the early twentieth century. But Alden's later extant canvases are quite different from his father's. Whereas during his Greenwich years John Henry employed a varied and animated brush handling, a rich palette, many layerings of color, and thick impasto dragged and swirled onto the canvas, his son generally relied on uniform, staccato brushstrokes, a linear definition of forms, crosshatching, a restricted palette, and an even rather than a roughly textured surface. It can thus be surmised, with reasonable assurity, that Alden Twachtman's contribution to *Greenwich Garden* was mainly the addition of the foliage at the canvas's upper register where one can see the short, clipped strokes typical of Alden's style.

LNP

1. For sources on the artist, see cat. 5, note 1.
2. W. R. Butler, "Garden Design in Relation to Architecture." *American Architect and Building News* 82 (5 December 1903): 75.

Figure 56.
Back of John Twachtman's former home in Greenwich, Connecticut, photograph, 1988. Courtesy, Lisa N. Peters.

21

F R A N K A . B I C K N E L L

(1866, Augusta, Maine-1943, Essex, Connecticut)

Miss Florence Griswold's Garden,
Old Lyme, Connecticut, c. 1910s
Oil on canvas
16 x 20 in. (101.6 x 81.3 cm)
Private Collection

A painter of Impressionist-inspired landscapes, Frank Bicknell worked in such diverse locales as France, Italy, and Japan.[1] However, he was best known for his views of New England, especially the rolling hills, meadows, and country lanes in and around Old Lyme, Connecticut. Indeed, Bicknell began spending his summers in Old Lyme around 1902. He subsequently became a well-known member of the colony of painters who visited this charming village, among them Childe Hassam, Willard Metcalf, and Frank Vincent DuMond. Like many of his contemporaries, Bicknell enjoyed the friendly ambiance and restful accommodations provided by the "Holy House," the Colonial mansion-turned-boarding house operated by Florence Griswold (1850-1937), who became the artist's good friend.[2]

Bicknell continued to stay at the Griswold mansion until 1917, when he moved into a house bequeathed to him by Louis Cohen, a fellow painter.[3] Like other resident artists, such as George Burr, Edmund Greacen, and Clark Voorhees, he went on to surround his home with flowers. An avid gardener, he brightened the grounds around his house with "blooms of all colors," including his driveway, which was lined with daffodils in the early spring and "bobbing chrysanthemums" in the fall.[4] He also cultivated honeysuckle and crocus and erected an elaborate flower-covered trellis over his doorway that his pupils liked to paint.

The inspiration for Bicknell's luxuriant garden, as well as those of his contemporaries, was that of Miss Griswold herself, who "endeavored to infuse the air of yesteryear through the medium of good old-fashioned flowers," favoring a casually arranged garden filled with a dazzling array of fragrant blossoms and pathways overgrown with "wild tangles of roses, vines, and weeds."[5] These "wild," naturalistic gardens were considered to be typically American, intended for personal use and enjoyment rather than as objects of display.[6]

Bicknell captures the distinctive quality of the American floral environment in *Miss Florence Griswold's Garden,* which features a view of the garden looking towards the southwest. Painted on a bright summer's day, the scene includes a lush mélange of flowers and shrubbery in the foreground—including an array of blazing red poppies—and, on the right, a large barn and a working studio whose second floor served as a residence for the gardener.[7] On the left, a woman kneels amidst the various shrubs, grasses and blossoms, a rare instance in American Impressionist painting of a female figure "working" in a flower garden. The gently rolling hills of southern Connecticut can be seen in the distance.

Bicknell describes the myriad textures of the garden and the effects of scintillating sunshine by means of quick, fluid brushstrokes. He combines his summary execution with a vivid Impressionist palette dominated by the fresh, cool greens and high-keyed yellows of the landscape and the lighter blues and mauves used in the area of sky. Rapidly applied daubs of pigment—bright red, white, pink, yellow, and blue—represent the dense clusters of blossoms while adding sparkling color accents to the composition.

In addition to underscoring his reputation as a skilled purveyor of light and air, *Miss Florence Griswold's Garden* represents Bicknell's very personal response to the traditional, old-fashioned gardens he encountered in Old Lyme. Certainly, his skillful manipulation of paint, his sensitivity to color, and his keen sense of design effectively convey the most salient qualities of domestic American gardens: abundance, informality, and, as stated so succinctly by the writer Anna Bartlett Warner, "fair, rich confusion . . . and the greater the confusion, the richer."[8]

CL

1. For biographical details, see "F. A. Bicknell, Artist of Lyme, was James G. Blaine's Godson," unsourced newspaper clipping, 1931, The National Arts Club Records, Archives of American Art, Smithsonian Institution, Washington, D.C., roll 4267, frame 1025. See also *Connecticut and American Impressionism,* exh. cat. (Storrs, Conn.: William Benton Museum of Art, 1980): 152; and William H. Gerdts, *American Artists in Japan, 1859-1925,* exh. cat. (New York: Hollis Taggart Galleries, 1996), 37.
2. So-named by Childe Hassam as a "takeoff" on Holley House, the popular artist's inn in nearby Cos Cob. See Jeffrey W. Andersen, "The Art Colony at Old Lyme," in *Connecticut and American Impressionism* 1980, 125.
3. Bicknell moved to Pittsburgh in 1919 to teach at the Carnegie Institute of Technology. Upon retiring from that position in 1925, he settled permanently in Lyme.
4. "F. A. Bicknell, Artist of Lyme, was James G. Blaine's Godson."
5. H. S. Adams, "Lyme-A Country Life Community," *Country Life in America* 26 (April 1914): 94; Jeffrey W. Andersen, "The Art Colony at Old Lyme," 1980, 125.
6. See May Brawley Hill, "Grandmother's Garden," *Antiques* 142 (November 1992): 730, and her *Grandmother's Garden: The Old-Fashioned American Garden, 1865-1915* (New York: Harry N. Abrams, 1995).
7. According to Jeffrey Andersen, director of the Florence Griswold Museum in Old Lyme, the barn in the painting is still standing today on property adjacent to the museum. Telephone conversation with the author, 14 November 1996.
8. Anna Bartlett Warner, *Gardening by Myself* (New York: Anson D. F. Randolph, 1872), 64.

22

WILLIAM MERRITT CHASE

(1849, Williamsburg, Indiana–1916, New York City)

Chase Homestead, Shinnecock
(*Summer House and Studio*), c. 1892
Oil on panel
14 1/2 x 16 1/8 in. (38.1 x 40.6 cm)
San Diego Museum of Art,
Gift of Mrs. Walter H. Fisher

In 1878, after six years of study in Munich, William Merritt Chase settled in New York and was soon recognized as a leading figure in the American art scene.[1] He was appointed to a teaching position at the newly established Art Students League, and his studio on Tenth Street, which he decorated with an eclectic array of art and objects, became a celebrated gathering place for the city's elite in the spheres of art and culture. Inspired by the works of the Old Masters, which he had studied in Munich, Chase at first focused on portraiture. Indeed, he would paint brilliantly insightful images of members both of his family and of high society throughout his career. Landscape played a smaller part in his oeuvre in the 1870s and early 1880s, but by the mid-1880s he was giving more attention to the genre, painting a series of scenes in the public parks of Manhattan and Brooklyn in which he began to explore effects of outdoor light.

In his park scenes, Chase's approach suggests his awareness of French Impressionism, both in his technique and his focus on a subject matter drawn from contemporary life. However, the Impressionist approach that Chase formulated derived more from an attempt to convey his personal thematic interests than from a desire to emulate French mentors. This is especially apparent in Chase's most famous landscapes, the works he created at Shinnecock, Long Island, from 1891 until 1902.[2] Chase visited Shinnecock initially when he was invited to teach a summer class. The area consisted of barren sand dunes, but Chase recognized the artistic merit in the flat, endless plainness of the terrain, which made qualities of light, atmosphere, and patterns in the grassy and sandy turf become manifest. In his art, Chase took his inspiration directly from this landscape, using his brush rhythmically to

convey the movement of the wind rippling across the surface of scrub growth and grass, designing his compositions to emphasize the subtle, abstract patterns established by roads and paths leading through the flat countryside, and capturing thin clouds moving quickly across open skies.

This coastal landscape was compelling to Chase for reasons in addition to its aesthetic possibilities: the artist had many personal associations with his summer home. At Shinnecock, Chase enjoyed the company of his wife and many children, and their delight in long vacations at the coast enhanced the artist's pleasure and became a part of his art. In his landscapes, he often featured family members seated in the dunes, absorbing the refreshing breezes and the sunlight's warmth. He also at times portrayed his Shinnecock home, a shingle-style structure designed by the prominent architect Stanford White and completed in 1892 (fig. 57).[3] Featuring a gambrel roof and dormer windows, the home's design was based on Colonial prototypes, but its simple shape and horizontal emphasis reflected the contemporary desire for country homes to have "balance and harmony without symmetry" with their "dominant and subordinate features… arranged as to give a feeling of unity, strength and repose in the design."[4] Although originally created in 1888 for another client, the house was perfectly suited to Chase's needs, providing ample room for family activities and for painting; he situated his studio in a tall room in the structure's west side.

Illustrated with the caption "Summer House and Studio" in John Gilmer Speed's article on Chase in *Harper's New Monthly Magazine* of June 1893, *Chase Homestead, Shinnecock* was created in July 1892 during the first summer that Chase spent in his Shinnecock home (during his first Long Island summer, he stayed with his family at an inn).[5] In the painting, Chase portrayed his daughter Dorothy picking flowers, while we look north, facing the south and east sides of the house. Speed was able to see the personal content of the painting, describing it as:

A SKETCH OF THE ARTIST'S HOUSE, WITH A LITTLE GIRL IN THE ROADWAY THAT CLIMBS THE HILL AND LEADS TO THE FRONT DOOR. WE WHO HAVE NOT THE GIFT TO MAKE PICTURES, WHEN WE BUILD NEW HOUSES, OR EVEN HIRE THEM, MUST EMPLOY SOME ONE TO SKETCH THEM FOR US OR TO SET UP A CAMERA IN FRONT. HERE IS ANOTHER ADVANTAGE ARTISTS HAVE. THEY CAN MAKE VALUABLE SOUVENIRS OF WHATEVER PLEASES THEM.[6]

Figure 57.
William Merritt Chase house from the front, Shinnecock Hills, cyanotype, c. 1908. The William Merritt Chase Archives, Parrish Art Museum, Southampton, New York.

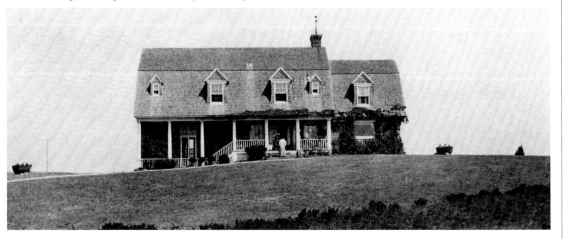

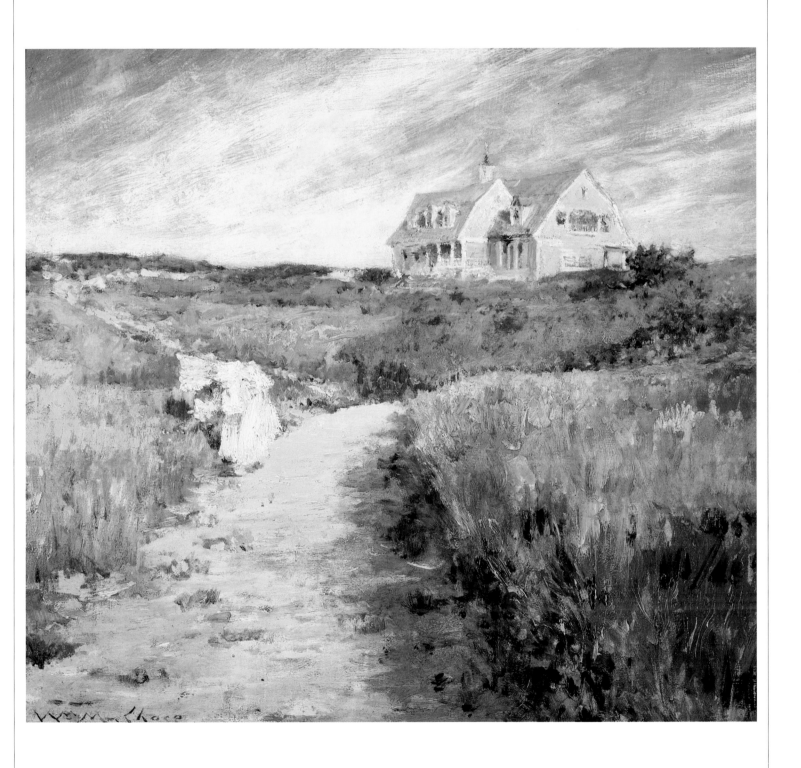

In the painting, Chase experimented with Impressionist color and light, painting with firm, quill-like strokes in the foreground grasses and tighter dabs of blended hues in the dry turf dotted with Indian paint brush and other wildflowers that stretches out toward the distance. However, it was the vision of his home situated firmly at the horizon with the sky as its background that inspired the artist. Indeed, elements in the landscape seem to correspond to the architectural structure. The tones of the ground cover are echoed in the building's facade and patches of green lead in a circle around the residence and direct our eye to it from the foreground path. The house, as well as the child, give the painting a personal note, making the landscape seem more like a comfortable backyard than an expansive coastline. For Chase, the countryside's charms were not diminished through familiarity. Instead, it was the feelings that he received from the association of the landscape with the harmony of his domestic life that he expressed in his Shinnecock art. Recognizing this quality in Chase's work William Howe Downes wrote that the Shinnecock paintings "pretend to nothing more complicated than free and happy descriptive pages which give forth an aroma of summer holidays in a most paintable region of dunes, breezes, wild flowers and blue seas."[7]

LNP

1. The principal sources on Chase are Katharine Metcalf Roof, *The Life and Art of William Merritt Chase* (New York: Charles Scribner's Sons, 1917); Ronald G. Pisano, *William Merritt Chase* (New York: Watson-Guptill, 1979); Ronald G. Pisano, *A Leading Spirit in American Art: William Merritt Chase, 1849-1916*, exh. cat. (Seattle, University of Washington, Henry Art Gallery, 1983); Ronald G. Pisano, *Summer Afternoons: Landscape Paintings of William Merritt Chase* (Boston: Little, Brown and Co., 1993); and Barbara Dayer Gallati, *William Merritt Chase* (New York: Harry N. Abrams, Inc. in association with The National Museum of American Art, Smithsonian Institution, 1995).
2. On Chase's Shinnecock art, see D. Scott Atkinson and Nicolai Cikovsky, Jr., *William Merritt Chase: Summers at Shinnecock, 1891-1902*, exh. cat. (Washington, D.C.: National Gallery of Art, 1987).
3. The house still stands and is well preserved, although trees now surround it so that it no longer appears isolated in the landscape. Many homes set on small plots now surround it as well.
4. Clarence A. Martin, "The Making of a Country Home: Being A Series of Practical Papers on the Possibilities of Home-Making by Persons of Moderate Means—V. The External Aspect of the House," *Country Life in America* 2 (August 1902): 144. "The Contemporary Suburban Residence," *Architectural Record* 11 (January 1902): 69-81.
5. John Gilmer Speed, "An Artist's Summer Vacation," *Harper's New Monthly Magazine* 87 (June 1893): 4. On page 6, Speed describes the painting as one of two created in July of 1892.
6. Speed 1893, 4-5.
7. William Howe Downes, "William Merritt Chase: A Typical American Artist," *International Studio* 39 (December 1909): xxxii.

Chase Homestead, Shinnecock (Summer House and Studio), c. 1892 (Detail of Plate 22)

23

GAINES RUGER DONOHO

(1857, Church Hill, Mississippi–1916, East Hampton, New York)

A Garden, 1911
Oil on canvas
30 x 36 in. (76.2 x 91.4 cm)
Art Gallery of Ontario,
Toronto, Canada
Gift of the Canadian National
Exhibition Association, 1965

In his youth, Gaines Ruger Donoho moved from his native Mississippi to Washington, D.C., where he received training as a draftsman and worked briefly for the Office of the United States Architect.[1] Upon deciding to study painting, in 1878, he moved to New York, where he became a pupil of Walter Shirlaw and William Merritt Chase at the Art Students League. In the fall of the following year, Donoho continued his training in Paris at the Académie Julian. He remained in France for eight years, working in the countryside towns of Barbizon and Grez-sur-Loing, where painters had gathered for many years.

On his return to America in 1887, Donoho established a studio on West 55th Street in Manhattan and became involved in artist organizations such as The Players Club. His stay in New York was short, however. Three years later, he abruptly left the city for East Hampton at the far end of Long Island. The area was not yet the affluent summer resort that it is today, but it had attracted artists since the 1880s, when Thomas Moran moved there, establishing a home that was a gathering place for the artist community (see fig. 55; cat. 18). Among those who visited East Hampton were Donoho's former teachers Shirlaw and Chase—the latter was teaching at nearby Shinnecock during the summers from 1891 to 1902. In 1891 Donoho acquired a home for himself, which was situated on an expansive parcel of land on Egypt Lane near the end of the village (Childe Hassam bought a piece of Donoho's land after Donoho's death). Three years later, when Donoho married, he chose to remain in East Hampton with his wife, although he kept a studio in New York City throughout his life.

In East Hampton, Donoho worked in a modified Impressionist style characterized by deft, short brushstrokes built up to create dense surfaces. Although he painted a number of Long Island sites, including fields and beaches, he reserved his most lively Impressionist treatments for images of his own garden and of the neighboring Woodhouse Gardens created by Mrs. Lorenzo G. Woodhouse, which were directly across from his home.[2] Similar to gardens created by Claude Monet on his property in Giverny, France, the Woodhouse Gardens covered three acres and featured streams, abundant flower beds—containing irises, bracken, and Oriental flowers—and small ponds crossed by red Japanese bridges. Although the site of *A Garden* has not been identified, it may portray the Woodhouse Gardens or a piece of the adjoining swampy meadow, which was covered with deep green bracken, elderberries, and blackberries. The homes seen through the trees reveal the inconspicuous way in which settlement had made its way into the rugged marshland.

As in other American Impressionist views of such abundant floral plots, Donoho plunges us directly into a naturalized garden, where blossoms seem to float freely amidst the high grasses, and leafy trees shelter homes in secluded enclosures. Indeed, Donoho conveys the wild beauty of East Hampton, where Childe Hassam stated that "nature put forth her magic hand every Fall and spread before him a riot of color," and where a writer noted in the *East Hampton Star* in 1938 that in the fall, the landscape took on "the most marvelous colors, from soft tender hues to the rich and flaming reds of Autumn… the pattern of its growth is matchless. No gardener could achieve such harmony of line and color."[3]

LNP

1. The primary source on the artist is René Paul Barilleaux and Victoria J. Beck, *G. Ruger Donoho: A Painter's Path*, exh. cat. (Jackson, Miss.: Mississippi Museum of Art in association with University Press of Mississippi, 1995).
2. Information on Woodhouse Gardens has been compiled by Enez Whipple. Her unpublished notes may be found in the East Hampton Free Library Archives, which kindly made them available to the author.
3. Hassam and Hildreth King in Hildreth King, "Letters to the Editor: Beauty of Egypt Lane," *East Hampton Star* (30 June 1938), bound vol. 53, p. 318, Archives, East Hampton Free Library.

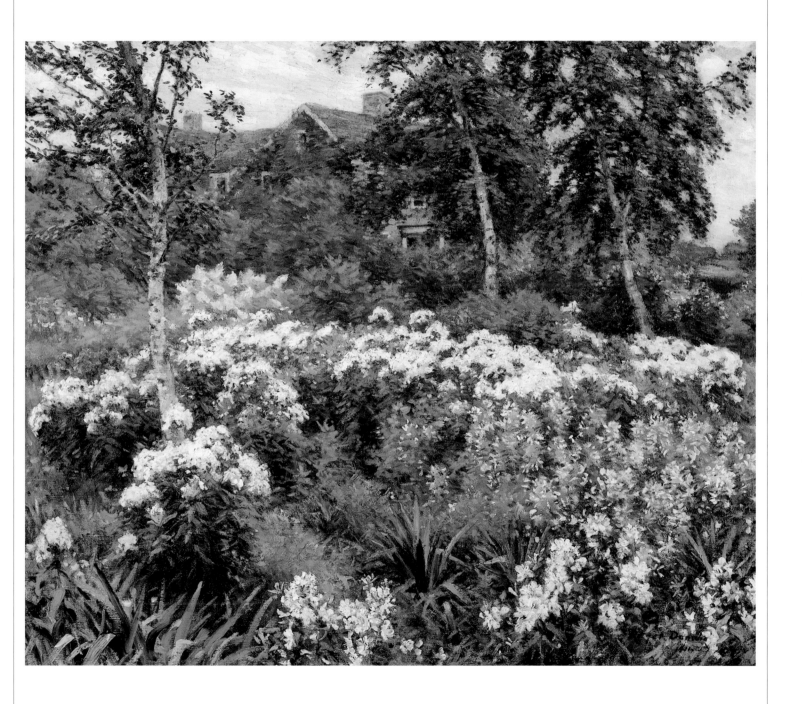

24

DANIEL PUTNAM BRINLEY

(1879, Newport, Rhode Island-1963, Norwalk, Connecticut)

The Peony Garden, c. 1912
Oil on canvas
45-1/4 x 40-1/2 in. (114.9 x 102.8 cm)
Virginia Museum of Fine Arts,
Richmond, Museum purchase;
The Adolph D. and Wilkins C. Williams
Fund, 79.149

In the summer of 1909, the wife of the art critic Charles Caffin introduced Daniel Putnam Brinley and his wife to Silvermine, Connecticut, a suburb of New Canaan.[1] Delighted with the picturesque qualities of the countryside, Brinley continued to visit and paint in the area over the next few years. At first he rented a "little and white" house called "Blanchards" that faced an abandoned mill. Nearby was the home of the sculptor Solon Borglum, and Brinley became involved in the local artists' group called "The Knockers," which met on Sunday mornings in Borglum's barn. This group eventually became the Silvermine Guild of Artists. In 1913 Brinley established his primary residence in Silvermine, purchasing a home he called "Datchet House," after the name of the English village where one of his ancestors had lived in the seventeenth century.

The art Brinley produced falls into two groups. During his early career, he painted in an Impressionist style influenced by the art of John Henry Twachtman, with whom he studied at the Art Students League in New York and during summers in Cos Cob, Connecticut. After 1913, however, he became a key figure in American modernism. He helped to organize the 1913 Armory Show, which introduced European abstraction to audiences in the United States, and a short time later he began to use expressive coloration and to emphasize the two-dimensionality of the picture surface, demonstrating the influence of Vincent van Gogh, Henri Matisse, and the French Fauves.

Rendered around 1912, *The Peony Garden* was created during the time that Brinley was renting "Blanchards" in Silvermine. Instead of featuring the old mill that his home faced, Brinley focused on a vivid garden that appears to issue forth in a cascade of flowers from a small cottage, representing the type of "formless and wild" garden where nature is brought up to "the threshhold of the house," which

writers of the period considered a quintessentially American type.[2] Indeed, Brinley accentuated the freedom and proliferation of the flowers by treating them as sculptural masses built up with loose, gestural strokes of paint. However, as we move into the distance, flowers become less individuated, and Brinley's low vantage point emphasizes the degree to which they blend together in a rich pattern of lavender and rose tones in the background.

The Peony Garden suggests the influence of Twachtman's images of growing gardens in which the flowers merge with nature and the viewer is plunged directly into the garden's midst. At the same time, the painting anticipates the modernist approach that Brinley would soon adopt. The textural flowers create an allover decorative surface pattern that suggests a modernist appreciation of color and form for their own sake. Indeed, although certainly not adopting the modern strategies of the Cubists, Brinley may have been aware of the advanced aesthetic exemplified in their work. He must have felt confident about being au courant since he chose, in 1913, to exhibit *The Peony Garden* at the Armory Show.

LNP

1. The principal source on the artist is Margaret Burke Clunie, *Daniel Putnam Brinley, The Impressionist Years*, exh. cat. (Brunswick, Me.: Bowdoin College Museum of Art, 1978). Clunie mentions Brinley's introduction to Silvermine, note 25. See also Elizabeth Loder, *M. D. Putnam Brinley: Impressionist and Mural Painter* (Published for the New Canaan Historical Society and the Silvermine Guild of Artists by University Microfilms International, Ann Arbor, Mich., 1979).
2. Mary Caroline Robbins, *The Rescue of an Old Place* (Boston: Houghton, Mifflin and Company, 1892), 68-69 and W. R. Butler, "Garden Design in Relation to Architecture," *American Architect and Building News* 82 (5 December 1903): 75.

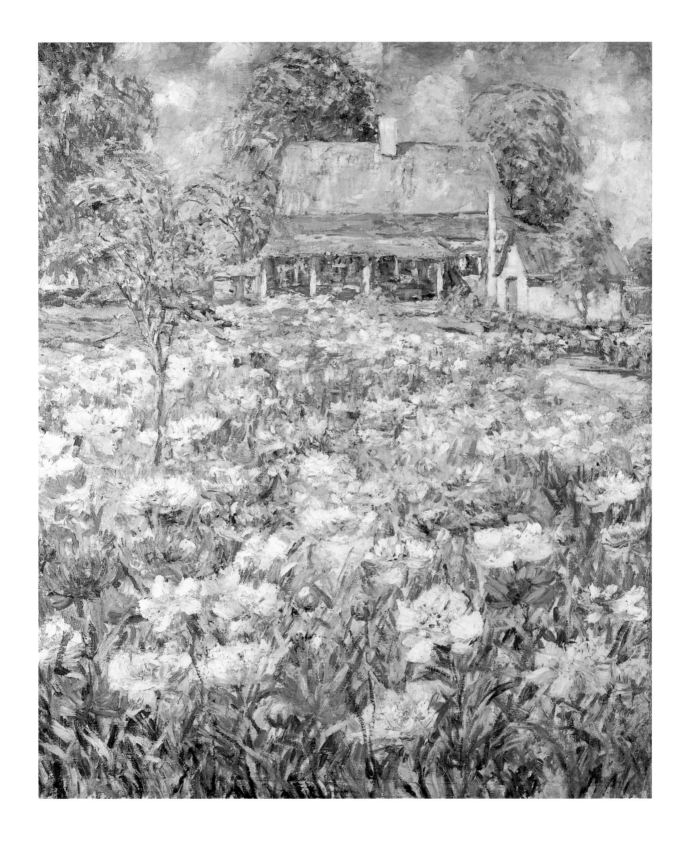

25

JULIAN ALDEN WEIR

(1852, West Point, New York–1919, New York City)

The Laundry, Branchville, c. 1894
Oil on canvas
30 1/8 x 25 1/4 in. (76.5 x 64.1 cm)
Weir Farm Heritage Trust,
Wilton, Connecticut,
Gift of Anna Ely Smith and
Gregory Smith

In the summer of 1882, J. Alden Weir was simultaneously planning his wedding to Anna Dwight Baker, which would take place the following April, and building a home in the Adirondacks.[1] He was expecting that his mountain residence in the Keene Valley would be a place to spend summers with friends and family in the years ahead. However, he never completed his wilderness dwelling, choosing instead to establish his summer quarters in the more modest and unassuming countryside of southwestern Connecticut. His Branchville, Connecticut, property—which he was given in exchange for a painting—was not only more convenient to New York City, where he had teaching responsibilities and club affiliations, it also offered a type of landscape that suited his aesthetic interests. Like other artists of his generation, he preferred gentle places where one could concentrate on subtleties in nature rather than grand scenery with its obvious drama. Weir's 155 acres of land consisted of rolling grassy hillsides crossed by old stone property lines and artful clusters of trees, along with smatterings of wild flowers. Situated on poetically named Nod Hill Road, his home was an old farmhouse built around 1790 and expanded in the Greek Revival style in 1825. Still standing today, Weir's home and land are now part of a historic site, maintained by the National Park Service.

Following the general tendencies of the day, Weir chose to make few changes to his property. Respectful of the intrinsic beauty of the locale, he sought to bring out its best qualities by planting a few trees, creating gardens, moving rocks, digging a fishing pond, and pruning the foliage. In 1888 he expanded the house by about ten feet to the west, and in 1900, an addition designed by architect Charles Platt doubled the size of the house in the same direction. At that time, Platt changed the entryway so that the nongabled end of the structure became its front.[2] In 1911 the firm of McKim, Mead, and White designed an addition to the northern side of the house, which provided the artist with a new dining room.

Weir only began creating landscapes in the late 1880s, and as he adopted an Impressionist approach his palette brightened and his brushstrokes became looser, although he retained a firm draftsmanship evident in his crisp definition of forms and his thoughtfully ordered compositions. As may be seen in *The Laundry, Branchville*, he applied his brush in short, delicate, and fluid strokes of bright green and yellow, but areas of light and shadow are well

defined, and old trees and new saplings are drawn with care and precision.

The Laundry, Branchville conveys Weir's delight in seeing the place where his family life was centered, nestled comfortably at the top of Nod Hill. A contemporary photograph shows the same perspective as the painting, including the laundry line strung between trees and the path leading down the hill (fig. 58). In his painting Weir took liberties with his residence. As if taking note of the suggestion in *Country Life in America Magazine* in 1901 that one's house should "be low and broad" to convey comfort and accord with nature, he elongated the structure so that it seems to hug the line of the hill, and he hid its gabled roof in the leafy foliage at the right.[3] Harmonized with its site, the house looks as if it always were there. At the same time, it denotes informality and repose, qualities that writers of the turn-of-the-century period associated with the new American suburban ideal.

Weir's choice of a vertical format is also interesting in light of the period's values. Using a high horizon line, Weir accentuated the foreground rather than the distance, calling our attention to the breadth and expansiveness of the sunlit grassy lawn.[4] Indeed, Weir is known to have tended to the lawn; references to a push-blade apparatus appear in the artist's papers.[5] During the 1890s, such open smooth lawns were believed to be good for health, rest, recreational pursuits, and the wellbeing of children.[6] In addition, swards were popular because they assured the privacy desired by those who sought to escape the crowded city, while evoking a sense of freedom perceived as impossible in rigid urban quarters.

Weir's inclusion of a laundry line in the painting reminds us that this is a landscape to be enjoyed everyday rather than a place to experience nature's splendor; yet the drying clothes do not evoke the drudgery of domestic chores. Whereas in the contemporary photographs of Jacob Riis, laundry lines crisscrossing between buildings in dark urban courtyards suggested the unsanitary conditions and stifling congestion of the tenement districts of New York City, in Weir's painting the laundry line with white clothes drying in the sunlight (see detail) evokes the freshness of country air. Continuing the lower contour of the house into a path in the hillside, the laundry line in Weir's painting gracefully links human and natural zones, contributing to the unified arrangement. Indeed, Weir anticipates Beatrix Jones's recommendation in 1907 that in designing one's home grounds, one "must put [one's] composition down in the open air with the sky and the trees and the grass as a background and must juggle nature in order that [one's] composition may not look out of place, keeping always in…mind the balance between masses of color and offsetting masses of green."[7]

LNP

Figure 58.
Home and property of J. Alden Weir, photograph, c. 1894. Courtesy, Weir Farm Heritage Trust, Wilton, Connecticut.

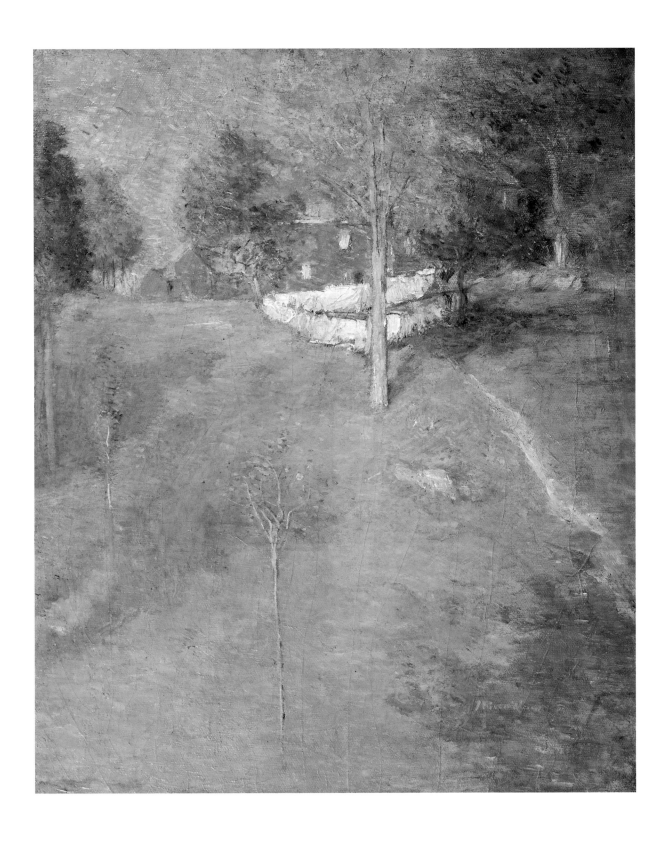

1. The primary sources on Weir are Hildegard Cummings, Helen K. Fusscas, and Susan G. Larkin, *J. Alden Weir: A Place of His Own*, exh. cat. (Storrs, Conn.: William Benton Museum of Art, 1991); Doreen Bolger Burke, *J. Alden Weir, An American Impressionist* (Newark, Del.: University of Delaware, 1983); and Dorothy Weir Young, *The Life and Letters of J. Alden Weir* (New Haven, Conn., 1960). On Weir's plans for his Adirondacks home, see Cummings 1991, 18-21.

2. Information on Weir's home may be found in the Archives at Weir Farm and Heritage Trust. I would like to thank the Farm's curator, Gay Vietzke, for providing material about changes made to the home in a conversation of 5 November 1996.

3. "Making of a Country Home: Being A Series of Practical Papers on the Possibilities of Home-Making by Persons of Moderate Means—I: Choosing the Site, and General Advice," *Country Life in America* 1 (April 1901): 203.

4. On the history of lawns in America, see Virginia Scott Jenkins, *The Lawn: A History of an American Obsession* (Washington, D.C.: Smithsonian Institution Press, 1994).

5. As noted in a telephone conversation between the author and Gay Vietzke, Weir Farm Heritage Trust, 5 November 1996.

6. See Jenkins 1994, 19-20.

7. Beatrix Jones, "The Garden as a Picture," *Scribner's Magazine* 42 (July 1907): 4.

The Laundry, Branchville, c. 1894
Oil on canvas
(Detail of Plate 25)

26

PHILIP LESLIE HALE

(1865-1931, Boston)

The Cottage, c. 1912
Oil on canvas
28 x 20 in. (71.1 x 50.8 cm)
Private Collection
Photograph, courtesy Vose Galleries
of Boston, Inc.

In 1912 Philip Hale and his family moved to their second home in Dedham, Massachusetts, a 1727 Colonial farmhouse located at 213 Highland Street.[1] According to Hale's daughter Nancy, the house, dubbed Sandy Down, backed "up against the woods"; its extensive grounds included apple and crabapple orchards, as well as a luxuriant flower garden which Lilian Hale tended with great devotion.[2]

Hale regularly commuted to Boston, teaching life drawing and anatomy at the Museum School and painting portraits and Impressionist-inspired figure subjects in his space in the Fenway Studio building on Ipswich Street. However, he also found aesthetic inspiration on his home grounds. According to his daughter, "the only thing that ever kept my father home from his Boston studio in the daytime was to be at work on a painting of the white hollyhocks in our garden, or of a model in a veiled hat standing beside his favorite white standard rose tree."[3] She also noted that he would remain in Dedham to paint "his all-green pointillist landscapes of meadow and orchard." Indeed, despite his interest in portraying the female figure, Hale also explored landscape themes, producing intimate, sunlit views of his immediate surroundings.

The Cottage was probably painted on or near the Sandy Down property. In this painting, Hale emphasizes the broad expanse of well-groomed lawn in the foreground, a feature that was considered part and parcel of the new American suburban ideal. At the turn of the century, country homes were surrounded by smooth, open lawns that provided the opportunity for outdoor leisure activity, thereby contributing to good health and a sense of well-being, especially for the children of the household. Most were graced by the presence of colorful flower beds, such as the one depicted in the foreground of

Hale's image. As our eye moves across the property, we encounter a small dwelling nestled beyond a protective line of trees—including pine, spruce and a tall poplar—that establishes a boundary between the two properties. The scene is bathed in warm, late afternoon sunshine which casts long shadows across the verdant lawn.

Hale defines the architecture and landscape elements by means of a delicate pointillist technique, applying small daubs of pigment—luminous greens, pinks, blue, purple, and his characteristic chrome yellow—across the surface of his support. In so doing, he defines the various forms within the composition and, at the same time, effectively conveys the shimmer and vibration of warm summer sunshine on grass, flowers, and trees.

Hale's disciplined, Neo-Impressionist technique was highly appropriate for a work such as *The Cottage*, for it imbues the painting with a sense of order, structure, and harmony that parallels that of the cultivated lawn and flower bed. Certainly, this lyrical and very colorful conception of the domesticated landscape is very much in keeping with American Impressionist visions of home at the turn of the century.

CL

1. For sources on the artist, see cat. 3, note 1.
2. Nancy Hale, *The Life in the Studio* (Boston: Little, Brown and Co., 1957), 37.
3. Hale 1957, 198.

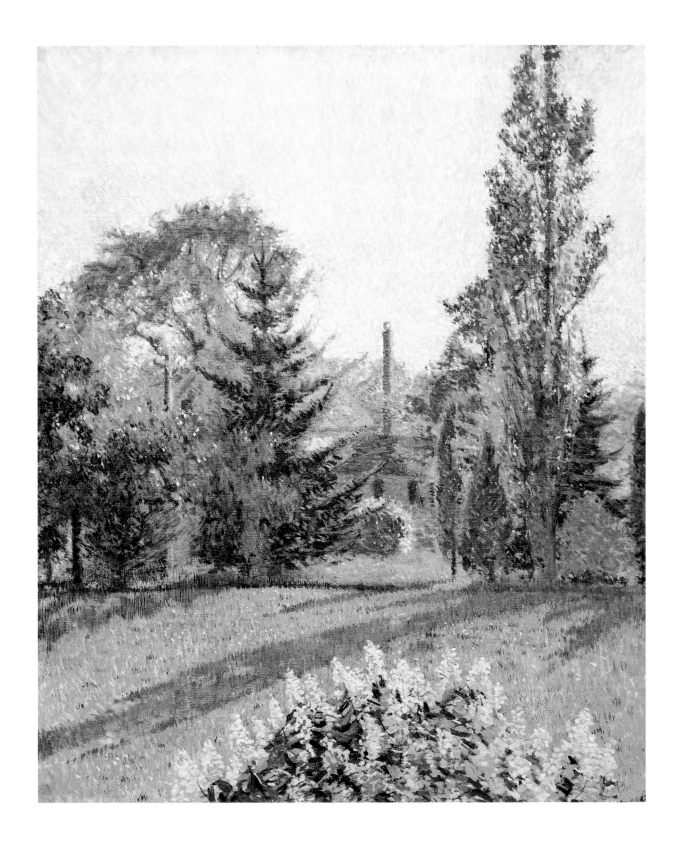

27

DANIEL GARBER

(1880, New Manchester, Indiana-1958, Lumberville, Pennsylvania)

Glen, Cuttalossa, 1925
Oil on canvas
42 x 42 in. (106.7 x 106.7 cm)
Private Collection
Photograph, courtesy the Daniel
Garber Catalogue Raisonné

Daniel Garber's early mentors included a number of significant figures in American art.[1] He studied at the Art Academy of Cincinnati under Frank Duveneck and at the Darby Summer School in Fort Washington, Pennsylvania, under Thomas Anshutz and Hugh Henry Breckenridge. In Philadelphia, where he moved in 1899, Garber was inspired by the art of William Merritt Chase and Cecilia Beaux, and on a visit to London and Italy from 1905 to 1907, he was influenced by the work of James McNeill Whistler and of the Italian Divisionist Giovanni Segantini.

Upon returning to America from Europe in 1907, Garber began to reside for significant periods of time in Lumberville, Pennsylvania, where he became a leading figure in the New Hope artists' colony. Members of the colony, including Edward Redfield and Walter Schofield, were distinguished by their focus on local scenery in Bucks County, Pennsylvania, and by their styles which merged dynamic realist approaches with an Impressionist sensitivity to light. In the years that followed, Garber settled into a pattern of spending six months in Philadelphia—where he taught first at the Philadelphia School of Design for Women and later at the Pennsylvania Academy of the Fine Arts—and six months in the country. After he purchased a small stone cottage situated in the glen of Cuttalossa Creek near Lumberville in 1912-1915, however, he stayed in the country for several nights every week throughout the year, making the commute to Philadelphia when he was required to teach.

Garber's home was initially known as the "Kenardine Homestead," but he changed its name to the more poetic "Cuttalossa." Here, he worked constantly to personalize his home grounds, turning an old barn into his studio, creating a large flower garden, damming a creek to form a pond, and con-

structing new outbuildings, while allowing some existing structures to decay gracefully (fig. 59). Garber acknowledged his complete identification, both as an artist and as a person, with his home and land. In 1929 he wrote to his cousin: "To know me now you would have to know the place. Everyone knows it's half of *me*."[2]

Although Garber painted in a variety of sites on the Pennsylvania and New Jersey sides of the Delaware River, his immediate surroundings were his primary subject matter. He refined his aesthetic sensibility directly in response to the enchanting hemlock and sycamore valley where he had settled, rendering canvases that are so highly structured as to often appear stylized and painted with soft, delicate, and luminous tones that produce a lyrical feeling. Garber's compromise between the spontaneity of an Impressionist approach and a modern concern for the geometry of the two-dimensional surface is apparent in *The Glen, Cuttalossa*. While soft, autumnal tones suffuse the canvas in a misty light, the tall sycamore trees, whose trunks and branches parallel the picture plane, give structure to the design. Indeed, Garber emphasized the work's abstract pattern by using a square canvas, which focuses attention on the surface rather than on the distance, and by depicting the trunks and branches of trees up against the picture plane. As one writer suggested, their spread was like Chinese tracery across the canvas surface.[3]

In the left middleground, a decaying stone building has become submerged in the artist's glen. Indeed, Garber often included such reminders of human contact with nature in his art, but their presence does not imply intrusion or a subjugation of the landscape. As the author to the introduction in a Garber exhibition catalogue stated in 1931: "In general he delights in using the old houses of Pennsylvania for his material. His quarries are never pits in the ground nor scenes of industrial realism, but sunlit amphitheaters accepted by the framing woods and reflecting rivers; screens to catch the subtle variations of color and season, to which the valley artist is so sensitive."[4]

Despite the formal connection that can be made between Garber's works and early twentieth-century abstract art, his images of humanized landscapes in peaceful countrysides were often praised for their nationalist qualities, for capturing the "American landscape at its best," and representing "the spirit of American art, a thing one sees and feels, but which, perhaps,…is not so easy to define."[5]

LNP

Figure 59.
Daniel Garber's home and studio (at right) as seen from the Cuttalossa Glen. Photograph, courtesy the Garber family and the Daniel Garber Catalogue Raisonné.

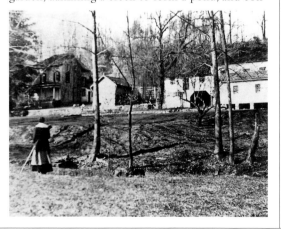

1. The principal source on the artist is Kathleen A. Foster, *Daniel Garber, 1880-1958*, exh. cat. (Philadelphia: Pennsylvania Academy of the Fine Arts, 1980).
2. Daniel Garber, to his cousin Charles, 12 May 1929, Courtesy of Mrs. Ellen Smith. Quoted in Foster 1980, 24.
3. *Recent Paintings of Daniel Garber*, exh. cat. (New York: Macbeth Gallery, 1931), 3.
4. *Recent Paintings of Daniel Garber* 1931, 2-3.
5. Henry Pitz, "Daniel Garber," *Creative Art* 2 (January-June 1928): 252; and Teall Gardner, "In True American Spirit: The Art of Daniel Garber," *Hearst's International* 31 (June 1921): 77.

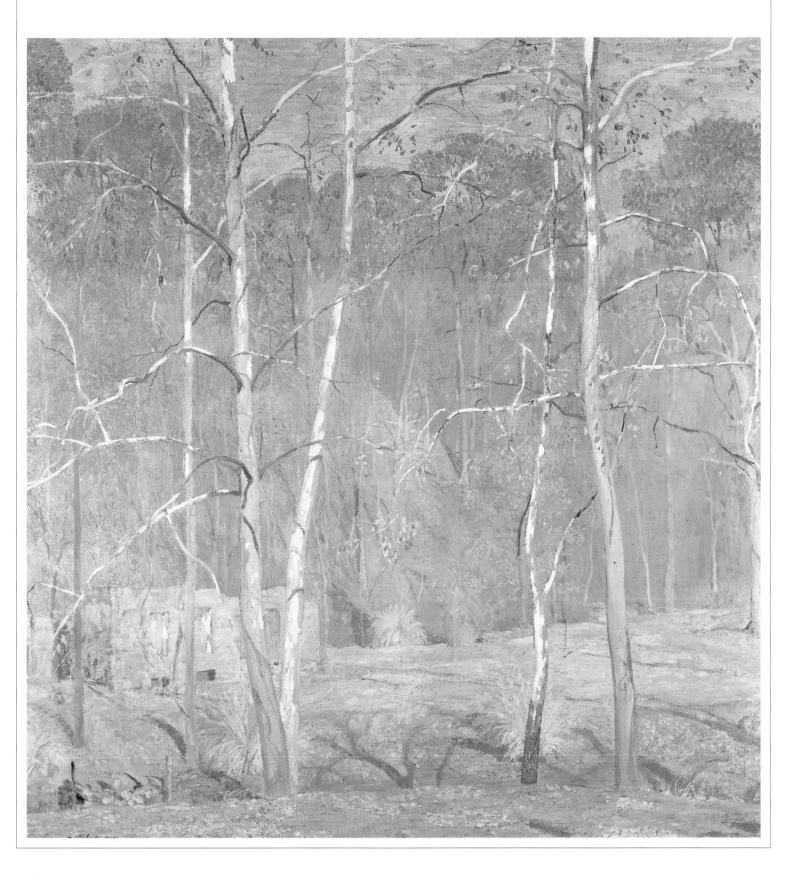

28

EDMUND W. GREACEN

(1876, New York City-1949, White Plains, New York)

The Old Garden
(Florence Griswold's Garden, Old Lyme, Connecticut), c. 1912
Oil on canvas
30 1/4 x 30 1/4 in. (76.8 x 76.8 cm)
Florence Griswold Museum, Old Lyme, Connecticut, Gift of Mrs. Edmund Greacen, Jr.

The range of color and the variations in form and silhouette made the garden a compelling subject for American Impressionist painters. The number of turn-of-the-century garden paintings—important examples of which are seen in the current exhibition—reflected the broader view that gardening was a distinct art adhering to the same design principles of color, light, shadow, and mass associated with landscape painting. The artist Edmund Greacen became somewhat of an expert at "Garden Portraits" for the wealthy during the second decade of the twentieth century.[1] As his brother advised the painter in 1913, "I think brooks and gardens are your long suit but you make it something you enjoy and can do in your sleep—in fact the subject you most enjoy."[2]

Greacen's fascination with the garden first developed while in Giverny, where he and his wife rented a house from 1907 to 1909. Prior to his trip to France, Greacen had enrolled in the Art Students League in 1899. Shortly thereafter, he attended William Merritt Chase's art school where he would have been introduced to plein-air painting and an Impressionist palette. After his marriage to Ethol Booth in 1904, the Greacens sailed for Europe and by 1907 had rented an old stone house in Giverny near the French master Claude Monet. While living in Giverny, Greacen painted numerous views of the River Epte bordered by poplars, picturesque scenes of walls and doorways overhung with flowering vines, and garden pictures that frequently included his wife picking flowers or holding a parasol. Greacen befriended a number of American artists in Giverny who were also working in an Impressionist style and frequently depicted women in sunlight or the garden. The members of this circle were Frederick Carl Frieseke, Richard Edward Miller, Karl Anderson, Karl Buehr, and Theodore Butler, who was married to Monet's step-daughter.[3]

Although Greacen shared with his fellow Americans an interest in the female figure in the landscape, he tended to generalize his figures and integrate them into their garden settings, focusing more on the landscape component of the subject. While at Giverny, Greacen adopted a rough surface texture and the bright colors of the Impressionist palette which he fused with a harmonious atmospheric tonality.

Upon his return to the United States in 1909, Greacen visited Old Lyme where he and his wife enjoyed the jovial spirit of the colony as well as the attractive setting of the Griswold estate. Since 1899 the home of Miss Florence Griswold served as the principal boarding house for the artists associated with the Old Lyme Art Colony. The Florence Griswold home, located on about twelve acres of orchards and gardens, bordered the Lieutenant River where three small rowboats, available for use, lined the shore. Outbuildings and barns converted into studios provided working spaces for artists on the grounds of the estate. Old Lyme and the Florence Griswold House became a kind of "American Giverny" for the Greacens over the next several years. They came to Old Lyme several times a year, staying at Miss Florence's for weeks at a time. There, Greacen created some of his most significant paintings, depicting the same subjects—rivers and gardens—he had rendered in Giverny.

The Old Garden of 1912 is one of a series of pictures that the artist painted of the gardens of Florence Griswold between 1910 and 1913. These gardens were located off the back ell of the house and could be seen from the back porch where the artists frequently had their meals, as seen in the contemporary photograph (fig. 45). Nearly all of these garden pictures, like the present one, were painted on a square canvas, a format popular with other native Impressionists. *The Old Garden* depicts a view looking westward toward the Lieutenant River from the house. Upon careful examination, one is able to discern that originally a female figure was placed in the center left of the composition. Evidently dissatisfied with the figure, Greacen painted over it and the background is now a solid mass of trees and greenery. In this work, Greacen simplified the details of the garden and flattened out the green, blue, and gray areas of color to produce a harmonious gradation of tone suggestive of a misty, overcast day. Orange daylilies and bright blue delphiniums are seen growing in bunches interplanted with garden phlox. A wall of trees and greenery form a backdrop to the garden.

The Griswold home, once the stately residence of a prosperous sea-captain, had fallen into decline during its years as the hub of the artist colony. Describing the house, Arthur Heming wrote, "The patched roof, the crumbling cornice, the decayed pillars, the dilapidated shutters, the rotten steps, and the broken windows spoke loudly of the ravages of time."[4] Surrounding what Childe Hassam designated as the "Holy House," were circuitous paths, overgrown with wild tangles of roses, vines, and weeds which led to the orchard, flower gardens, and the barns. Although the grounds and the house itself were in a state of constant disrepair, Miss Florence, an avid gardener, maintained a vegetable

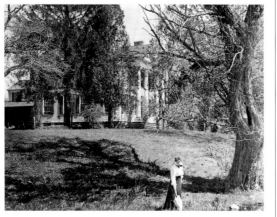

Figure 60.
Florence Griswold strolling in the field by her house, photograph, c. 1905. Courtesy, Florence Griswold Museum, Old Lyme, Connecticut.

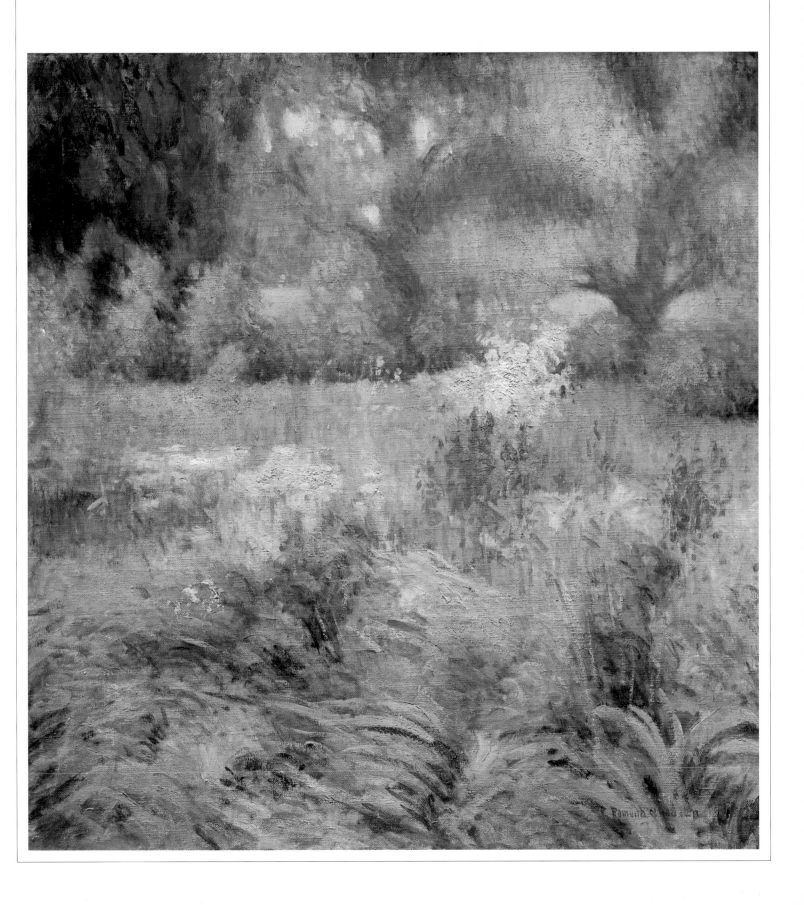

The Old Garden
(Florence Griswold's Garden, Old Lyme,
Connecticut), c. 1912
(Detail of Plate 27)

garden and a beautiful flower garden filled with "old-fashioned" flowers. A contemporary photograph provides a panoramic view of the house, the landscape, and a figure in the foreground, probably Miss Florence Griswold (fig. 60).

The gardens and home of Miss Florence provided a sense of artistic community for American artists. Situated in the rural and colonial town of Old Lyme, Connecticut, artists escaped the frustrations of urban life for the pastoral beauty of an unindustrialized landscape and a homogeneous community that reflected an idealized Colonial past. For the Greacens, recently returned from France, the estate of Miss Florence provided an artistic haven reminiscent of the one they experienced in Giverny. The gardens of Miss Florence were a vehicle for Greacen to explore Impressionist technique and palette, and, simultaneously, they were a subject that conveyed the special nature of the Griswold estate and the Old Lyme art colony.

JB

1. The primary source on the artist is Elizabeth Greacen Knudsen, *Edmund W. Greacen, N.A., American Impressionist 1876-1949*, exh. cat. (Jacksonville, Florida: Cummer Gallery of Art, 1972).
2. July, 1913. Edmund N. Greacen Papers, Archives of American Art. Reel 99.
3. For a discussion of this group of artists see Bruce Weber, *The Giverny Luminists: Frieseke, Miller and Their Circle*, exh. cat. (New York: Berry-Hill Galleries, Inc., 1996).
4. Arthur Heming, *Miss Florence and the Artists of Old Lyme* (Old Lyme: Lyme Historical Society, 1971), 2.

29

WILLIAM DE LEFTWICH DODGE

(1867, Liberty, Virginia-1935, New York City)

Sunken Garden (*Villa Francesca, Setauket, Long Island, New York*), c. 1928
Oil on panel
32 x 36 3/4 in. (81.3 x 93.3 cm)
Ursula and Leftwich D. Kimbrough

William de Leftwich Dodge spent much of his youth in Europe.[1] His mother took him abroad when he was twelve, and during the ten years that followed he lived mostly in Paris, where he studied with a number of academic teachers including the well-known classicist Jean-Léon Gérôme. After returning to America in 1889, Dodge settled in New York, where he created easel paintings and murals, but from 1894 until 1900, he again lived in Europe. He spent the last two years of this sojourn in Giverny, France, fraternizing with the active international group of artists that had gathered there and undoubtedly became familiar with the art of Claude Monet, Giverny's most famous resident.

After returning to America, Dodge again chose to reside in New York, where he focused on mural work and portrait painting. However, by 1906, he was tiring of city life and traveled to the North Shore of Long Island in search of the repose he had enjoyed in Giverny. Stumbling upon a site at Setauket overlooking Dolphin Bay (also called Smithtown Bay), he purchased land and designed and built a home in the Greek Revival style, which he called the Villa Francesca (fig. 61). Originally spending only summers at Setauket, Dodge later chose to live there year round. Perhaps inspired by the setting Monet had created in Giverny, Dodge crafted an aesthetically unified plan that encompassed his home within a network of extensive terraces and gardens. Across the front of the house were fluted Ionic columns, while a side porch was decorated with graceful caryatids. Eventually Dodge built an expansive pergola, covered with a wooden trellis overgrown with vines, that overlooked the ocean, while below the house he fashioned another pergola in which two sets of crisscrossing Doric columns were set into a "sunken" niche in the landscape (fig. 62).

Dodge's many years abroad may have influenced his choice of a Greek style for his home, but pergolas were popular additions to the home and garden in America in the early twentieth century. For example, in 1907, the *Craftsman* reported:

SLOWLY...WE ARE ADJUSTING OUR HOMES, OUR GARDENS, OUR PORCHES TO OUTDOOR LIVING. OUR APPRECIATION OF THE POSSIBILITY OF THE USE AND BEAUTY OF THE PERGOLA HAS DONE MUCH TO AWAKEN A CHANGE OF HEART TOWARD OUTDOORS, FOR PERGOLAS FURNISH THE SECLUSION OF A LIVING PORCH AT THE SAME TIME THAT THEY GATHER TOGETHER THOSE WHO HAVE GROWN TO APPRECIATE THE LURE OF OUTDOOR LIFE.[2]

In his paintings, Dodge featured the upper terrace's pergola at different times of day, often capturing the beauty of the ocean seen from its flower-laden columns. He even depicted the site at moonlight as in *Dolphin Bay* of about 1915 (George P. Tweed Memorial Art Collection, Tweed Museum of Art, University of Minnesota at Duluth).

In *Sunken Garden*, Dodge portrayed the trellised pergola and its plantings situated below his home. A photograph of this site from the artist's era reveals it to have been a formal garden, where pathways passed under the arbor and rose bushes benefitted from full sunlight (fig. 62). In the painting, however, Dodge downplayed the garden's formality in order to accentuate the way that human and natural forms flowed together. The columns echo the narrow lines of three trees in the foreground, while leaves create a natural bower overhead. The dappled play of light across the ground, noted by Dodge with brisk dabs of Impressionist color, creates an effervescent surface and conveys the refreshing and ordered qualities of the site.

LNP

1. The main source on the artist is Sara Dodge Kimbrough, *Drawn From Life* (Jackson, Miss.: University Press of Mississippi, 1976).
2. "How Pergolas Add to the Appreciation and Enjoyment of Outdoor Life," *Craftsman* 17 (November 1907): 202.

Figure 61. (left)
Villa Francesca, Setauket, Long Island, photograph, c. 1925. Private Collection.

Figure 62. (right)
Villa Francesca, lower terrace with Sara Pryor Dodge and her mother, Mrs. William de Leftwich Dodge (left to right), Setauket, Long Island, photograph, c. 1925. Private Collection.

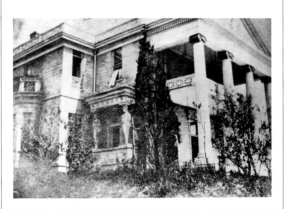

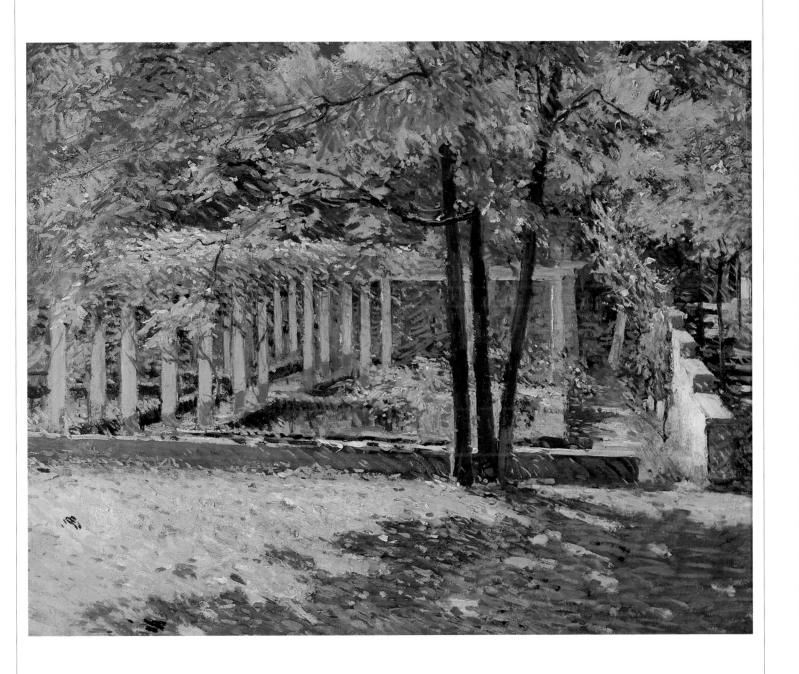

30

HUGH HENRY BRECKENRIDGE

(1870, Leesburg, Virginia–1937, Philadelphia)

White Phlox, 1906
Oil on canvas
30 x 25 in. (76.2 x 63.5cm)
Terra Foundation for the Arts,
Daniel J. Terra Collection

The principal American Impressionist painter to be associated with Philadelphia, Hugh Henry Breckenridge, studied at the Pennsylvania Academy of the Fine Arts and in Paris at the French Academy.[1] After returning to America in 1893, he settled in Philadelphia, where he taught classes in drawing after antique casts at the Pennsylvania Academy. By contrast with the conventional approach he was conveying in the classroom, Breckenridge began to paint landscapes, portraits, and figure studies in a lively Impressionist style. His exploration of Impressionism was enhanced during summers that he spent teaching in the outdoors. In 1900 he joined forces with Thomas Anshutz, another important teacher at the Academy, to teach summer art classes in Darby, Pennsylvania, where students set to work amidst an abundant natural garden (fig. 63). Two years later, Breckenridge and Anshutz moved the school to Fort Washington, Pennsylvania, near Valley Forge, where Breckenridge purchased a home he named "Phloxdale" in honor of the flower that dominated both the region and the artist's garden.

Until 1920, when Breckenridge opened his own school in East Gloucester, Massachusetts, he lived year round in Fort Washington, commuting to Philadelphia to teach during the winter and spending summers at his home. In 1908, when Breckenridge exhibited works with titles such as *A House in the Country*, *A Corner of the Garden*, *The Homestead*, *Homestead in Winter*, *The Phlox Garden*, and *The Open Garden* at the Albright Art Gallery in Buffalo, a critic commented on the inspiration Breckenridge received from his immediate environment:

THE FIRST IMPRESSION PRODUCED BY A VIEW OF THIS COLLECTION IS THAT OF THE GREAT VERSATILITY OF THE ARTIST. WHILE THE MAJORITY OF THE PICTURES ARE LANDSCAPE SUBJECTS, ALMOST EVERY SEASON AND MOOD OF NATURE IS REPRESENTED. THERE ARE EFFECTS OF SUN-

SHINE AND SHADOW, OF EARLY MORNING, EVENING, MOONLIGHT EFFECTS, AND CONTRASTING EFFECTS OF DAYLIGHT AND LAMPLIGHT....MR. BRECKENRIDGE EVIDENTLY IS VERY FOND OF FLOWERS; THERE IS A CONSIDERABLE NUMBER OF GARDEN PICTURES IN THE COLLECTION, AND ALL ARE FINE IN COMPOSITION AND COLOR AND ARE EXTREMELY DECORATIVE IN CHARACTER.[2]

Painted in 1906, *White Phlox* suggests the freedom of Breckenridge's garden. In the foreground, white phlox and plum-colored salvia are interspersed, their tall green stalks scattering blossoms in all directions. Painting with spontaneous daubs of color applied with vigor, Breckenridge animates the picture plane, creating an overall sense of movement. The vibratory qualities of the image are gently counterbalanced, however, by the horizontal band of lavender that indicates a path through the plantings and a series of vertical lines beyond that reveal the presence of a pergola. The pergola's structure echoes that of the picture itself, demonstrating Breckenridge's awareness of issues of abstract design.

Indeed, with its emphasis on surface texture and the diffusion of forms into patterns of color, the work anticipates the artist's later participation in the modernist movement in America. In 1922 Breckenridge would state: "Technically, every inch of a canvas ought to be intrinsically a part of the whole. A blank place is to the painting what a paralyzed wrist would be to a man—the whole thing isn't functioning properly."[3] Judging from the image in *White Phlox*, Breckenridge came to this understanding as early as 1906, and designed both his garden and his canvases with an awareness of the necessity of filling space meaningfully. His aesthetic decisions in the garden comply with the recommendation made by Beatrix Jones who, in 1907, stated that gardens should not be subdued in coloring, but should instead "vibrate with color as the air rising over some reflecting surface on a summer day vibrates with heat."[4] Thus, Breckenridge's turn to modernism can be associated as much with the inspiration he received in Europe in 1909, where he studied works by the Post-Impressionists and by Henri Matisse, as with the inspiration he received from his wildflower-filled garden near Philadelphia.

LNP

Figure 63.
The Darby Summer School of Painting, photograph, 1915. Courtesy, Valley House Gallery, Dallas, Texas.

1. The main sources on the artist are Margaret Vogel, *The Paintings of Hugh H. Breckenridge (1870-1937)*, exh. cat. (Dallas, Tex.: Valley House Gallery, 1967) and Gerald L. Carr, "Hugh Henry Breckenridge: A Philadelphia Modernist," *American Art Review* 4 (May 1978): 92-124.
2. "The Breckenridge Pictures at the Albright Art Gallery," *Academy Notes* 3 (February 1908): 150.
3. Dorothy Grafly, cited in Vogel 1967, 20.
4. Beatrix Jones, "The Garden as a Picture," *Scribner's Magazine* 42 (July 1907): 6.

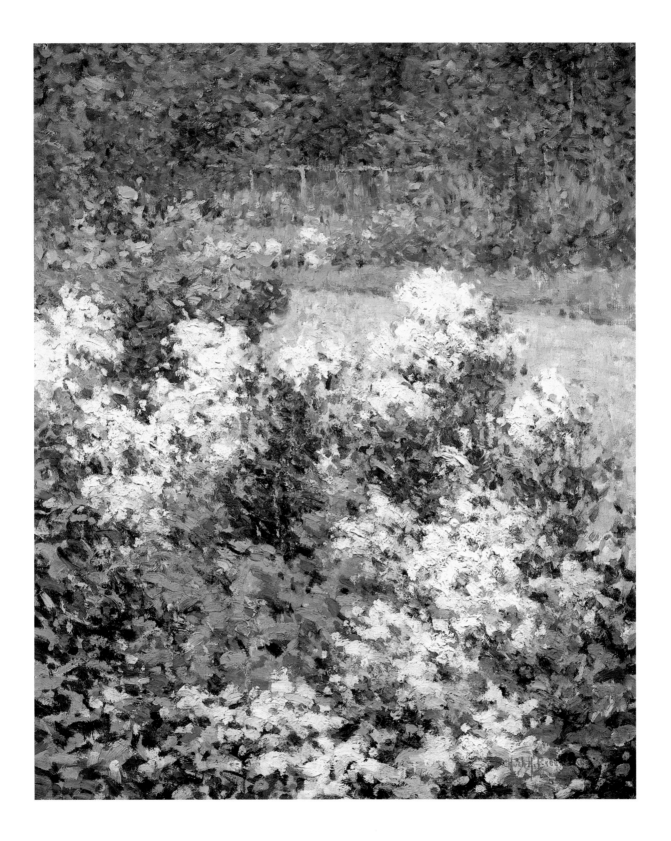

31

GEORGE BRAINERD BURR

(1876, Middletown, Connecticut-1939, Old Lyme, Connecticut)

Old Lyme Garden, n. d.
(Burr active in Old Lyme, 1910-1939)
Oil on panel
12 x 9 in. (30.5 x 22.9 cm)
Florence Griswold Museum,
Gift of Patricia Burr Bott

Figure 64.
George Burr painting behind his house, photograph, c. 1910-1920. Courtesy, Florence Griswold Museum, Old Lyme, Connecticut.

George Burr, like Edmund Greacen and other artists associated with the Old Lyme Art Colony, explored the subject of the cultivated garden. The son of a prominent Middletown, Connecticut, banker, George Burr studied art in Berlin, Munich, Paris, and later at the Art Students League in New York. After living in Europe for fourteen years, Burr returned to New England and settled in Old Lyme in 1910. By the time Burr moved to Old Lyme, the art colony was well established as an Impressionist center well known for the accomplishments of such painters as Childe Hassam and Willard Metcalf. Burr purchased "Cricket Lawn," an 1844 cottage-style home built by Alexander Jackson Davis from a plan by Andrew Jackson Downing. This simplified version of a Gothic cottage, atypical for the colonial town of Old Lyme, had a steeply pitched roof, decorated bergeboards, and a full-width one-story porch supported by flattened Gothic arches. Conveniently located near the Florence Griswold home, Burr's house became a center of activity for the Old Lyme artists.[1]

Burr's undated *Old Lyme Garden* represents a segment of his own garden. Burr owned twenty acres of land around his home and this painting provides a view away from the house looking toward an open meadow either toward the back or the side of the house. Executed with strong dabs of paint, loosely applied, Burr creates a lively, textured landscape. A central informal grouping of flowers is rendered in heavy strokes of reds, whites, pinks, and purples with green foliage surrounding the border. This planting of hollyhocks and annuals forms a geometric arrangement that one would encounter walking through the paths in the landscape outside of Burr's cottage. In the foreground the brown color of the wooden panel is exposed, which is suggestive of the color of dirt in the garden paths. Two large trees define a spatial recession against a purple sky in the background.

The dense grouping of different kinds of flowers displayed in Burr's painting is in keeping with contemporary gardening advice. As May Brawley Hill points out, Mariana Griswold van Rensselaer, in her *Art Out-of-Doors: Hints on Good Taste in Gardening* (1893), argued for massed flowers informally arranged in box-bordered beds close to the house.[2] For van Rensselaer, this arrangement was always in good taste and echoed old-fashioned gardens. The gardens surrounding Burr's house were indeed old fashioned, and, in fact, were some of the oldest in Old Lyme. A 1914 article in *Country Life in*

America claimed that beyond the detached studio

IS SOME OF THE BEST PRESERVED BOX IN ALL LYME — ONE OF THE FEW NOTABLE REMNANTS OF OLD-TIME GARDENS THEREABOUTS. THE BOX, WHICH HAS STOOD THERE FULLY SEVENTY-FIVE YEARS, FORMS TWO VERY LARGE SQUARES, AND EXCEPTING THROUGH THE CENTER, WHERE THERE ARE GRAPE VINES AND FRUIT TREES, THERE IS AN OUTER HEDGE OF THE SAME EVERGREEN. ROSES FILL THE RIGHT SQUARE AND THE OTHER IS MASSED WITH SUCH PERENNIALS AS FOXGLOVE, PEACH BELL, GAILLARDIA, AND COREOPSIS, AS WELL AS SOME ANNUALS.[3]

The article also noted that honeysuckles and vines growing on the side of the house were "adding to its picturesqueness."[4]

An undated photograph of Burr painting outside his house documents the gardens directly at the rear of "Cricket Lawn" (fig. 64). A woman and child on the left look on as Burr paints. Although at first glance it appears that Burr is rendering a portrait of the woman and child, closer examination of the image on the easel and of Burr's posture suggest that he is painting the garden directly behind the ivy-covered detached structure on the left, his studio. Between the studio and Burr is a large conical boxwood that appears to be the subject of the painting in progress. The densely planted garden plot between the studio and Burr is filled with perennials, peonies, phlox, and other flowers. A trellis to the left of the studio is covered in vines, and wild grasses can be seen nearby.

For Burr, the variety of color and form made the garden a compelling subject for his Impressionist palette and technique. Moreover, the age of the box and of the landscape components surrounding his home were an important reason for his interest in depicting his garden. Box itself was an indication of an old-fashioned garden. As Elisabeth Woodbridge wrote, "box implies…human life on a certain scale: leisurely, decorous, well-considered. It implies faith in an established order and an assured future."[5] As demonstrated by the photograph, the historic gardens surrounding Cricket Lawn combined the artistic sphere with the everyday domestic world of family life. More than a mere transcription of the landscape, *Old Lyme Garden* conveys a sense of that domesticity as well as the historicity to be found in the gardens surrounding the home of George Burr.

JB

1. The primary source on the artist is *Three American Impressionists: From Paris to Old Lyme: Lucien Abrams, George Burr, Charles Ebert*, exh. cat. (New York: A.M. Adler Fine Art, Inc., 1978).
2. See May Brawley Hill's essay in this volume.
3. H.S. Adams, "Lyme—A Country Life Community," *Country Life in America* 26 (April 1914): 94.
4. Adams 1914, 94.
5. Collected as *The Jonathan Papers* (New York: Houghton, Mifflin Co., 1912), 109. As cited in May Brawley Hill's essay, note 12.

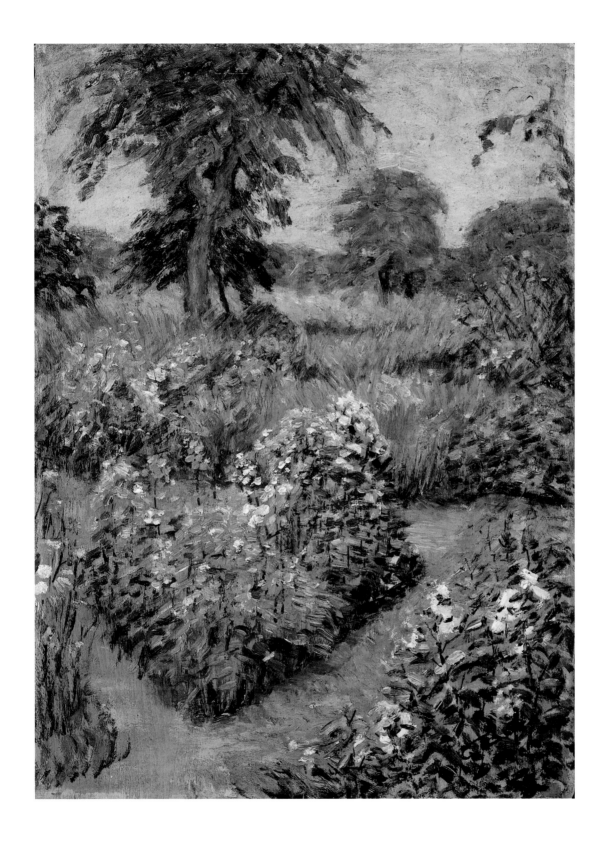

32

EDWARD REDFIELD

(1869, Bridgeville, Delaware-1965, Center Bridge, Pennsylvania)

Hillside at Center Bridge, 1904
Oil on canvas
36 x 50 in. (91.4 x 127 cm)
The Art Institute of Chicago,
W. Moses Willner Fund, 1905. 152

Edward Redfield studied in Philadelphia for a number of years before choosing to continue his training in Paris.[1] Between 1889 and 1893, he spent most of his time in the French capital, taking classes at the Académie Julian and the Ecole des Beaux-Arts. After returning to the United States with a French wife, Redfield chose not to live in the city. Instead, he settled in the Pennsylvania countryside north of Philadelphia, settling at first at Glenside and then in nearby Center Bridge, situated in Bucks County. As a writer for *Arena* commented in 1906: "His love of nature has led him from the crowded, nerve-racking, brain-distracting metropolitan centers to a quiet nook on the picturesque banks of the beautiful Delaware."[2]

At Center Bridge, Redfield and his wife moved into a small abandoned stone house flanked by trees which fronted on an old towpath. Restoring the building over time using weathered timber from the river, they followed the prevailing domestic aesthetic, which called for harmony between the homes and their sites. Describing Redfield's home in *A Little Journey to the Home of Edward W. Redfield* (1947), C. Valentine Kirby observed: "This building seems to belong to mother nature in its setting of grand old trees, shrubbery and garden tract."[3]

After settling in Center Bridge, Redfield became the leading figure in a group of Impressionist landscape painters who resided nearby, including Daniel Garber, William Langsom Lathrop, Robert Spencer, and Walter Schofield. Known as the New Hope School, these artists gained acclaim for their forceful and direct Impressionist styles. Indeed, Redfield was the principal exponent of this approach. His bold and vigorous brush handling was considered "masculine and virile," as well as typically American.[4] As J. Nilsen Laurvik wrote in 1910:

AMONG THE MEN WHO HAVE DONE THE MOST TO INFUSE AN AUTHENTIC NOTE OF NATIONALISM INTO CONTEMPORARY AMERICAN ART EDWARD W. REDFIELD OCCUPIES A PROMINENT POSITION. HE IS THE STANDARD BEARER OF THAT PROGRESSIVE GROUP OF PAINTERS WHO ARE GLORIFYING AMERICAN LANDSCAPE PAINTING WITH A VERACITY AND FORCE THAT IS ASTONISHING THE EYES OF THE OLD WORLD, LONG ACCUSTOMED TO A SERVILE APING OF THEIR STANDARDS. HE IS A REJUVENATING FORCE IN OUR ART, THE DOMINANT PERSONALITY OF HIS CIRCLE, IN WHOM IS EPITOMIZED THE EMANCIPATING STRUGGLE OF THE YOUNGER MEN.[5]

Redfield found his subject matter in the immediate vicinity of his home. Working throughout the year, he painted views of roads, fields, frozen streams, the Delaware River snaking through the landscape, and the hills above Center Bridge. Although most of his images of the last-mentioned subject show the countryside in winter, he did not portray new snows, instead preferring to depict landscapes patchily covered with old snow, a subject that demonstrates Redfield's commitment to depicting his sites directly, "accepting nature as she is."[6]

In *Hillside at Center Bridge*, Redfield takes this approach, showing the last vestiges of a winter snowfall clinging to the damp muddy ground that covers an open hillside. A line of bare trees leads our eye gradually down the hill where a cluster of the town's homes are intermingled with foliage and nestled along the riverbank, while a long covered bridge provides access to the opposite bank. The directness of Redfield's painting method, his unself-conscious design, and his ability to portray the truths of his sites reveal what critics identified as the artist's uniquely American form of Impressionism. As John Trask wrote in 1909:

HIS PRESENTATIONS OF THE EVER MULTIPLYING BEAUTIES OF SNOW-COVERED COUNTRY (AND BY THESE HE IS UP TO THE PRESENT TIME BEST KNOWN) HAVE IN THEM SUCH QUALITIES OF DEEP-CHESTED VIGOR, HONESTY OF VISION, OF OPENNESS, AND ABOVE ALL, OF RESPECT FOR THE SUBJECT IN HAND....AMONG THE MEN WHOSE WORK MAY BE CONSIDERED TYPICAL OF OUR TIME NO ONE IS MORE CHARACTERISTICALLY AMERICAN THAN MR. REDFIELD. HIS GREAT SUCCESSES HAVE BEEN MADE THROUGH THE PRESENTATION OF THE ASPECTS OF THE LANDSCAPE UNDER CLIMATIC AND ATMOSPHERIC CONDITIONS PECULIARLY OUR OWN.[7]

Writing in 1906, B. O. Flower stated that many critics considered Redfield's *Hillside at Center Bridge* to be his "best painting" and commented:

MR. REDFIELD IS ONE OF THE COTERIE OF AMERICAN ARTISTS WHO ARE DOING SINCERE AND HONEST WORK THAT CANNOT FAIL TO AID IN THE BUILDING UP OF A GREAT AMERICAN ART. HE IS A MAN GIFTED WITH THE IMAGINATIVE POWER THAT ENABLES HIM TO CATCH THE BROODING SPIRIT OF NATURE, THE SOUL OF THE LANDSCAPE, AND TO SO REPRODUCE IT THAT IT IS MUCH THE SAME WHETHER ONE LOOKS ON THE LANDSCAPE OR ON THE ARTIST'S CANVAS.[8]

LNP

1. The principal sources on the artist are: Thomas Folk, "Edward Redfield: Pennsylvania Impressionist," *Art and Antiques* 4 (March-April 1981): 56-63 and J. M. W. Fletcher, *Edward Willis Redfield (1869-1965): An American Impressionist—His Paintings and The Man behind the Palette* (Lahaska, Pa.: J. M. W. Fletcher, 1996).
2. B. O. Flower, "Edward W. Redfield: An Artist of Winter-Locked Nature," *Arena* 36 (July 1906): 20.
3. C. Valentine Kirby, *A Little Journey to the Home of Edward W. Redfield* (Doylestown, Pa.: Bucks County Series—Unit 3, 1947).
4. See J[ohn] E. D. Trask *Catalogue of the Exhibition of Landscape Paintings by Edward W. Redfield*, exh. cat. (Philadelphia, Pa.: Pennsylvania Academy of the Fine Arts, 1909) and J. Nilsen Laurvik, "Edward W. Redfield—Landscape Painter," *International Studio* 41 (August 1910): xxix-xxxvi.
5. Laurvik 1910, xxix.
6. Laurvik 1910, xxix.
7. Trask 1909, n.p.
8. Flower 1906, 25-26.

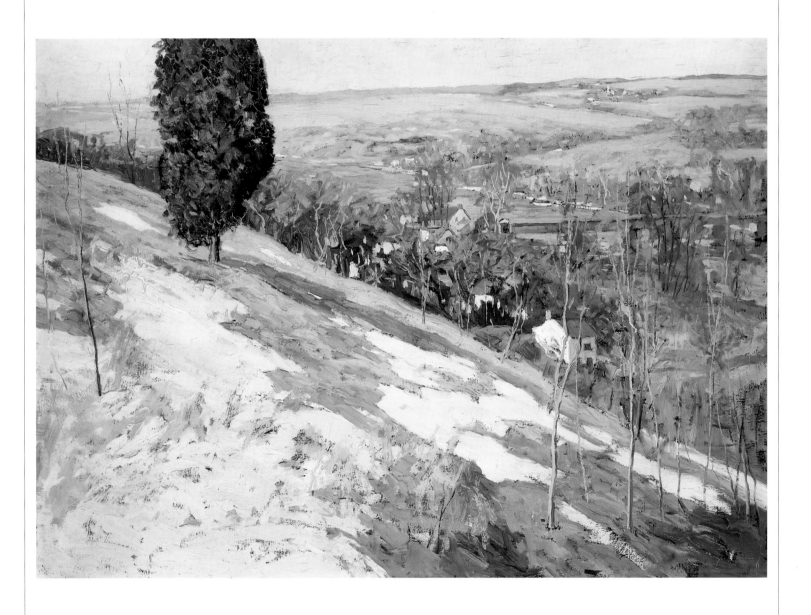

33

E R N E S T L A W S O N

(1873, Halifax, Nova Scotia-1939, Miami Beach, Florida)

Winter Landscape, Washington Bridge,
c. 1900s
Oil on canvas
18 1/4 x 24 3/8 in. (46.3 x 62.0 cm)
The Brooklyn Museum, New York
Bequest of Laura L. Barnes

In 1898 Ernest Lawson settled in the Washington Heights neighborhood of New York City.[1] The landscape that surrounded him in this area of upper Manhattan would consume his attention in the years ahead. True to an Impressionist perspective, he derived his subjects from his immediate surroundings. However, in contrast to the majority of American Impressionists who favored pastoral countrysides that evoked the pre-industrial past, what fascinated Lawson were rural areas where urbanization had begun to infiltrate. Lawson's interest in urban themes links his art to that of his associates in the Eight, the group of New York-based artists led by Robert Henri, whose aim was to create works of art that related directly to concerns of contemporary life, and in keeping with the viewpoint of the Eight, Lawson chose a perspective on the city that was positive. As art patron Duncan Phillips wrote in the *Magazine of Art* in 1919, Lawson could "bring beauty out of a region infested with squalid cabins, desolate trees, dumping grounds, and all the more important familiarities of any suburban wilderness."[2]

During his years in Washington Heights, Lawson painted the bridges of upper Manhattan, focusing most often on the two that crossed the Harlem River between Manhattan and the Bronx, the High Bridge situated at 175th Street in Manhattan and built on top of the old Croton Aqueduct, and Washington Bridge, six blocks to its north, which was constructed in 1888 (fig. 65). The bridges were highly picturesque elements of their neighborhoods since their Roman-inspired masonry arches made them "seem to belong to another city, an earlier age," as John C. Van Dyke wrote in his 1909 *The New New York*.[3] Indeed, the bridges made Washington Heights a popular place for Manhattanites to gather in the early twentieth century. Their spans were built to accommodate foot traffic, and horse racing took place along a Speedway below them. At the same time, the Grand View Hotel, just south of Washing-

ton Bridge, operated a boathouse. The area under Washington Bridge, featured often by Lawson, was "one of the most popular places of public resort in the city" as noted by Moses King in his *Handbook of New York* (1893).[4]

In *Winter Landscape, Washington Bridge*, we appear to be looking north toward Washington Bridge, with Manhattan on the left and the Bronx on the right. Showing barges and tugs on the river at the right and homes and/or hotels submerged in the trees at the left, Lawson captured the transitional character of an area that was on the border between city and country. This locale was indeed featured in an illustration in Jesse Lynch Williams's 1899 article "The Water-Front of New York" which was captioned: "Here is where the town ends, and the country begins."[5]

With its sparkling opalescent tonalities and thickly built up surface, the painting illustrates Lawson's ability "to luxuriate in pigment, loading it lavishly."[6] Blending his colors on canvas with both short dabs and long, broken strokes that skim the surface, Lawson expressed the vibratory qualities of the terrain. Indeed, it was exactly for the richly textured qualities of works such as *The Harlem River* that critics described Lawson's canvases as resembling "crushed jewels."[7] Although depicting a place where urban forces were increasingly making their presence known, Lawson's image is not of a drab industrial scene. Eliminating detail in favor of a more suggestive approach, he presented a peaceful landscape where modern progress and domestic settlement were harmoniously in balance. Such tranquility in a place on the border between country and city was usually shortlived, as the city would soon dominate, overtaking all traces of rural life. It was in response to the city's reach that green and quiet suburban neighborhoods far beyond urban limits and serene country and coastal towns became popular with the American middle class in the early twentieth century. As works in this catalogue and show demonstrate, many Impressionist painters recorded places untouched by the city. Lawson was, indeed, one of the few to feature the transitional zone. With a poetic and tonal Impressionist approach, he created a lyrical interpretation of the "new New York."

LNP

Figure 65.
View of Harlem River and Washington Bridge, and the Water Towers, New York, from Moses King, *King's Handbook of New York City* (1893, reissued, New York: Benjamin Blom, Inc., 1972), 822.

1. The principal sources on Lawson are Sidney and Henry Berry-Hill, *Ernest Lawson, American Impressionist, 1873-1939* (Leigh-on-Sea, England: F. Lewis, 1968) and Adeline Lee Karpiscak, *Ernest Lawson, 1873-1939*, exh. cat. (Tucson, Ariz.: University of Arizona Museum of Art, 1979).
2. Duncan Phillips, "Ernest Lawson," *American Magazine of Art* 8 (May 1917): 259.
3. John C. Van Dyke, *The New New York* (New York: Macmillan Co., 1909), 306.
4. Moses King, *King's Handbook of New York City*, 2 vols. (1893, reissued, New York: Benjamin Blom, Inc., 1972), 192.
5. "High Bridge from Washington Bridge" illustration in Jesse Lynch Williams, "The Water-Front of New York," *Scribner's Magazine* 26 (October 1899): 396.
6. Phillips 1917, 60.
7. F. Newlin Price, "Lawson of the 'Crushed Jewels,'" *International Studio* 78 (February 1924): 367.

INDEX TO PAINTINGS
REPRODUCED

CONTRIBUTORS

JACK BECKER is curator of the Florence Griswold Museum in Old Lyme, Connecticut. A graduate of Carleton College, Mr. Becker is a doctoral candidate in art history at the University of Delaware, where he is completing a dissertation on American Tonalism. He has had fellowships from the Henry Luce Foundation, the National Gallery of Art, and the National Museum of American Art. Mr. Becker has co-authored the forthcoming book, *American Garden Literature in the Dumbarton Oaks Collection, 1785-1900: From The New England Farmer to Italian Gardens* (Dumbarton Oaks, 1997) and has curated the exhibition *E. C. Eirich: A Drexel Technical Illustrator* (Drexel University, 1991). Mr. Becker is currently preparing an exhibition on the work of Henry Ward Ranger for the Florence Griswold Museum.

MAY BRAWLEY HILL graduated from Salem College and received her masters in art history from the Institute of Fine Arts, New York University, where she completed courses toward her doctorate. She also completed courses toward her doctorate in art history at the Graduate School of the City University of New York. She curated and wrote catalogues for a number of exhibitions, including *Grez Days: Robert Vonnoh in France* (Berry-Hill Gallery, 1987), *The Woman Sculptor: Malvina Hoffman and Her Contemporaries* (Berry-Hill Gallery, 1984), *Fidelia Bridges: American Pre-Raphaelite* (New Britain Museum of American Art, 1981), and *Three American Purists: Mason, Miles, von Wiegand* (Springfield Museum of Fine Arts, 1975). Ms. Hill is also the author of *Grandmother's Garden: The Old-Fashioned American Garden, 1865-1915* (Harry N. Abrams, 1995) and is currently preparing a related book for Abrams on nineteenth-century American garden structures.

CAROL LOWREY is curator of the permanent collection at The National Arts Club, New York, and research associate at Spanierman Gallery, New York. A doctoral candidate in art history at the Graduate School of the City University of New York, Ms. Lowrey is writing her dissertation on Philip Leslie Hale. She has master's degrees in art history and in library and information science from the University of Toronto. She is the author of numerous articles and essays relating to nineteenth- and early twentieth-century American and Canadian painting, such as "The Art of Philip Leslie Hale," in *Philip Leslie Hale, A.N.A.* (Vose Galleries of Boston, 1988). Exhibitions she has curated include *Visions of Light and Air: Canadian Impressionism, 1885-1920* (Americas Society Art Gallery, New York, 1995), *A Noble Tradition: American Paintings from The National Arts Club Permanent Collection* (Florence Griswold Museum, Old Lyme, Connecticut, 1995), and *American Painters in Giverny, 1885-1920* (Spanierman Gallery, New York, 1993). Ms. Lowrey is currently preparing a catalogue of The National Arts Club Permanent Collection and organizing an exhibition of nineteenth- and early twentieth-century genre painting for the Americas Society.

LISA N. PETERS is director of research at Spanierman Gallery, New York and coauthor of the forthcoming catalogue raisonné of the work of John Henry Twachtman (with Ira Spanierman). A native of Portland, Oregon, she graduated from Colorado College; received her masters in arts administration from New York University; and completed her doctorate in art history at the Graduate School of the City University of New York, where she specialized in American art and wrote her dissertation on Twachtman. Among her recent publications are *American Impressionist Masterpieces* (Hugh Lauter Levin, 1991), an essay in *John Twachtman: Connecticut Landscapes* (National Gallery of Art, Washington, D.C., 1990), *James McNeill Whistler* (Smithmark, 1996), and *A Personal Gathering: Paintings and Sculpture from the Collection of William I. Koch* (Wichita Art Museum, 1996). Exhibitions she has curated include *Painters of Cape Ann, 1840-1940: One Hundred Years in Gloucester and Rockport* (Spanierman Gallery, 1996), *In the Sunlight: The Floral and Figurative Art of J. H. Twachtman* (Spanierman Gallery, 1989), and *Twachtman in Gloucester: His Last Years, 1900-1902* (Universe/ Spanierman Gallery, 1987).

DAVID SCHUYLER is professor of American Studies at Franklin & Marshall College, where he has taught since 1979. A native of Albany, New York, Professor Schuyler received his doctorate in history from Columbia University, where his dissertation was awarded the Richard B. Morris Prize. He is author of *Apostle of Taste: Andrew Jackson Downing, 1815-1852* (Johns Hopkins University, 1996), *The New Urban Landscape: The Redefinition of City Form in Nineteenth-Century America* (Johns Hopkins University, 1986), and coeditor of three volumes of *The Frederick Law Olmsted Papers*, the most recent of which is *The Years of Olmsted, Vaux & Company, 1865-1874* (Johns Hopkins University, 1992). He has also written more than a dozen articles in professional journals. He is advisory editor of the *Creating the North American Landscape* series at The Johns Hopkins University Press and a member of the editorial board of the Olmsted Papers publication project. He is a recipient of the Christian R. and Mary F. Lindback Award for distinguished teaching at Franklin & Marshall.